# Sculpture Parks & Trails of Britain & Ireland

# Sculpture Parks & Trails of Britain & Ireland

ALISON STACE

B L O O M S B U R Y

LONDON · NEW DELHI · NEW YORK · SYDNEY

First published in Great Britain in 2013
Bloomsbury Publishing Plc
50 Bedford Square
London WC1B 3DP
www.bloomsbury.com

ISBN 978-1-4081-6475-4

Book design by Susan McIntyre
Cover design by Eleanor Rose

Printed and bound in China

This book is produced using paper that is made
from wood grown in managed, sustainable forests.
It is natural, renewable and recyclable. The logging
and manufacturing processes conform to the
environmental regulations of the country of origin.

## IMAGE CREDITS

PAGE 1: *6 Times RIGHT* from *6 Times*, Antony
Gormley, 2010. (See p.135.) *Photo © Keith Hunter
Photography, courtesy of National Galleries of
Scotland*

PAGE 2–3: *Stem*, Eilís O'Connell, 2008. (See p.98)
*Photo: Barnaby Hindle, courtesy of Cass Sculpture
Foundation, Goodwood*

PAGE 6: *Conversation Piece*, Juan Muñoz, 1999.
(See pp.32–3.) *Photo: courtesy of South Tyneside
Council, by permission of the Estate of Juan Muñoz*

PAGE 7: *A Tree in a Sculpture*, Naomi Seki. (See
p.170.) *Photo: James Fraher, courtesy of Sculpture
in the Parklands*

# Acknowledgements

Huge thanks are due to all the sculpture
parks, trails and gardens for their help in
making this book possible, for their time,
efforts and images, or permission for use
of images. Without their very generous
input the guide would not exist. I would
particularly like to thank those that kindly
answered many queries, revised their
maps, or gave a guided tour.

In terms of book production, I would like
to thank Julian Beecroft for his substantial
pruning of the text and Susan McIntyre
for her many revisions and careful designs.
Thanks also to Brian Southern for his maps.
On a personal level, I would also like to
thank all the people that came with me
to research various places, Helen Downhill
for her help as travelling companion, and
Alison Evans for all her help with general
research and map reading. Thanks also to
my mother for her editorial help and baby
minding in the car, and above all thanks
to my long-suffering husband for not
only driving me all over Scotland but for
his understanding, patience and support.

FRONT COVER, TOP : *Flat Man*, Giles Penny, 1998.
From Broomhill Art Hotel, see p.119. *Photo: Bob
Van de Sande*

FRONT COVER, BOTTOM, LEFT-RIGHT: *Pont de Singe*,
Olivier Grossetête, 2012. From Tatton Park Biennial,
see p. 43. *Photo: Thierry Bal, courtesy of Tatton
Biennial*

*Fallen Deodar*, Jilly Sutton. From Broomhill Art
Hotel, see p.120. *Photo: Bob Van de Sande*

*Bog Wood Road*, Johan Sietzema, 2005. From
Sculpture in the Parklands, see p. 170. *Photo: Alison
Stace, by permission of Sculpture in the Parklands*

*Ball Player*, Ana Duncan, exhibited in 2012. From
Mill Cove Gallery, see p.182. *Photo: Alison Stace, by
permission of Mill Cove Gallery & Gardens*

*Poise: Shifting Skies*, Edwin Baldwin, 2012. Steel
and porcelain. From Broomhill Art Hotel (see p.
119). *Photo: courtesy of Broomhill Art & Sculpture
Foundation*

*The Brockhall Warrior*, Joanna Malin-Davies, 2003.
Jesmonite. From The Sculpture Park, see p. 88.
*Photo: courtesy of The Sculpture Park*

BACK COVER, CLOCKWISE FROM TOP: *System
No.30*, Julian Wild, 2009. Welded scrap metal.
From Sculpture in the Parklands, see p. 172.
*Photo: Alison Stace, by permission of Sculpture
in the Parklands*

*Striding Arch*, Andy Goldsworthy. The arch on
Bail Hill, from Striding Arches, see p.145. *Photo:
© Mike Bolam, courtesy of Striding Arches
Project.*

*A Tree in a Sculpture*, Naomi Seki. From
Sculpture in the Parklands, see p.170. *Photo:
James Fraher, courtesy of Sculpture in the
Parklands*

*New Riders*, Terence Coventry, 2011. Bronze.
From Quenington Sculpture Trail, see p.68.
*Photo: Steve Russell, courtesy of Quenington
Sculpture Trust*

Inverness

Loch Ness
Aviemore 43
Feshiebridge
Fort William

Aberdeen 39

Dundee
44 Perth

Loch Lomond 45 Stirling
Aberfoyle
Glasgow

37 Edinburgh
38

Dolphinton 41
Peebles

Kelso

40 Moniaive 1 Newcastle upon Tyne
42 Dumfries 5 3 2
Kirroughtree Carlisle

Middlesbrough

Kendal
6 Ripon

York
Leeds
4

Preston

Strabane 47

Belfast

Sligo Enniskillen Banbridge
51 46 48

Ballina Dundalk

Tullamore 49 Dublin

55 57
53 Ashford Wicklow
Carlow

Limerick

Waterford

Lismore
Sneem 50
56 54
52
Glengarriff

Cork

Holyhead 59
62 Llanrwst
Bangor Wrexham
65

61 Ellesmere Telford
Newtown 12
66

Aberystwyth

Fishguard

Carmarthen Brecon
58

Haverfordwest
Swansea 63
64 60

Cardiff

Bath

Liverpool 8 10 Manchester
9 7
Runcorn

16 Chesterfield

18
Southwell

Leicester Stamford Norwich
14 30
Peterborough

Birmingham

Worcester

Kettering

Cambridge

Gloucester Aylesbury
11 15
Cirencester 19 Harlow
29
25
22
LONDON
Reading
Guildford
21 20 26
Ashford
28 24 23 27
Salisbury 31
Southampton
Bognor Regis

Barnstaple 32

35 34
Exeter

36
Portland Bill
St Ives
33 Plymouth

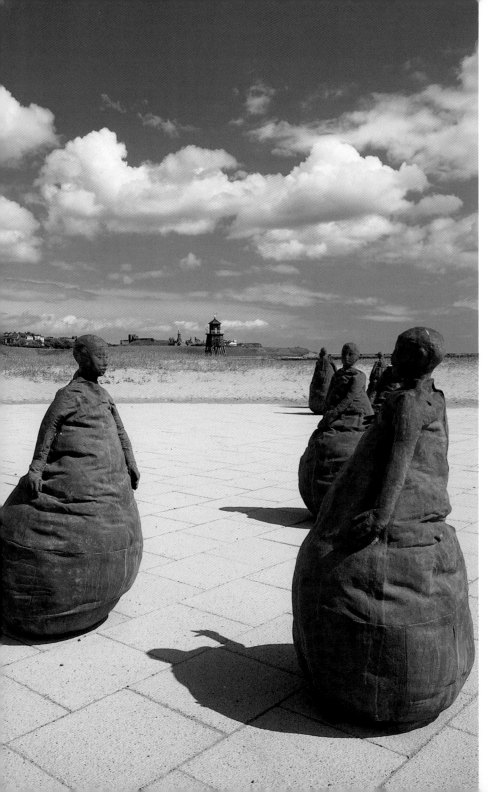

# Contents

# Introduction

The reasons for writing this book were many. Firstly, the vast number of sculpture parks and trails around England seems to be one of the nation's best-kept secrets, even to many serious art lovers. Secondly, many keen walkers I know had not heard of some of these parks, and seemed to think they would be small, strange places full of odd sculptures appealing only to wealthy art buyers. The idea of the book, therefore, was to introduce a wider group of art lovers to the delights of outdoor sculpture in beautiful settings, many of which I felt were being overlooked simply due to a lack of awareness. Equally, a large number of outdoor types could be introduced to accessible art in an unthreatening, non-gallery environment. Combining the two (art and landscape) is an ideal way to spend some of your weekend, providing a chance to see a variety of sculpture you would not necessarily see otherwise.

The vast and very mixed assortment of sculpture parks and trails is a little bewildering, especially if you have never visited one before. For this reason, I thought that a guide-book could be helpful in offering an overview of places to see sculpture in an outdoor setting. As well as featuring the most prominent and well-established, it also includes other places of interest which are much less well-known but which also have something to offer.

Amongst these 'other places of interest', the size, the quality and the amount of sculpture varies enormously, and this guide aims to give you a good feel for each place so that you can decide what would suit you best, depending on your location, available free time and level of interest. I apologise in advance to any parks or trails that have been left out or overlooked, as space was tight. One trail actually requested not to be included as the sculpture stands on private grounds. I would be pleased to consider any left out for future inclusion if suitable.

For the more discerning sculpture buff, there are distinctions to be made between sculpture parks, gardens and trails, but there is not space here for the length of discussion this issue deserves. Broadly speaking, my interpretation is that the sort of sculpture found in a park tends to be on a monumental scale. It may address issues of land and nature, while actually being made from natural materials (such as work by Andy Goldsworthy), or in the right setting it may simply relate to and/or

LEFT: *Fallen Fossil*, Stephen Marsden, 1985. Tout Quarry Sculpture Park and Nature Reserve, see p.132. *Photo: courtesy of Tout Quarry Sculpture Park & Nature Reserve*

RIGHT: *The Family of Man (detail)*, Barbara Hepworth, 1970. Yorkshire Sculpture Park (see pp. 26–31). *Photo: Jonty Wilde, courtesy of Yorkshire Sculpture Park*

visually enhance the surrounding landscape. In a vast landscape such as Kielder, for example, it becomes a way to relate to and place yourself in the landscape, as well as a way to orientate yourself. At the Forest of Dean the question came up of whether it was a good idea to put a sculpture in a naturally beautiful spot, or whether it was better to place it in a less scenic environment, in order to encourage interest in and engagement with less appealing areas. This tactic has been used to great advantage in Gateshead, where *Threshold* (see pp. 20-25) has enlivened an otherwise derelict corner of the town.

Sculpture in gardens tends to be on a smaller, more domestic scale, and the work is perhaps more about how the individual relates to the space or makes it their own. Sculpture in gardens is usually about personalising and enhancing a private area, whereas sculpture trails are often set up to encourage the visitor to explore and to navigate the landscape (often it's a wood) from point to point; although at the Forest of Dean they are keen to point out that the journey is as important as the destination.

Each park, trail or garden is completely different. This does make it hard to compare when some are publicly funded while others are commercial ventures, but I have tried to give a clear summary of what you can expect from each place. In view of this, I have tried to offer honest but not overly harsh critiques.

Maps have only been included where necessary for places where maps were hard to obtain or did not show artwork locations. Some were just too enormous to reproduce here, and most are easily obtained either on site or from websites (especially for the more organised or more obscure).

Above all, each trail and park is unique, with its own strengths and character. Ultimately, I hope this guide will go some way toward opening up the world of sculpture parks and trails to the large number of people who until now have quite simply been missing out.

*Disclaimer: All opening times, prices and public transport were correct at time of going to press, but these are all subject to change.*

*The Old Transformers*, David Kemp, c. 1991. On the Consett to Sunderland cycle route, see p. 32. *Photo: courtesy of Nicola Jones/Sustrans*

# England

# THE NORTH-EAST

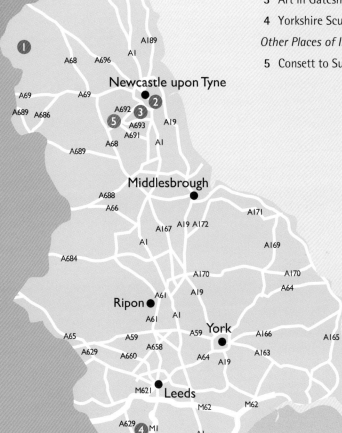

1 Art & Architecture at Kielder
2 The Angel of the North
3 Art in Gateshead
4 Yorkshire Sculpture Park
*Other Places of Interest*
5 Consett to Sunderland

A189
A1
A68   A696
A69
A69
A689   A686
Newcastle upon Tyne
A692
A693   A19
A691
A68   A1
A689
A688
A66
A171
A167   A19 A172
A1   A169
A684
A170   A170
A19   A64
Ripon   A61
Middlesbrough
A61   A1
York   A166
A59   A165
A65   A59   A59
A629   A658   A163
A660   A64   A19
M621   Leeds
M62   M62
A629   M1
A1

# 1 Art and Architecture at Kielder

Leaplish Visitor Centre
NE48 1BT
Tel: 01434 251000
Open mid-Feb–Oct, 8am–6pm daily.

**Information only:**
Kielder Partnership Tourist
   Information Centre
Main Street, Bellingham,
Northumberland, NE48 2BQ.
Tel: 01434 220643
www.kielderartandarchitecture.com
www.visitkielder.com (for visitor centres)

**Facilities:** 3 cafés/visitor centres & toilets.
Also offers canoeing, sailing & mini golf.
**Open:** All year
**Admission:** Free (car park £4, same ticket
can be used at all car parks).
**Time needed:** 2–3 days

## Getting there

**BY ROAD**
From the south take the A1(M) north and
at Jct 58 take A68 through Consett,
turn left onto A69 briefly and then right
onto A68 again. • Turn left (or right from
the north) off A68 towards Bellingham.
• Follow signs towards Falstone and Kielder
Water.

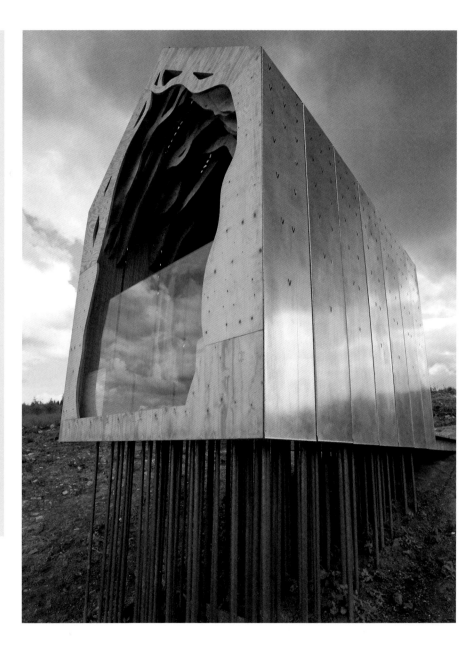

*Freya's Cabin*, Studio Weave, 2009. *Photo: David Williams, courtesy of Kielder Art & Architecture*

RIGHT: *Map courtesy of Kielder Art & Architecture*

## OVERVIEW

Kielder Water and Forest Park is an enormous area of land and lake, with sculptures situated all around the lake itself – a total distance of 27 miles that doesn't include hiking off down little paths to see specific works that are tucked away. To do the place justice, and to fully appreciate the rural scenery and solitude, you really need three days here (probably two if you drive to the car park nearest each sculpture – there are several – and walk from there). The park is very well served by three different visitor centres. The main one, and the most central, is Leaplish Waterside Park, with accommodation on site and also mini golf (which has been carefully designed as one of the sculptures!). Kielder Castle visitor centre (originally an 18th-century hunting lodge) is next door to *Minotaur* (the maze sculpture) – or, to be more accurate, *Minotaur* has been constructed on the site of the lodge's old vegetable garden.

Kielder is actually a manmade lake, created originally as a reservoir to supply other areas with water in times of crisis. When it was built a large area including a railway line and many farms was flooded. Notice boards at viewpoints occasionally show you (somewhat creepily) where these were – or are – located beneath the surface of the lake.

The art programme at Kielder has been running for over fifteen years, and architectural pieces have been an integral part of it since 1999. A major new project,

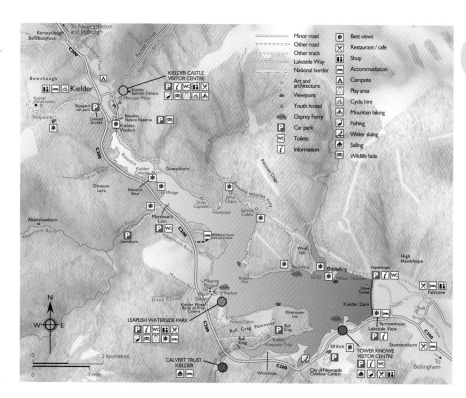

*Observatory*, was built in 2008. Designed by Charles Barclay Architects, the piece is an enormous platform on stilts with open areas and rooms with telescopes from which to observe the stars. Apparently, the sky here is among the clearest and least light-polluted in England, making it an ideal location for astronomers.

Most of the work at Kielder is superb (especially the more recent pieces), and the location is stunning, but there is a lot of ground to cover. The sculpture helps to draw people out into the forest to engage with it in some way, offering a new way of looking at or reflecting on it. The latest pieces of sculpture here are to be experienced rather than simply viewed

as objects. As Peter Sharpe from the arts programme puts it, 'the actual physical sculpture is only two thirds of the project, the final third is the work being used and experienced by people, which fulfils and completes its purpose'. Be warned that in this part of the country it does rain a lot, and sometimes it can take a couple of hours to reach a sculpture – so be prepared and take provisions.

## FINDING YOUR WAY AROUND

It is now possible to print off detailed information sheets about each sculpture from the Kielder website. If you prefer, you can pick up the art and architecture pamphlet from one of the centres. You

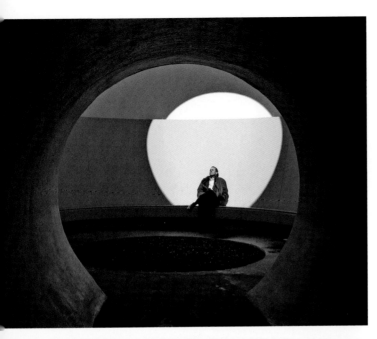

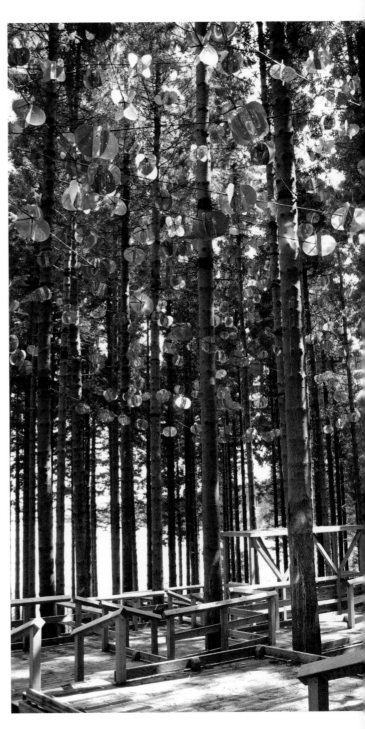

TOP: *Skyspace*, view through the tunnel into the chamber.

ABOVE: *Skyspace*, looking up at the sky through the circular hole inside.

RIGHT: *Mirage*, detail, Kisa Kawakami, 2006. Consisting of shiny disks suspended in the trees. The wooden area below is a viewing platform.
*Photos: Alison Stace, by permission of Kielder Art & Architecture*

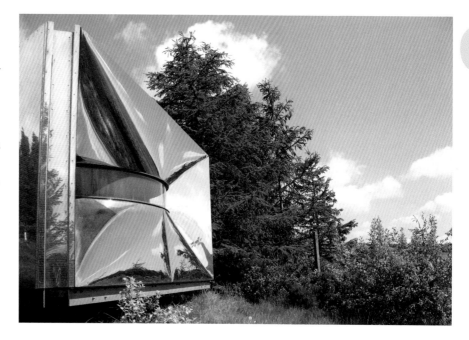

RIGHT: *Belvedere,* Softroom, 1999. The strange-shaped back of the shelter, with its panoramic window. *Photo: Alison Stace*

really need a map to find all the pieces. The pamphlet contains a map that gives a broad overview of the park (as shown here), and it also offers more detailed maps to help locate each piece. You can also print out or download maps to your phone, and choose to download a specific trail. More crucially for somewhere this large, it also gives an approximate walking time to each work from the nearest car park, as well as information about each sculpture.

There are a couple of ways to access sculptures. You can set off on foot along forest tracks from the nearest visitor centre. The sculptures are signposted with waymarkers, posts beside the path with an arrow pointing in the direction of a named piece. These are crucial to follow, as at times paths can criss-cross in all directions. Alternatively, you can cheat a little by driving to the nearest car park and walking along forest tracks from there. If you have the time it is much nicer to walk but with so much ground to cover, even doing it with a car you may need to divide the area up into sections and drive to a different point each time, setting out from there. The actual sculptures are not always signposted from the road, but the area will be named, and this is signposted, so check on the pamphlet maps for details and see the map on p.13 (for example, for the Kielder Keepsake you should park at Bull Crag).

In summer a ferry also runs across the lake to the *Belvedere,* and many other transport connections are being developed to make the north side of the lake more accessible. The Lakeside Way is a large new track (27 miles all the way round), which enables walkers, cyclists and horse riders to completely circumnavigate the lake. The Lakeside Way also helps to connect many of the current art and architectural works, and in fact some of these are shelters situated on the route. The north side can also be reached by tracks through the forest (or by the ferry in summer).

## THINGS TO SEE

The James Turrell *Skyspace* is a wonderful creation. A mile and a half from the Kielder Castle visitor centre (signposted from the car park), it takes approximately an hour

to reach on foot, depending on your speed. James Turrell has been working with light since the 1960s, and the fantastic concept behind *Skyspace* has to be experienced to be appreciated. This one was built in 2000 and the only other one that can be found in the UK, at the Yorkshire Sculpture Park (see p. 27), was built in 2007. These pieces are effectively shrines to light, evoking a sort of spiritual experience. In the case of the Kielder *Skyspace* it is a bit like visiting a temple, especially with the pilgrimage needed to get there. A tunnel takes you into a circular chamber with seats all the way round. The focal point of the round space is a circular hole cut out of the ceiling. The thick ceiling is chiselled down to an edge from the outside, so although the ceiling is very solid, the edge of the hole appears to be very thin. This allows more light in, and enables the viewer to

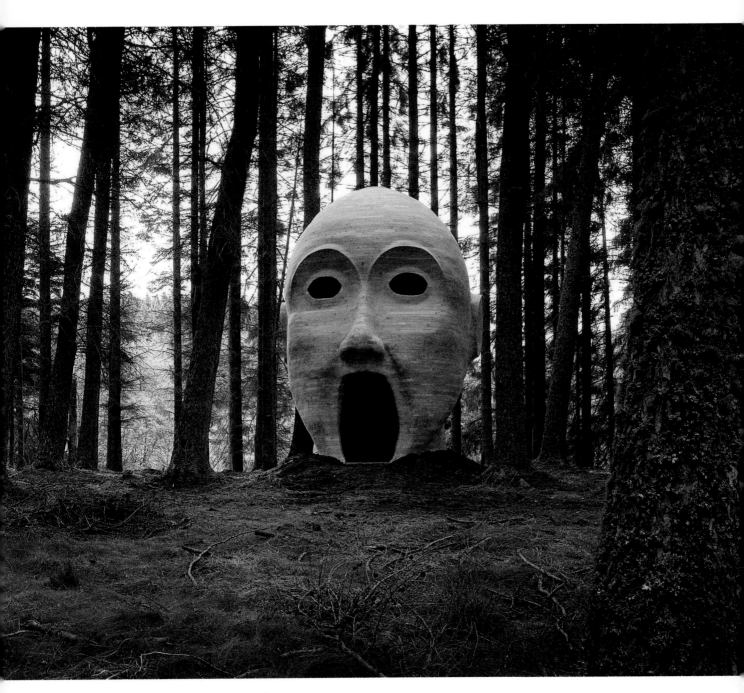

*Silvas Capitalis*, SIMPARCH (American artists' collective), 2009.
*Photo: Michael Baister, courtesy of Kielder Art & Architecture*

not only watch the sky changing, but also to experience the light changing inside the chamber. At dawn the experience is totally different to that at dusk. As the sun goes down the subtle interior lighting takes over, as gradually it becomes a softly glowing haven from the dark outside world. As Kielder has open access you can stay to watch the light change as the sun sets (try to park at the nearest point to avoid getting lost in the forest afterwards, and take a torch), or get up early to watch it as the sun rises. The circular hole in the ceiling is echoed by the round space inside, the circular tunnel, the black circle of gravel in the centre of the floor and, when the sun shines, the bright circle of light which hits the wall. This was certainly one of my favourite pieces.

More recent additions to Kielder include *Freya's Cabin* and *Robin's Hut*, which are on opposite sides of Kielder Water by Lakeside Way, their location reflects the story of Freya and Robin – two characters who live across the water from each other, and the tale of how they eventually meet. Their stories are inside the cabins for visitors to read. *Freya's Cabin* is created beautifully, with layers of flat wooden shapes representing all the plants and flowers that Freya collects and presses, which eventually become part of her cabin, while the gold areas are from the tears she sheds. The inside is also very pretty, with soft and wavy forms, while the whole thing is raised up on long thin stilts so that Robin can see it from the opposite shore. This is just a snippet, the full story is far more engaging!

*Silvas Capitalis* (meaning 'forest head') is made from timber, and this impressive but somewhat frightening construction enables the viewer to literally 'get inside it's head' by walking in through the mouth and climbing up to view the forest through its eyes. It was made by an American artists' collective (SIMPARCH) and the idea was that it is a 'watcher', observing the comings and goings, evolution and changes in the forest.

*Salmon Cubes* are a series of four giant cubes at various points on the water's edge made to reflect a part of the life cycle of the salmon that live in the river Tyne, and were created to raise awareness of this, while the very well-designed and rotating *Janus Chairs* offer both seat and shelter in one, allowing the visitor to sit, revolve and reflect on the whole view.

*Belvedere* is a fantastic architectural shelter, which looks as if it has just landed from space (it was actually constructed by Softroom). Situated at Benny Shank, it can be reached by ferry (in summer) or by walking from Hawkhope car park. The idea was to create something that would blend in with its surroundings in a new and contemporary way, rather than by using traditional wood or stone. The stainless-steel surface does this by reflecting back its surroundings, and once you have got accustomed to the shock of seeing this peculiar-shaped steel construction perched on the edge of the lake it actually works very well. Inside the shelter are not only benches, but a long thin window offering a curved and

panoramic view of the lake. This amazing window is framed at both edges by wings of steel which are part of the outer wall, throwing back the last bit of the view as a reflection.

*Wave Chamber* is perched right on the edge of the lake, where on a windy day waves crash against the rocks. It can be reached by walking from Hawkhope car park. You could be forgiven for thinking that this cone-shaped stone construction is one of Andy Goldsworthy's cones, but it is actually a hut by Chris Drury. It is effectively a camera obscura, and really needs the sun to enable it to work properly, so you may or may not get lucky. The light hits the waves and bounces off onto a mirror, which then directs the light through a small glass lens in the roof of the domed hut onto a stone slab in the floor. Once you are inside the hut with the door shut, you will notice how the darkened interior emphasises the silvery light of the waves, which plays on the floor in mesmerising patterns.

*Mirage*, by Kisa Kawakami, is accessed from Bakethin Weir, and looks like a strange, slightly messy collection of silver discs suspended from the trees above a series of wooden platforms. The piece intrigued me as I approached it on a cloudy day - but then the sun came out and it was suddenly transformed as the rays of light bounced off the discs, making the treetops, tree trunks and the surrounding forest floor flash and twinkle with thousands of little spots of light. A magical experience.

# 2 The Angel of the North

## Getting there

**BY ROAD**
Located on A1 at the entrance to Gateshead.

**From the north** (central Gateshead), head south on the Durham road (A167) to Low Fell. Continue through Low Fell until you reach the dual carriageway, then keep going until you reach main roundabout leading to the A1. • Go round the roundabout and take the exit back towards Gateshead South. The Angel site is on your left about 300 yards further on, with parking indicated in the second lay-by.

**From the south** follow the A1 and A1(M) north until you pass Washington service station. Just past this is jct 65; come off the A1 here. • At the main roundabout take the A167. Continue on for a few hundred yards. The Angel site is on your left, with parking indicated in the second lay-by.

**BY BUS**
Buses run to the Angel of the North from Gateshead Interchange, Bus Stand K
Buses: 21, 21a, 21b, 724, 728

## OVERVIEW

The *Angel of the North* by Antony Gormley, which marks the entrance to Gateshead, has become an iconic symbol of the North. Completed and installed in 1998, the *Angel* is Britain's largest sculpture. At 20 m (65 ft) tall and with a wingspan of 54 m (175 ft), it can be seen easily from the A1 as well as from the East Coast train line. It stands on a hilltop, the site of a former colliery, reflecting the industrial history of the area.

It is impossible to appreciate exactly how big the *Angel* is until you stand at its feet. Both awe-inspiring and slightly terrifying, the figure could be either offering protection or demanding compliance, or possibly both, and has immediate connotations with myths and legends from the ancient past.

As one of Gateshead Council's first public commissions, the *Angel* has done much to regenerate the area and open up further opportunities for public-art funding. It also appears to have had a much bigger impact than expected, both on local people and on the general public's attitude towards the area. The *Angel* has won many art awards including the National Art Collection Fund Award for outstanding contribution to the visual arts.

Hartlepool Steel Fabrications constructed the piece for Gormley using Cor-Ten™ weather-resistant steel, plus 32 tonnes of reinforcing steel, and 700 tonnes of concrete poured down into the foundations to anchor the sculpture to solid rock, helping it to cope with winds of more than 100 mph. It is hoped that *The Angel of the North* will last for more than 100 years.

A more recent installation by Antony Gormley is *Another Place* at Crosby, Merseyside (see pp. 44–5).

*Angel of the North*, by Antony Gormley, 1998. View of the back showing the ribs. *Photo by Alison Stace with permission of Gateshead Council and Antony Gormley Studios*

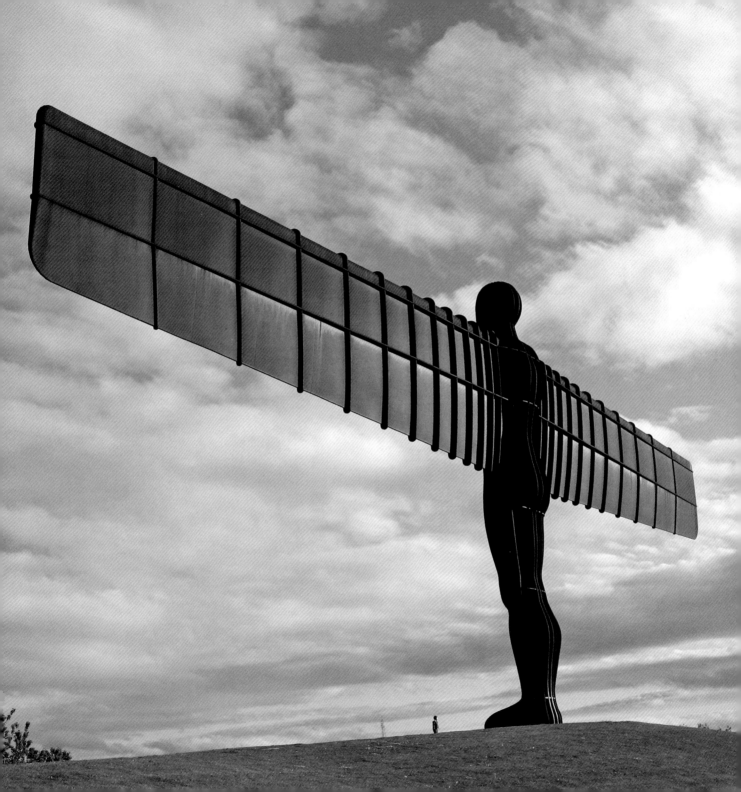

# 3 Art in Gateshead

## OVERVIEW

Walking around the sculptures at Gateshead is very much an urban experience. Sculptures are scattered all around the town, and while a good many are by the attractive Quayside or the Riverside park area, many others are located by car parks and shopping centres, sometimes involve crossing busy junctions or large roundabouts, or walking along stretches of rather bleak roadside. However, they are worth the effort.

While many councils have tried to improve their towns with a few sculptures in public places, Gateshead have taken the policy to a new level, commissioning nearly 50 artworks since the early 1980s, including some very exciting, modern pieces. The best-known of these pieces is undoubtedly the *Angel of The North*, beside the main road leading into the town. But the large investment in so many pieces has resulted in a strong body of work sited

The Sage, Gateshead
Hillgate Quay, St Mary's Square,
Gateshead NE8 2GR

**INFORMATION:**
St Mary's Church
Oakwellgate
Gateshead NE8 2AU
Tel: 0191 478 4222
www.gateshead.gov.uk
www.gateshead.gov.uk/Leisure%20
and%20Culture/home.aspx

**Facilities:** The Sage in Gateshead (where you can start) has a café and toilets.
**Open** (visitor centre): Mon-Fri 9am–5pm, Sat 10am–5pm, Sun & bank hols 11am–5pm
**Admission:** None, though if you come by car you'll need to pay for parking at The Sage – rates depend on how long you will be.
**Time needed:** 2 hours

## Getting there

It is important to note that the city of Newcastle and the town of Gateshead are located on opposite sides of the Tyne, though to the untrained eye they appear to merge into one big urban sprawl. A good place to start a tour of sculpture in the area is The Sage, the enormous undulating silver building housing a cafe, toilets and music halls next to the Baltic Mill (centre for contemporary art), located on the Gateshead side of the river.

### BY ROAD
Take the A167 from the A1, and once you enter Gateshead or Newcastle, head for the bridge and then follow the brown signs to Quayside and The Sage.

### BY TRAIN
The nearest station is Newcastle Central, from where you can either walk (about 20 mins) or take a yellow QuayLink bus (Q1) to The Sage in Gateshead (approx. 5 mins).

all over the town. The quayside has also undergone major renovation, including the attractive Sage centre, designed by Norman Foster, a music venue with state-of-the-art concert halls. This imposing building is nevertheless a very welcoming place, with a nice café. Its fantastic architectural qualities can only really be appreciated from the inside, while one of the town's sculptures, the *Ribbon of Colour*, runs through it (see p.24). Opposite The Sage is the Baltic Centre for Contemporary Art. Converted from a flour mill, this lovely building has changing exhibitions and views across the river from the fifth floor.

## FINDING YOUR WAY AROUND

Start at the tourist information centre, located in St Mary's Church, next to The Sage. This has copies of the town map showing both Newcastle and Gateshead, and more importantly a booklet called The Gateshead Art Map. Be sure to ask for a copy if it is not visible. The Art Map has information on all the sculptures, and shows you where they are located (see also map overleaf). Although the map does include some street names, it is helped by having the town plan alongside for backup. There are now about 50 sculptures in the Gateshead area, and many of them are scattered and far-flung, involving buses or car journeys. The ones around the centre are in my opinion some of the best, and can be reached just by walking around central Gateshead. It took me about two hours

LEFT: *Foliate Form*, Gilbert Ward, 2010. Riverside Park (Rose St). *Photo: courtesy of Gateshead Council*

*Acceleration* (detail), John Creed, 2005. Cor-Ten™ steel and stainless steel. The whole piece is in two parts and is 7m (23ft) long. *Photo: Alison Stace, with permission of Gateshead Council*

to walk around the ones included on the suggested route (not all are included). Of course, there is no set way, and you can follow your own path. The Sage is a convenient place to start from, however, as it is easy to spot, well signposted, has two of the sculptures on its doorstep, and the added advantages of parking, a café and toilets.

The route I took incorporated the following pieces (see corresponding numbers on the list): 15, 13, 10, 5, 3, 1 – retrace steps back down West St – 7, 11,

then in the park – 19, 20, 21, 22, 23; then walk back along Pipewellgate to 14 and end at 16 (by entrance to car park). The area covered a rough triangle, created by the Baltic, along to Queen Elizabeth Bridge (although if you have time you can continue to Redheugh Bridge) and the Gateshead Civic Centre. The nicest area is the Quayside and along the river, and it also has many of the best sculptures, so if you are short of time you could just stick to this route – although you would miss out on several good pieces, including *Threshold* (on Arthur St).

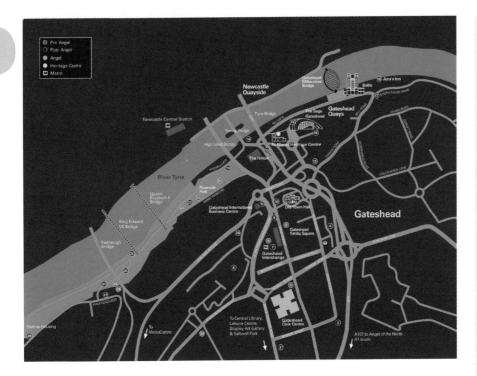

1 *The Family* by Gordon Young, 1991. Cumbrian limestone.

2 *Penny Circus* by Matthew Blackman, 2006. Enamel and concrete.

3 *Threshold* by Lulu Quinn, 2003. Sound work and steel.

4 *Subways* by David Goard, 2004/05. Printed ceramic tiles.

5 *Sports Day* by Mike Winstone, 1985–6. Painted concrete.

6 *Nocturnal Landscape* by Keith Grant, 1982. Terrazzo mosaic panels.

7 *Opening Line* by Danny Lane, 2004. Steel and glass.

8 *Wind Vane* by Richard Woods, 2001. Stainless steel.

9 *Subways* by David Goard, 2004/05. Printed ceramic tiles.

10 *Acceleration* by John Creed, 2005. Cor-Ten™ steel and stainless steel.

11 *Counterpoise* by John Creed, 2005. Stainless steel with coloured spheres.

12 *Orange Beacon* by David Pearl, 2004. Stainless steel and coloured acrylic.

13 *James Hill Monument* by Peter Coates, 2006/07. Blaxter stone.

14 *Blue Beacon* by David Pearl, 2004. Stainless steel and coloured acrylic.

15 *Ribbon of Colour* by Kate Maestri, 2004. Stainless steel, and printed, curved and coloured glass.

16 *Star Ceiling* by Jo Fairfax, 2004. Fibre-optic cables and tubing.

17 *Swirl* by Colin Rose, 2009. Stainless steel.

18 *Jury's Inn café/bar* by Bridget Jones, 2011. Architectural glass – etching and enamels.

19 *Rise and Fall* by Lulu Quinn, 2007. Glass, LED lighting and stainless steel.

20 *Cone* by Andy Goldsworthy, 1992. Steel plate.

21 *Rolling Moon* by Colin Rose, 1990. Steel.

22 *Thornbird Railings* by Marcela Livingston, 2005. Painted, cast iron.

23 *Goats* by Sally Matthews, 1992. Recycled materials.

24 *Once Upon a Time* by Richard Deacon, 1990. Painted mild steel.

25 *Riverside Rivets* by Andrew McKeown, 2010. Cast iron.

26 *Phoenix Cobbles* by Maggy Howarth, 1994. Pebble mosaic.

27 *Entrance Features* by Graeme Hopper, 2005/06. Steel.

28 *River Arch* by Keith Barrett, 2010. Cor-Ten™ steel and painted steel.

29 *Window* by Colin Rose, 1986. Steel.

30 *Ribbon Railings* by Gateshead Council landscape architects and Alan Dawson Associates, 2002. Galvanised steel.

31 *Foliate Form* by Gilbert Ward, 2010. Carved Stone.

## THINGS TO SEE

At The Sage you will find the 200m-long *Ribbon of Colour*, designed by Kate Maestri and incorporated into the building by Norman Foster. This consists of coloured panels attached to the balustrade, creating a lovely curving line of changing blues and greens running from the front of the building all the way through the inside. The well-named *Acceleration* (by John Creed) is found on your way into town, dividing the car park from the road. Behind it is the Old Town Hall, at one point housing a temporary cinema (and nice coffee room). As you walk along West Street you will pass *Sports Day* (by Mike Winstone), an enormous jet-black sculpture depicting the sack race on a school sports day, with animals from Aesop's fable of the tortoise and the hare. It looks incongruous outside the shopping centre but it's still a great piece of accessible art relating to the community. Turn left down Charles Street at the Civic Centre (a red-brick building), then right onto the High Street, and continue along past St Edmund's Church (on your left) until you come to a sharp right bend at the end of the road. In front of you is a short cut through some trees, with *Threshold* (by Lulu Quinn) standing very tall above the entrance to the path. This sound sculpture was one of my favourites – it is not much to look at; it has to be experienced. Once you have opened

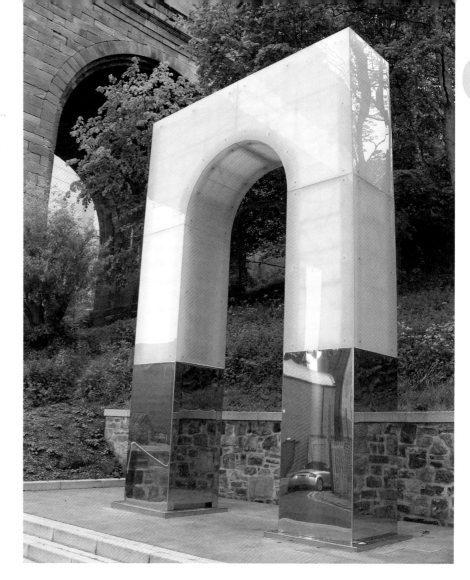

*Rise and Fall*, Lulu Quinn, 2007. The arch echoes the railway arches behind it, and is lit up gradually through the day. *Photo: Alison Stace, with permission of Gateshead Council*

the 'invisible gate' by walking through the sculpture along the path (listen for the sound of an enormous creaking door), a random soundtrack is played, a recording from some 300 local people. This can be literally anything – I heard ducks, hundreds of running feet, and a child's birthday party, amongst other things. Then when someone else walks through, the gate 'shuts' (listen for the slamming sound!). Located on a busy walkway, it is constantly being triggered off, turning an uninteresting corner into an active and engaging spot. Well worth the walk.

From here, follow the sharp bend and turn right back past the civic centre, where you'll find Gordon Young's chunky figurative stone sculptures of people at various times of life (situated significantly close to the register office). Walk back down West Street, passing on your left the fantastic wave-like sculpture of steel and glass (*Opening Line* by Danny Lane) situated in the middle of Gateshead Interchange (the bus depot). Heading down towards the river you will reach *Acceleration* again and see *Counterpoise* by the same artist, John Creed (away to your left in the International Business Centre car park, which is lit up at night). Once you reach the road heading towards the river again, you want to veer left down the side of the buttresses holding up the bridge. After you have passed the James

Hill Monument marking the life of the fiddle player who lived here, turn left (after the *Orange Beacon*) into Pipewellgate, towards the park.

*Rise and Fall* by Lulu Quinn (also responsible for *Threshold*) is a fabulous archway, installed in 2007, marking the entrance to Riverside Park. Standing

6m high, it is constructed from stainless steel and turquoise glass, with hundreds of tiny lights inside it. Lights come on gradually throughout the day, until by the evening it is entirely lit up and can be seen across the river. They also light up in a sequence to create the illusion of the arch wobbling, collapsing and rebuilding itself. The park is also home to *Cone* by

Andy Goldsworthy. Looking like a giant brown egg through the trees, there was (at the time) no path taking you down to it – so you have to settle for glimpsing it through the trees.

After passing *Rolling Moon* further down into the park, if you get back onto the road and turn left you will find Sally Matthews's *Goats* nibbling grass on the embankment. Made from salvaged metal and sited in stages up the embankment, the goats gaze out as if on a terraced Mediterranean hillside.

Also in the Riverside park area, further on, are a few pieces added in 2010. Amongst these are *Riverside Rivets* by Andrew McKeown, giant cast-iron rivets which appear to be scattered by the roadside, reflecting Gateshead's industrial heritage, and also *Foliate Form* by Gilbert Ward, a carved stone monolithic form which livens up the path and cycle way. Meanwhile Keith Barrett's *River Arch* marks the western entrance to Riverside Park.

In the Gateshead Quays area there are also some recent additions (all quite near the Baltic), amongst them Colin Rose's *Swirl*, which twists upwards for 10 metres in Baltic Place, and the very beautiful glass features of Jury's Inn by Bridget Jones. This hotel features architectural glass, using enamels and screen prints in the bar area, while the glass screen in the courtyard gives a view outside through many layers of pattern and detail, building up a fantastic view from both inside and out. The colours were inspired by the many products traded along the river such as wine, leather, coal and wax.

Return to The Sage on your way out, and be sure to look at the very well-hidden *Star Ceiling*. To find it, head out around the back of the centre to the car-park entrance, a stainless-steel and turquoise-fronted area with lifts up to the top floors. Stand right in front of the lift doors. Now look up – an unexpected, beautiful starry night stares back at you from this secret dark space, its illuminated neon stars suspended on long hanging tubes.

ABOVE LEFT: *Ribbon of Colour*, Kate Maestri, 2004. *Photo: Philip Vile, courtesy of Gateshead Council*

ABOVE RIGHT: *Riverside Rivets*, Andrew McKeown, 2010. Riverside Park (Rose St entrance). *Photo: courtesy of Gateshead Council*

BELOW: *James Hill Monument*, Peter Coates, 2007. Carved from Blaxter stone (the same stone as the base of the bridge). *Photo: Alison Stace, with permission of Gateshead Council*

Architectural glass, Jury's Inn Bar, Bridget Jones,
2011. *Photo: courtesy of Gateshead Council*

# 4 Yorkshire Sculpture Park

Yorkshire Sculpture Park,
West Bretton, Wakefield, WF4 4LG.
Tel: 01924 832631
Web: www.ysp.co.uk

**Facilities:** Café, toilets, educational programmes.
**Open:** Summer: 22 March–28 Oct, grounds & centre 10am–6pm,
Longside Gallery 11am–4pm.
**Winter:** 29 Oct–21 March, grounds & centre, 10am–5pm.
Longside Gallery 10am–3pm
**Closed:** 23–25 Dec
**Admission:** free (donations), (car park: Mon–Fri, all day £7.50, 1–2 hours £5, weekend & bank holidays, all day £7.50)

## Getting there

**BY ROAD**
Exit 38 off the M1, follow brown heritage signs to YSP on the A637, then turn off at the first roundabout (signposted).

**BY TRAIN**
Wakefield Westgate station (about 2 hours from London King's Cross), and approx. 15 mins by taxi.

*Oval with Points*, Henry Moore, 1968–70. Reproduced by permission of the Henry Moore Foundation. *Photo: Jonty Wilde, courtesy of Yorkshire Sculpture Park*

FACING PAGE: *Deer Shelter Skyspace*, James Turrell, 2006. An Art Fund Commission. *Photo: Jonty Wilde, courtesy of Yorkshire Sculpture Park*

## OVERVIEW

The first impression of the Yorkshire Sculpture Park that greets you on arrival (apart from the state-of-the-art angular visitor centre designed by Feilden Clegg Bradley, with its long path of names leading to the door), is the hilarious juxtaposition of sheep and grass with enormous bronze sculptures by Henry Moore. Fluffy Yorkshire sheep nibble around the base of the plinths on which these giant sculptures stand.

Yorkshire Sculpture Park is one of the biggest and most established of the sculpture parks. The standard of sculpture is very high, with pieces by many internationally recognised artists from the last 100 years, including Henry Moore, Anthony Gormley, Elisabeth Frink, David Nash and Barbara Hepworth. As such it is a great place to get an instant overview of the development of British sculpture since the first part of the 20th century. The Henry Moore section that greets you on arrival is set out across a wide hillside, with a sweeping view down towards a river. Work by Barbara Hepworth is also shown on a regular basis. The visitor centre has a large gallery downstairs, with changing exhibitions which sometimes spill out into the formal gardens below. The Longside Gallery at the opposite end of the park also houses exhibitions and in any case is worth the walk, given the

interesting sculptures along the way. Check the website or ask at the main centre reception what is showing – be warned, though, that the Longside Gallery does not have a café, so you may want to have lunch before setting off for the other side (approximately a 30–40 minute walk).

A more recent addition to YSP is the new *Skyspace*, designed by James Turrell. This work has been in progress since 1993 and finally opened in 2007. Turrell has worked with concepts of light and space for 40 years, and this *Skyspace* is only the second one he has built in this country (the first is at Kielder Water, see pp. 12–17). The Skyspace has been constructed within the Deer Shelter – an 18th-century construction. If you go to YSP you simply have to go and experience this amazing space; it is relatively near the visitor centre, so even if you are short of time you should still be able to see it.

YSP was established 35 years ago for the public to enjoy and has changed radically from its beginnings in a small wooden hut. The grounds were part of an estate that was landscaped over 200 years ago, but was split up in the 1940s before being brought back together by the sculpture park in recent years. The Underground Gallery, following the building of the impressive visitor centre, was also designed by architects Feilden Clegg Bradley, and was shortlisted for the 2006 Gulbenkian Prize.

## FINDING YOUR WAY AROUND

The park is divided up into sections to aid navigation, and the leaflet (with map) has the main oudoor sculptures marked on. More information can also be obtained from a small guide book on sale (£5) and from the website.

The park has a veritable feast of sculptures, and trying to see everything is quite exhausting. This is partly because there is so much here, and partly because significant sculptures are scattered throughout the various areas, as well as across the 1 ¼ mile (2 km) stretch of fields and grounds between the visitor centre and the Longside Gallery at the opposite end. Our visit lasted five hours, which included looking at everything, a half-hour lunch stop at the very pleasant café, as well as walking across to the Longside Gallery. The map suggests routes to follow, and gives a rough idea of how long it will take. From experience, I would recommend covering the smaller, upper areas first and having lunch, before heading over to the caféless Longside Gallery. If you feel it is all too much, you could simply target specific areas instead.

## THINGS TO SEE

As one of the YSP leaflets puts it, James Turrell's work 'is about light, but more importantly it is light', so one sculpture you should definitely see when coming here is Turrell's *Skyspace* in the Deer Shelter. This shrine to light is an almost spiritual experience, which on its own

makes the trip to YSP worthwhile. The entrance, which is hidden behind the three arches of the old deer shelter, consists of a doorway like that of an ancient Egyptian tomb. It leads into a secret chamber entirely lined by stone seats with very high backs. Along the top of the backs is very subdued lighting, while the whole room slopes gently outwards and upwards towards the ceiling, encouraging you to lean back and look up. Above you, cut out of the ceiling, is a perfect opening that appears to have edges as thin as a

line (although it is actually very solid). The cut-out space reveals the ever-changing sky, allowing light to fill the room, which changes dramatically or very subtly depending on the weather conditions outside. The space has an almost monastic feel. One of the greatest pleasures the piece offers is to be able to watch the light change in the Skyspace throughout the day, and especially as the sun comes up or goes down – although, given the opening and closing times at YSP, that is harder to do here than with the *Skyspace* at Kielder Water (see pp.14-16).

Most of the routes suggested by the map start with the Gardens Zone, which includes the Underground Gallery and the formal gardens and terrace, usually home to changing exhibitions. Many of Elisabeth Frink's sculptures were moved

here together in 2007, to the area just below the formal gardens.

The Hillside Zone is home to Jonathan Borofsky's *Molecule Man 1+1+1*. You can see right through this huge, spacious sculpture thanks to all the holes cut out of it (representing the molecules). The two enormous, flat cut-out figures are joined to each other around a central axis, and appear to be arguing and running through or at each other. This sculpture is presumably intended to represent the state of man in general.

Barbara Hepworth's work is also featured on this hillside (although pieces on display may change). Hepworth and Henry Moore were contemporaries and had a great deal of influence on the development of modernist sculpture. She spent

most of her life in St Ives in Cornwall, where her home and gardens have been open to the public for many years (see p.123). One of few artists at this time to create enormous pieces specifically for the outdoors, the curved, organic forms of her work make it particularly suited to being displayed in a landscape setting. *Two Forms (Divided Circle)* shows Hepworth's interest in abstract shapes and their relationship to each other. As with *Squares with Two Circles*, the shapes created by the holes and the spaces are as important as the shapes created by the solid sculpture.

Driveside Zone (next to Hillside) is a small area that could be easy to miss – but don't, as among others (including works by David Nash) it is home to some fantastic sculptures in bronze by Dame Elisabeth Frink, another internationally renowned 20th-century British artist. Frink was committed to figurative sculpture, and worked from themes linked to the Second World War concerning both the atrocities committed and the strength of those caught up in it. *Running Man* (most of her figures are male) appears thin and wiry, like someone who has struggled to survive, and wears a serious, intense look as he runs. Frink and Hepworth would build an armature and cover it in plaster, into which they carved directly, creating a model the same size as the final bronze piece which was cast from it. This means that the marks you see on Frink's sculptures are the marks she made herself. *Sitting Man*, in contrast to *Running Man*, looks like a warrior, heavily

muscled and with a sinister-looking painted face that is both fascinating and frightening. Be sure also to see the *Water Buffalo* which gaze at each other and capture the heavy-set essence of beast.

There is a great deal to see in the Lower Park Zone, but a couple of my favourites in this area are *The Arkville Minotaur* (Michael Ayrton) and *Large Nijinski Hare on Anvil Point* (Barry Flanagan). Barry Flanagan's irreverent dancing hare on top of a giant anvil has such brilliant presence, created in part by its bizarre size and subject matter (see his work also at Roche Court and Chatsworth). Don't miss Sophie Ryder's two large and fabulous sculptures, *Crawling* (1999) and *Sitting* (2007).

On arriving at YSP you encounter the Country Park Zone, a hillside covered in sculptures by Henry Moore. It is unusual to find so much of his work in one place (other than at the Henry Moore Foundation or specific exhibitions) so it is well worth taking a browse amongst the sheep to see it. It is important to mention here that the Henry Moore collection is one of the most mobile in the country, so sculptures at YSP are on loan from the Foundation but are often sent out to other exhibitions. However, though the inventory of pieces does change, there are always a few key works to see. One of these is the *Draped Seated Woman* (1957–58). This piece is more representational than much of his work, though the exaggerated torso and fabric is clearly what interested Moore. *Reclining Figure Arch Leg* is a somewhat bizarre and disjointed sculpture – literally disjointed, as the enlarged, elongated arched leg has been split off from the rest of the body,

making the viewer look at the body in a different way. Moore's approach to the figure forces the viewer to examine each part of the body separately, seeing it as a series of shapes creating spaces, rather than as biological anatomy. *Large Two Forms* are two enormous organic-shaped pieces that relate to each other and create amazing shapes as you walk around them. Like many of his two-piece forms, the shapes and the view change dramatically from each angle, another reason he felt his work needed to be placed outdoors where people could view it through the full 360 degrees. (For more information about Henry Moore see pp. 79–83.)

Lakeside Zone is home to Anthony Caro's enormous angular quasi-architectural steel sculptures, and Sol LeWitt's mathematical breeze-block construction. Anthony Caro was a contemporary of Moore's and was one of the first artists to do away with the plinth. A seemingly

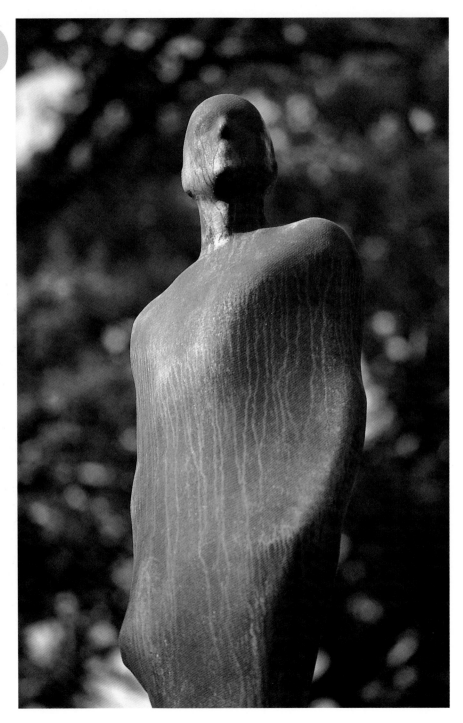

simple and unremarkable concept by today's standards, it was shocking and revolutionary at the time. It brings the art down to the viewer's level, inviting a more direct relationship with the piece, and also making us look around at other everyday objects and ask, 'What is art?'

Longside Zone covers the whole area on the other side of the lake. A large field lies between the lake and the Longside Gallery, and a few key sculptures can be seen along the way. One of these is Antony Gormley's stunning *One and Other*, whose site the artist chose very carefully. Gormley always works on figurative pieces, often using casts of his own body. Balanced on top of a huge tree stump this figure towers over the path and is visible from some distance away. This is both an awe-inspiring and frustrating experience, as you want to get up close for a proper look, but the piece stands tantalisingly out of reach. Made from cast iron, the work's intense orange colour comes from the natural rusting of the metal.

On the way to Longside Gallery are Andy Goldsworthy's installations. *Hanging Trees* and *Outclosure* are from the enormous exhibition of his work at YSP in 2007. Now one of the foremost contemporary land artists, Goldsworthy first created work here in 1983, and constructed these new pieces for the 30th anniversary of the sculpture park. As the YSP leaflet explains, much of his work deals with issues concerning land – in particular ownership and accessibility. *Hanging*

*Trees* has been deliberately constructed within the wall of the ha-ha on Oxley Bank. The ha-ha was a land construct or 'screen' often used by large stately homes, consisting of an embankment of earth which hid the stone walls so that divisions in the land were not visible from the house – the estate grounds then appeared to blend in with the surrounding land and fields, suggesting that the estate extended as far as the eye could see. Goldsworthy undermines this construct by forcing you to get up close and look at the divisions. His work forces the viewer to engage with the land more directly, and to draw visitors away from the 'safety' of the gallery.

The tree trunks Goldsworthy has built into and within the boxed confines of the wall are like giant specimens in cases. These specimens, however, are very much bound into their boxes. It is not clear whether the tree is trapped by the wall, or somehow supporting it. The two are intertwined.

*Outclosure*, located in a circular cluster of trees, called Round Wood, is found at the end of Oxley Bank walk near Longside Gallery. This perfectly enclosed drystone

wall is too high to see over and has no gaps or windows anywhere. I walked all round it twice, looking for a way in. The wall hides a secret internal space. It is very frustrating to be kept out. This, however, is the point.

*Basket No.7*, Oxley Bank, on loan to YSP since 2004, is a two-storey steel building situated on a hill on the way to the Longside Gallery. Designed by German collaborative artists Winter and Hörbelt, this piece, made of mesh, is quite disconcerting. It appears sometimes solid and sometimes transparent, and is hard to get a fix on until you get right up close. Inside is a kind of maze opening out into rooms, but also offering views through the walls of the landscape beyond. It offers both a fantastic and unsettling experience at the same time. You can see not only the trees and the field beyond, but also the sky above and the room beneath you all at once.

# OTHER PLACES OF INTEREST

## 5 Consett to Sunderland

**Information only:**
Sustrans (Head Office)
National Cycle Network Centre, 2 Cathedral Square, College Green, Bristol, BS1 5DD.
Tel: 0845 113 0065
www.sustrans.org.uk/whatwedo/art-and-the-travelling-landscape

## Getting there

### BY ROAD OR TRAIN

To start at Consett, take A1(M) and come off at Jct 63 onto A693, then A692 to Consett. To start at Sunderland, from A1(M) take Jct 65 onto A1231 to Sunderland. Route starts at Roker Pier promenade by marina. By train, Sunderland station then 10 mins by bicycle.

### BY BICYCLE (OR ON FOOT)

The route to Sunderland can be picked up at Consett where the B6308 meets the A692. The route from Consett goes over the bridge, crossing the B692, and then continues further on, on the right-hand side of the A693 briefly, before turning left onto the railway path. The route goes through Stanley, (past the Beamish Open Air Museum), Pelton, Rickleton, past Washington Arts Centre, through Fatfield, skirts South Hylton and then follows the River Wear to Sunderland, ending on the promenade. At Sunderland stay on the left-hand side of the river until you reach the marina and promenade by Roker Pier. Detailed maps of the route can be obtained from Sustrans.

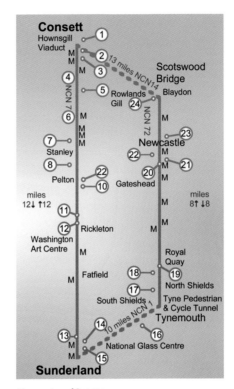

Map courtesy of Sustrans

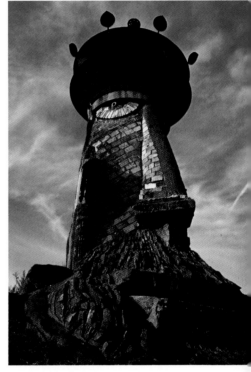

*King Coal*, David Kemp, 1992/3. Photo: courtesy of Nicola Jones/Sustrans

1 *Hot Metal Carriage* from former Consett Steelworks.
2 *Terris Novalis* by Tony Cragg.
3 Entrance to *Maze* by Graeme Hopper.
4 *Jolly Drover's Maze* by Andy Goldsworthy.
5 *Old Transformers* by David Kemp (*see image p.10*).
6 *Kyo Undercurrent* by Richard Harris.
7 *Flower Mine* by Ken Turnell.
8 *Beamish Shorthorns* by Sally Matthews.
9 *The Celestial Railroad* by John Downie.
10 *King Coal* by David Kemp.
11 *Lambton Earthwork* by Andy Goldsworthy.
12 *Sleeper Seats* by Liz Walmesley and Jim Partridge.
13 Sunderland Enterprise Park Stone Carvings by Colin Wilbourn.

14 St Peter's Riverside Sculpture Project by Colin Wilbourn, Karl Fisher, Craig Knowles, Chaz Brenchley and others.
15 *Ambit* by Alison Wilding.
16 *Conversation Piece* by Juan Muñoz (*see image on p.6*).
17 *Fish Quay* Bollards and Fencing by Northern Freeform.
18 *Tyne Anew* by Mark Di Suvero.
19 *Rugged Landscape* and *Waterfalls* (Redburn Dene & Chirton Dene) by Tyne & Wear Development Corp.
20 Gateshead Millennium Bridge by Wilkinson and Eyre.
21 *Blacksmith's Needle* by British Association of Blacksmith Artists (on Newcastle Quayside).
22 *Rolling Moon* by Colin Rose (in Gateshead Riverside Sculpture Park).
23 *Spheres* by Richard Cole (Newcastle Business Park).
24 *Derwent Walk Express* by Andy Frost.

## OVERVIEW

This is one of the many routes set up by Sustrans as a cycle route with artwork (although it can be walked) and is part of a much larger one (the Sea-to-Sea Cycle route). The whole sea-to-sea route goes from Whitehaven or Workington to Sunderland or Newcastle. We are just looking at a small stretch of it (cycle route No.7), which has some fantastic artworks along it, most of them commissioned by Sustrans and which includes work by Tony Cragg, Richard Harris, Andy Goldsworthy, Ken Turnell, David Kemp (see p.10 also) and John Downie amongst others. *The Jolly Drover's Maze* by Goldsworthy is a beautifully constructed maze built on the site of a former colliery, with the cycle path weaving its way through. From Consett to Sunderland is 24 miles but there is an alternative (and longer) way back for those feeling adventurous which measures 39 miles going through Gateshead and Newcastle, and passes some other fantastic sculptures (such as No.16 *Conversation Piece* by Juan Muñoz (see image p.6), consisting of 22 figures located at Little Haven beach, South Shields, near Little Haven Hotel) and also skirts past some of the artwork found in Gateshead Riverside Park (see pp. 20–25). Most of the route is off-road, but there are parts that follow roads through towns, and occasionally you need to make small detours to see artworks. You may also need to book a B&B to break up the journey, unless you are a particularly fit and speedy cyclist. Visit the Sustrans website for many other interesting sculpture routes.

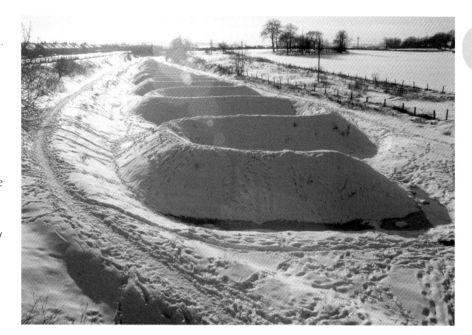

TOP: *Lambton Earthwork*, Andy Goldsworthy, c. 1990. In snow. *Photo: courtesy of S. Shorthouse/ Sustrans*

ABOVE: *Terris Novalis*, Tony Cragg, 1994/5. Located on the Consett to Sunderland cycle route. *Photo: courtesy of Cheatle/Sustrans*

# THE NORTH-WEST

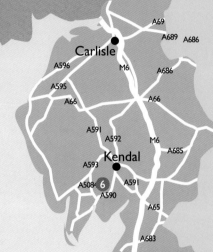

A69
A689    A686
**Carlisle**
A596
A595    M6    A686
A66    A66
A591
A592    M6    A685
**Kendal**
A593
A508    6    A591
A590
A65
A683
M6
A59
M55
**Preston**
M65
M6    A666    M66
**Bury**    M62
M58    M61
8    10
**Liverpool**    **Manchester**
M62    M60
9    A56    M6
**Runcorn**    7
M56    M6
A55
A49

**6** Grizedale Forest

**7** Tatton Park Biennial

**8** Another Place

*Other Places of Interest*

**9** Norton Priory Sculpture Trail

**10** Irwell Sculpture Trail

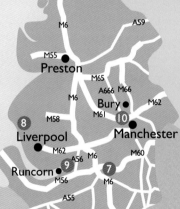

# 6  Grizedale Forest

Hawkshead, Ambleside, Cumbria,
LA22 OQJ.
Tel: 01229 860010
www. forestry.gov.uk/grizedaleforestpark
www.grizedalesculpture.org

**Facilities:** Toilet, café, book & gift shop.
**Open:** daily, all year, but check for
Christmas, New Year and January opening.
Visitor centre and café open: daily 10am–
5pm (summer), 10am–4pm (winter, from
end Oct to Easter).
**Admission:** Free (car park, 1 hour £1.60,
2 hours £3.20, all day £6.90)
**Time needed:** Anything from 1 hour to 3
days (to see everything)

## Getting there

**BY ROAD**
Grizedale Forest Park is pretty remote.
Currently, going by road is the easiest
option.
• To avoid the ferry, take the M6 to Jct
36, then the A590 towards Kendal and
Windermere. • The A590 runs out soon
after, becoming the A591, follow this up
to Ambleside. • At Ambleside follow signs
for Clappersgate and the A593, then turn
left shortly afterwards onto B5286 into
the forest, and follow signs to Hawkshead
(B5285). • At Hawkshead turn left and
follow signs to Grizedale Forest, and head
for the central visitors' centre.

**BY BOAT**
The Cross Lakes Shuttle boat covers many
of the tourist/lake areas and runs from April
to October. It is possible to take the train
to Windermere, then a bus to Bowness on
Windermere, and from there catch the Cross
Lakes Shuttle.
• Cross Lakes Shuttle Tel: 01539 448600
http://www.lakedistrict.gov.uk/visiting/
planningyourvisit/travelandtransport/
crosslakes

## OVERVIEW

Grizedale Forest Sculpture Park is one
of the largest of the sculpture parks,
and its management has now been
taken over by the Forestry Commission.
In the 1990s the focus of the Forestry
Commission broadened to include
'managing forests for the sustainable
production of timber, for recreation,
conservation and the landscape'.

*Stone Forest*, Kimio Tsuchiya, 1991. *Photo:
courtesy of Grizedale Forest*

The first thing to realise about Grizedale is the sheer size of the place – the landscape is some of the most dramatic of the sculpture parks and were you to try and see everything, it would probably take you about three days. There are currently about 50 works spread over 6047 acres (along specific trails). There is a wealth of sculpture to be found here, and there is a good variety of trails for all levels of assorted lengths and difficulty, so choose your routes carefully. Around the visitor centre there are some shorter and easier routes, but on the longer ones you are walking a fair distance between sculptures. It's as much about the land and forest as about the sculpture. Grizedale is one of the older sculpture parks and has been going for over 30 years. Combine this with the enormous area of forest and it is easy to see how some of the older works are starting to deteriorate. In some cases, however, the weathering of a piece has softened it and helped it blend in more with its surroundings, such as *Some Fern* by Kerry Morrison, an enormous wooden carving of a fern that increasingly blends in with the bracken around it, despite its size. In 2007 some of the older sculptures that had reached the end of their lives were removed. Excitingly though, new life is being breathed into Grizedale, so as part of the park's life cycle the older work is being retired from service, while new pieces are being commissioned and new projects are evolving.

Amongst the more recent things to happen at Grizedale is an initiative that has been started, entitled 'Art Roots'.

This commissioning programme (led by the Forestry Commission and supported by funding from the Arts Council and from South Lakeland District Council), is focused on asking chosen artists to respond to specific areas of the forest and produce site-specific works. This looks to be a very exciting new area for Grizedale, and will no doubt inject new life into the forest sculpture. With a mixture of established artists and emerging talent, the ten chosen artists should produce an interesting mix of work for a variety of locations. As well as developments in the art, the visitor centre has also had a much-needed makeover, and is now a much more modernised version of itself, though still includes a shop as well as café and toilets.

Mountain biking has always been a big part of Grizedale's makeup, and there is also some work being commissioned for these trails which will bring together two separate parts of Grizedale, the sculpture and the biking. Whether walking or biking however, Grizedale is well worth a visit for the spectacular scenery and the great sculpture which is tucked away all over the place, and can often be located just off the path, sometimes it has almost been claimed by the forest, so it's like a giant treasure hunt – just be sure to take the map.

## FINDING YOUR WAY AROUND

The beauty of the paths and trails through the forest is that they often cut across each other, so a walk can be tailored as you go, depending on the weather, the

length required or specific sculptures of interest. The visitor centre provides maps with trails graded as to length and difficulty, from 1 mile up to 10 miles – don't even think about setting off without one! One of the longer trails, the 'Silurian Way', described as 'strenuous', was supposedly 10 miles, and is estimated to take five hours to complete. Of course, that doesn't allow for the weather, lunch stops, short sideways expeditions to locate sculptures hidden amongst the trees, or the occasional small detour due to a lapse in map reading. We pruned about a mile and a half off our walk by taking short cuts, but still managed to use up five hours. If you are following a longer route such as this, be sure to take a packed lunch, as the only café is back at the start by the visitor centre. If you are relatively local, or have the time, the size of Grizedale Forest means that you could easily spend about three days here and only just about see everything. Obviously, if you are not quite this keen, there are plenty of shorter trails nearer the centre.

## THINGS TO SEE

A misleading concept in the case of Grizedale, as you are unlikely to be able to see everything in one visit. As the forest is managed by the Forestry Commission for the enjoyment of the public, sculptures here are not for sale. Amongst the more recent commissions is *The Clockwork Forest*, by Greyworld (2011), an art group that specialise in art for public spaces. *The Clockwork Forest* has been developed for the Ridding Wood

Trail, the most popular walking trail within Grizedale. This fantastic large gold wind-up key sticks out of a huge tree trunk and, on being wound, unwinds to play a little tune as if from the trunk of the tree itself. Created by artist Katherine Clarke from a tree blown over in 2005, *The Wood for The Trees* is a sound work made in collaboration with composer Neil Luck in 2011. Phrases of sounds have been compiled from musical instruments and voices of forest staff, which have been arranged into a sonic composition following the cry of the hen harrier bird, and played 'on a shuffle system organised by the DNA code of the Sitka Spruce tree'. This complex mixture of components lends levels of meaning to the root system of the fallen tree, slightly hovering above the ground. It is located by the visitor centre so there is no excuse not to take a look and listen. Meanwhile, Keith Wilson's *Boat Race* weaves in and out of the trees creating a tall blue corridor, giving the surreal experience of being in a tiny curving corridor amongst the trees.

From the older work, many still look great and some have simply mellowed into the landscape; the *Stone Forest* still looks fabulous in its hilltop location looking out over a lovely view. Andy Goldsworthy's *Taking a Wall for a Walk* is vaguely reminiscent of Gaudi's mosaic bench in the Gaudi Park, Barcelona, as it weaves in and out of the trees. This has now crumbled somewhat since some trees fell on it, but as the artist has pointed out, this is the nature of the piece in its outdoor location and he has asked that it be left like this.

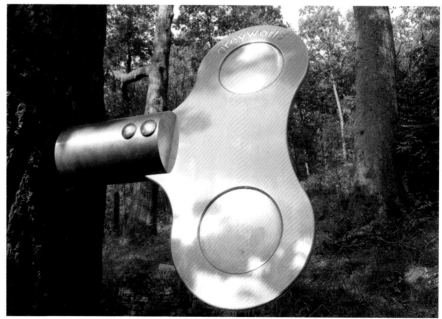

TOP: *Taking a Wall for a Walk*, Andy Goldsworthy, 1990. Located on the High Bowkerstead Trail. *Photo: courtesy of Grizedale Arts*

ABOVE: *The Clockwork Forest*, Greyworld, 2011. *Photo: courtesy of Grizedale Forest*

The two *Ancient Forester* sculptures by David Kemp are very tall and melancholy wood carvings, each one looking as though it was carved from a single tree. One is hard to miss, located in the car park by the visitor centre. *Habitat* by Richard Caink is a bizarrely relocated front room, complete with TV, lampshade and armchair, and makes you rethink the idea of urban comfort as being the norm. Iraido Cano's *Between Elephants* was quite hard to locate, despite its size – eventually we stumbled across it while looking for something else – but it was impressive once found.

Some of the more unusual sculptures included *You Make Me Feel Mighty Real*, by Fat, which looked totally out of place in the forest. The outside of this modern-looking structure is covered with tiny squares which move and shimmer in the wind, making it look like a huge building-shaped disco mirror ball. *After the Rain/ Flood* by David Stewart is an eerie group of what looks like bits of building and columns, half-buried, scattered through a patch of forest, like the remains of a civilisation after the deluge has subsided. Let's hope it isn't a glimpse of the future after global warming.

TOP: *The Wood for the Trees*, Muf architecture/art, 2011. *Photo: courtesy of Grizedale Forest*

ABOVE: *Some Fern*, Kerry Morrison, 1997. *Photo: courtesy of Grizedale Forest*

RIGHT: *Boat Race*, Keith Wilson, 2010. *Photo: courtesy of Grizedale Forest*

# 7 Tatton Park Biennial

Tatton Park
Knutsford, Cheshire
WA16 6QN
Tel: 01625 374400
www.tattonparkbiennial.org

**Facilities:** Toilets, café, shop.
**Open:** 12 May–30 Sep 2012 (check website for future dates, next exhibitions 2014 and 2016). Parkland: daily 10am–7pm (last entry 6pm). Formal gardens and restaurant: daily 10am–6pm (last entry to gardens 5pm). Mansion: daily (except Monday) 1pm–5pm (last entry 4pm).
**Admission:** Adult £10, children (4–15) £5, family (2 adults + 3 children) £25. Single attraction entry ticket: adult £5.50, child £3.50, family £14.50. Also £5 car entry charge to Tatton Park. A Totally Tatton ticket is recommended by Tatton, which allows entry to the Formal Gardens and Mansion, both of which exhibit Biennial artwork along with the parkland; includes farm.
**Time needed:** 2–2½ hours

## Getting there

### BY CAR
Tatton Park is signposted from Junction 7 of the M56 and Junction 19 of the M6. The entrance to the park is approximately half a mile from Knutsford railway station. Use postcode WA16 6SG for sat nav systems.

### BY PUBLIC TRANSPORT
Knutsford railway station and a half-mile walk from the Knutsford entrance. It is a further two-mile walk down the estate drive to the mansion and stableyard area (by speciality shops and Stables Restaurant). Local bus services are available to Knutsford, including bus number 27 from Macclesfield, the 288 from Altrincham via Wilmslow, and the 289 from Northwich to Altrincham.

*Dead Cat*, Charbel Ackermann, 2012. Commissioned by Tatton Park Biennial.
*Photo: Thierry Bal, courtesy of Tatton Biennial*

## OVERVIEW

Tatton Park itself is a well-kept extensive garden and grounds, home to a Tudor Hall and a large mansion, not to mention a lot of deer (1000 acres of deer park) and a rare-breeds farm. It also has glasshouses, a Japanese garden and kitchen gardens. The last Lord Egerton (Maurice) bequeathed the estate to the National Trust in 1960, 'to educate and delight'. The biennial, which takes place within this setting,

began in 2008 as a relatively tame affair but has grown exponentially into what, in 2012, seemed to be a biennial for bold, larger-than-life sculptures by over 20 artists. The work was placed so as to lead you into most of the areas in the grounds, both the beautiful parts and the lesser-used areas, but always with the best setting for the work in mind. New commissions are always risky, the

curators Jordan Kaplan and Danielle Arnaud explain, because you never know exactly what you will get until a piece is almost finished. In the end, they were very pleased with the results, which this time around were based on the theme of 'Flights of Fancy', which according to the website was concerned with 'the human urge to reach for the impossible and the theme of aeronautics'.

*Trine Messenger*, Brass Art, 2012. Commissioned by Tatton Park Biennial.
*Photo: Thierry Bal, courtesy of Tatton Biennial*

Two pieces are in the parkland (to which access is free), but most of the work has been sited in the formal gardens (amongst other things to avoid it being damaged by the deer), with further pieces in the mansion itself. Overall, the work is of a high standard, with the theme providing inspiration in a variety of ways. Combined with the lovely grounds, it makes for a show that's worth keeping an eye on for future visits.

## FINDING YOUR WAY AROUND

A good A6 booklet with small, numbered images of all the works makes it a fairly straightforward business to see everything. Work is spread throughout the park, but the paths and well-kept grounds are easy to navigate. There are also audio guides for both adults and kids to listen to, or, if you prefer, let one of the curators take you on a guided tour.

## THINGS TO SEE

Obviously, the work will change for every biennial, but the most recent 'Flights of Fancy' biennial featured the works mentioned below.

The *Biennial Kiosk*, designed by Pointfive, was an ingenious giant representation of the black-box flight recorder (real examples of which are apparently now orange to make it easier to find).

David Cotterrell's *In Other Worlds, I Love You* looked suspiciously like a giant eyeball at first glance, and in some respects it functioned this way, offering a glimpse into space and time. Cotterell worked with Dr Tim O'Brien at Jodrell Bank Centre for Astrophysics to create a pattern of different wavelengths, with new bodies and events appearing and disappearing as the program moves through the radio spectrum. Charbel Ackermann's *Dead Cat* was a tribute to the last Lord Egerton's experiments with radio. The piece resembled both a giant boom microphone and an airship hovering up in the trees.

Olivier Grossetête's *Pont de Singe* beautiful floating bridge was held up by helium-filled balloons, so that it hovers lazily just above the water, leading from nowhere to nowhere. Looking like something out of Alice in Wonderland, it was entirely in keeping with the late Lord Egerton's plan for the gardens.

*Trine Messenger* by Brass Art was an enormous balloon (7 metres/23ft long) in the shape of a face with wings, apparently drawing inspiration from 'classical images of Hypnos, the god of sleep, and the Surrealists'. Strange and shocking, what appeared to be half a

TOP: *Gleaners of the Infocalypse*, Juneau Projects, 2012. Commissioned by Tatton Park Biennial. *Photo: Thierry Bal, courtesy of Tatton Biennial*

LEFT: *In Other Worlds, I Love You*, David Cotterrell, 2012. Commissioned by Tatton Park Biennial. *Photo: Thierry Bal, courtesy of Tatton Biennial*

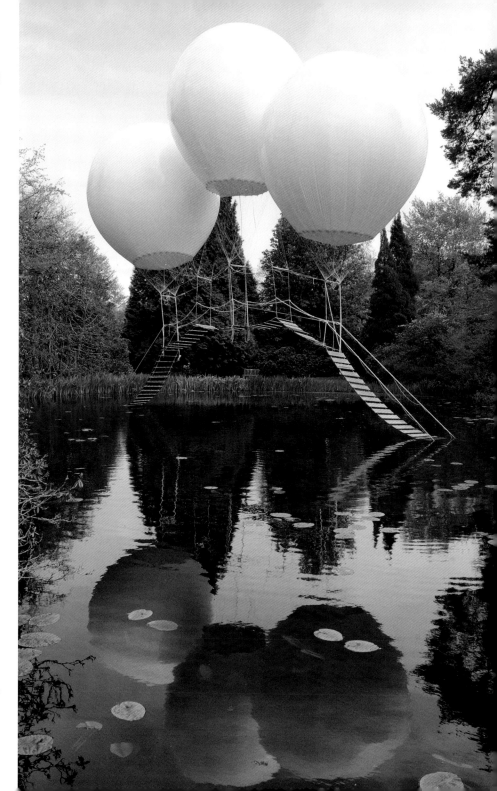

plane emerging from the trees (in fact the tail section of a BAe 146-200) turned out to be Juneau Projects' *Gleaners of the Infocalypse*. This piece of work was intended to suggest what life might be like after a technological disaster, with the artists even living in the remains of the plane for the duration of the biennial.

Hilary Jack's *Empty Nest* functioned as an observation point: raised up in the tree it allowed visitors to see the trees and grounds from higher up. This human-scale rook's nest, a reference to the last Lord Egerton (who being childless left the Tatton estate to the National Trust in his will), was based on ancient folklore 'that tells us that crows desert their colonies when a childless heir to a fortune dies'.

*Pont de Singe*, Olivier Grossetête, 2012.
Commissioned by Tatton Park Biennial.
*Photo: Thierry Bal, courtesy of Tatton Biennial*

Crosby Beach, Merseyside

**Facilities:** Public toilets and sometimes a
snack van (in summer)
**Open:** All year
**Admission:** Free (public car park)
**Time needed:** 30 mins–1 hour

## Getting there

### BY CAR

Take either the M57 or M58 motorway,
both of which end at Switch Island. On
the A5036, follow signs to 'All Docks'
until you get to a roundabout under a
flyover with signs to Crosby and the A565.
Turn right at the roundabout following
the signs to Crosby and the A565. Join
the A565 but stay in left-hand lane. At
the first set of traffic lights turn left into
Cambridge Road, then follow brown signs
for Another Place from this junction. At
the end of the road are two car parks
adjacent to a marine lake. The statues are
a five-minute walk from the car park.

### BY PUBLIC TRANSPORT

• From Hall Road Station: With the train
station on your right-hand side walk down
Hall Road West until it bends 90 degrees to
the left. On the bend there is an access road
that goes to the beach, past the Coastguard
Station. (5 minutes)
• From Blundellsands Station: On the
opposite side of the railway tracks to the
ticket office, i.e. the Southport train side,
walk down Blundellsands Road West to the
end, from where a short footpath leads to
the beach. (5–10 minutes)
• From Waterloo Station: Take South Road
with the station on your left. At the end of
South Road, cross over and walk down the
paved footpath between two parks. Then
follow the footpath which runs between the
two lakes to the beach. (10–15 minutes)

# 8  Another Place

## OVERVIEW

*Another Place* (installed here in 2005)
by Antony Gormley is an installation of
about 85 cast-iron figures which create a
dramatic scene along the coast at Crosby.
Originally it consisted of almost 100
figures; some have since been removed,
to no noticeable loss of impact. As is
often the case with Gormley's work, the
figures were created from casts of his
own body – in this case 17 different casts
– although for the untrained eye this is
hard to spot. The work was originally due
to move to New York but in 2007 was
granted permission to remain here.

The figures, which gaze out to sea, appear
to be scattered randomly for about a mile
along the beach and about a third of a
mile out to sea (although they are in fact
carefully located). Some are therefore
on their tiptoes in the sand, others have
the sea washing around their waists, and
of some only a head can be seen poking
above the waves at high tide. When the
tide goes out, however, you can walk
amongst many figures which are now
partly covered by fabulous accumulations
of barnacles and slimy green moss, giving
them the appearance of an army of lost
robots buried at sea.

According to Gormley, 'the idea was
to test time and tide, stillness and
movement, and somehow engage with
the daily life of the beach'. There is
certainly an expectant air about the
figures as they gaze somewhat sadly
at the horizon, somehow combining a
melancholic atmosphere with the hope
of something new.

*Another Place*, Antony Gormley, 1997. Cast iron,
100 elements: each 189 x 53 x 29 cm (74½ x 21 x
11½ in.). Installation view, Crosby, Merseyside, UK.
*Photo: Stephen White, London,* © *the artist*

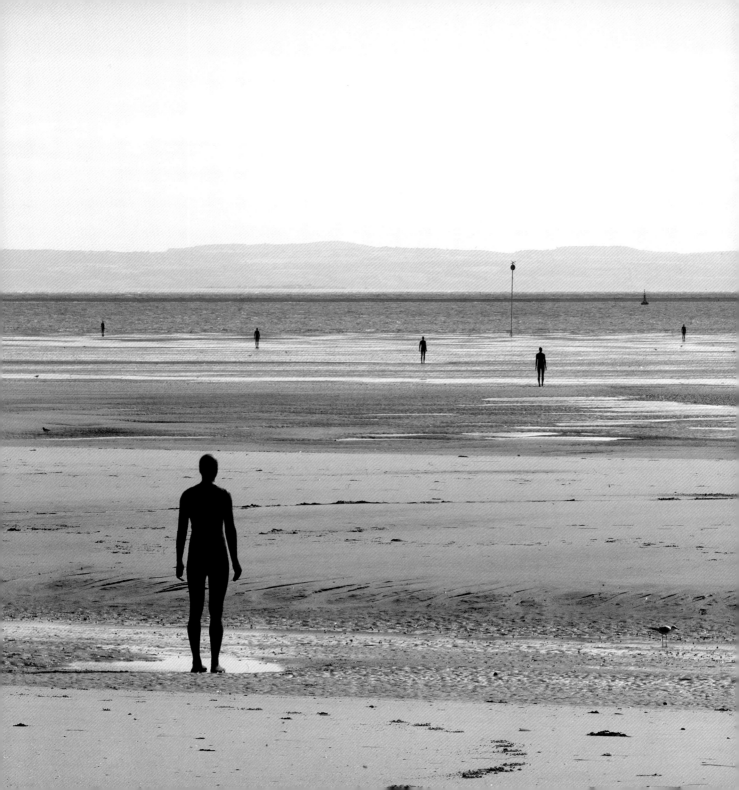

# OTHER PLACES OF INTEREST
# 9 Norton Priory Sculpture Trail

Norton Priory Museum & Gardens
Tudor Road, Manor Park, Runcorn,
Cheshire, WA7 1SX.
Telephone: 01928 569895
www.nortonpriory.org

**Facilities:** Café, toilets, educational
programmes, museum.
**Open:** April–Oct (Mon–Fri 12–4pm, Sat &
Sun 12–6pm), Nov–March (daily 12–4pm)
but walled garden shut; closed 24–26 Dec
& 31 Dec–13 Jan.
**Admission:** Adults £6.75, concessions &
kids (aged 5–15): £4.75, under 5s: free,
family: £19.25.
**Time needed:** 2–2½ hours

## Getting there

### BY ROAD
• Take M6 to Jct 20, then take M56
towards Runcorn and Chester. • Come off
at Jct 11 on M56, take A56 heading east
at roundabout. • Turn left onto A558, and
go straight over at roundabout immediately
after. • Follow brown signposts to Norton
Priory at the next series of roundabouts. • If
using sat nav, follow address, not postcode.

### BY BICYCLE
A cycle path runs right through this site
from Runcorn towards Sandymoor, and new
cycle paths are being developed in the area.

### BY TRAIN
Runcorn station, then a 10-minute taxi
ride (or a 3-mile walk).

## OVERVIEW

Norton Priory Sculpture Trail is situated
in the grounds of a ruined monastery. A
very atmospheric place, the remains of
the undercroft are still in evidence. The
sculpture is sited in the extensive gardens.
Ask at reception for the sculpture-trail
folder, which has information on all
the pieces and can be taken round with
you. The whole place is geared towards
education, and there are folders of
information on everything here – history,
trees, buildings, etc. The artwork here,
which has all been supported by various

public and private bodies, has been an
ongoing project for the last 20 years or so,
so some of the work does look a little jaded.

The site is divided by the A558, but
you cross from one side to the other
by means of a bridge above the traffic.
Despite this busy road, the priory is
a surprisingly calm and well-hidden
retreat. The gardens are very pretty. On
one half of the site a small wood full of
rhododendrons has little paths and old
water courses running through it, while

the other half comprises the attractive
and surprisingly large (2½ acres)
Georgian walled garden, with a variety of
flowers as well as space for a pagoda, a
walled walkway and a croquet lawn.

The work at Norton Priory is not the
most amazing sculpture you will ever
see, but there are some nice pieces set in
very attractive surroundings. The small
wooded area by the ruins has numerous
twisting paths to explore, while next to
the walled garden is an orchard.

## FINDING YOUR WAY AROUND

Entrance into the gardens and wood
is through the museum. There are a
number of ways you can navigate the
site. There is a leaflet at the desk with
a very good line drawing of the paths
and garden areas, with triangles marking
out the location of sculptures. However,

LEFT: *Archways*, Callum Moncrieff, 1991. *Photo: courtesy of Norton Priory*

RIGHT: *Walled Garden Mosaic*, Hannah Mudd, 1982 (detail). This mosaic is built into the wall in a far corner of the walled garden. The faces are children's faces that have been cast in plaster and then a mould taken in clay. *Photo: Alison Stace, by permission of Norton Priory Trust*

FAR RIGHT: *Kitty's Gate*, designed by Diane Gorvin and constructed in wrought iron by Tony Doughty, 1988. Located at Norton Priory. *Photo: Alison Stace, by permission of Norton Priory Trust*

this doesn't tell you what they are. Inside the sculpture-trail folder is a set of comprehensive information sheets on each of the works, and also another map with numbers which correlate to the printed sheets. The numbers are in sequence so as to take you round all the areas. The grounds cover a total of 38 acres (though a good chunk of this is just orchard), so allow between 2 and 2½ hrs to see all the sculpture.

## THINGS TO SEE

Don't leave without sticking your head inside the screened-off glass room in reception. It is hard to see through because of all the reflections, but inside is a huge original statue of St Christopher, dating back to the end of the 14th century. By the new herb garden, the unnervingly simple and serene expression of the *Kneeling Monk*, by Tom Dagnall,

was quite compelling. I wasn't sure that I liked the figure, but I did think it captured the history of the place really well. The monk is shown kneeling (trowel in hand) by the herb garden. The lovely *Archways* by Callum Moncrieff is a lovely architectural piece reflecting the shapes found at the monastery.

Strangely, one artist is responsible for several pieces of work here, all of which I thought stood out. Set near to a thriving patch of giant leaves (gunnera) *Planthead,* by Diane Gorvin, is located amongst rhododendron bushes. The enormous gunnera leaves look quite surreal, and so does the large morphing woman's head: her calm and beautiful face is framed by the folds of a plant form where you would normally expect to find hair. The head has been located so that the back of it faces outwards – possibly to display the strange, plant-like

form – you now have to squeeze in front of the bushes to see her face properly.

Diane Gorvin was also the designer of the two fabulous gates at the walled garden. One is a *Tree of Life*, inspired by a coffin lid from the museum. It represents both physical and spiritual growth and is the first gate to the walled garden (although this is not the entrance); through its waving branches you can see the garden flourishing. My favourite, though, was *Kitty's Gate*, inspired by a story about a maid from the mansion who had drowned herself in the pond nearby (then named Kitty's Pit). It was rumoured that she was pregnant – a not uncommon occurrence in housemaids, who were often seduced, coerced or forced by the master of the house, who would then generally deny all knowledge. The gate depicts her out on a windy day and captures her despair.

# 10 Irwell Sculpture Trail

## OVERVIEW

The Irwell Sculpture Trail has been (unintentionally) kept a very close secret. It was originally developed in 1993 by three councils (Salford, Rossendale and Bury) in collaboration, to create a 30-mile-long walk with sculptures of public art along the way. The works were either already existing, or have been subsequently commissioned. The sculpture trail follows the old Irwell Valley Way, which was originally just a walkers' route. The whole trail runs from Salford Quays outside Manchester all the way up to Bacup. Wherever possible, it follows the most attractive route, running alongside the River Irwell, the Manchester, Bolton & Bury Canal, through country parks or along the edges of fields.

Works are publicly funded through local grants, but the scheme also won an arts lottery award in 1996. The first sculpture was installed in 1987, and became the first artwork when the trail was started six years later. The trail now has approximately 70 sculptures lining the route (inevitably, some of these are now rather dated and crumbling, though more have been added recently). The idea began as a scheme to help regenerate and improve the use of public areas, but this original proposal has now grown into something more expansive, so it seems a shame that there aren't more people enjoying it.

## FINDING YOUR WAY AROUND

Since the whole trail is too long to cover in detail, I have focused on the most interesting stretch (just under half, approximately 12 miles) which at present has the greatest number of sculptures.

Essentially, it covers Radcliffe, Bury, Ramsbottom and Clifton. If it is longer than you want to walk, you can also walk part (or parts) of it, and drive or take the steam train between different sections (see details in information box).

The trail has remained underused because it has not been well documented in the past (although an art map was available from tourist offices). Fortunately, maps can now be printed off from the website, which has been greatly improved, and it also details all the work. The revised website has helpfully arranged work into areas or 'clusters' so that you can see a collection of sculptures together. This is a great way to plan your route. Alternatively, use the new Ordnance Survey (OS) maps showing the Irwell Sculpture Trail, or the old OS maps showing the original Irwell Valley Way. However, you still need to combine these with the map indicating artwork locations, as there are no signposts and sometimes the sculptures are slightly hidden, off the path amongst trees, and thus easily missed. The Irwell Trail website also breaks down the trail into sections, so you can click on each part of the route to see what is there (as well as downloading maps). Note that some works are not exactly on the route,

Bury Tourist Information Centre
The Fusilier Museum, Moss St,
Bury BL9 0DF
(Open: Mon–Fri 9.30am–5pm,
Sat 10am–4pm)
Tel: 0161 253 5111

**OR**

Clifton Country Park Visitor Centre
Clifton House Road, Clifton,
Salford M27 6NG
(Open: Mon–Tue 1–5pm,
Wed–Sun 9.30–5pm)
Tel: 0161 793 4219

www.irwellsculpturetrail.co.uk

East Lancashire Railway (steam train)
Tel: 0161 764 7790
www.east-lancs-rly.co.uk

**Facilities:** There are toilets and a café (in summer) at Burrs Country Park, otherwise use public facilities.
**Open:** All year
**Admission:** Free
**Time needed:** 1 day (for whole trail)

## Getting there

This is an unusual trail, which, being 30 miles long, covers a huge area and takes in several small towns. This summary will concentrate on a small section covering Radcliffe, Bury, Clifton and Ramsbottom. I would suggest starting in Clifton Country Park (which is a short detour off the main trail but is marked on OS maps) and walking towards Radcliffe and Bury. Alternatively, start from either Burrs Country Park (near Bury), which has parking and facilities, or Bury itself (which has a large car park right next to the steam train station), and walk up to Ramsbottom.

### BY ROAD

Take the M60 to jct 16 and then the A666 towards Bolton. Follow the brown signs towards Clifton Country Park.

### OR

Take the M60 to Jct 17, and follow the A56 to Bury (the steam train starts here). [Parking in Bury: Find Bolton St and turn into the steep car park by the steam train station. Come back onto Bolton St on foot and turn left, head to the end of the road, cross Carlyle St and go into the subway – you are now on leaflet 6 of the Bury-to-Burrs section of the written instructions.] For Burrs Country Park, once you arrive in Bury on the A56, turn left (from the south) or right (from the north) onto the A58 towards Ramsbottom, and follow the brown signs to Burrs Country Park, which is on the trail.

### BY TRAIN

The East Lancashire Railway steam train runs from Bury to Summerseat, Ramsbottom, Irwell Vale and Rawtenstall. Contact them (see details on p.49) for timetable and fares.

Untitled, Ulrich Rückriem, 1999. Porrino granite. Located in Outwood, Radcliffe. *Photo: courtesy of Tony Trehy, Arts & Museums Manager, Bury*

and require slight detours. It seemed to be slightly tricky to find the start of the trail from where I picked it up (though locals were helpful), but once on it the instructions were easy to follow.

If you have the time, you can also include Clifton Country Park cluster– by car this is off the A666, from junction 16 of the M60, or you can walk there, although it does represent a short detour from the main trail. It has several good pieces however: *Dig* by Rosie Leventon (now a little overgrown), *The Lookout* by Tim Norris (see image, left), and a few works by Stephen Charnock based around the theme of the wet earth coliery and the deep mineshaft. The best of these are the *Galloway Pony* and the *Collier and Pit Brow Lass*.

## THINGS TO SEE

Radcliffe currently has the most recent installation, *Northern Mirror*, located by the road. Viewed straight on, it seems to offer the viewer their own reflection surrounded by industrial cages in an industrial area.

In Burrs Country Park is *Picnic Area*, a giant version of a mousetrap, but this one is designed to catch tourists. This area is a lovely spot – you'll see an old mill with watercourses and old mill cottages now used as a café/information centre. *Stone Cycle* is also here, which is well worth a visit.

Ulrich Rückriem has created several sets of standing stones (see p.49) along the path by the former Outwood Colliery, which runs from Radcliffe over the river and on towards Bury. On this very flat and wide route (an old railway path) is a monumental rectangular granite stone standing in the path, and just before it on the right is a small path that leads you to the other standing stones. There are now four pieces by the same artist along this stretch.

LEFT, TOP: *Halo*, John Kennedy and LandLab, 2007. Located in Rossendale. Steel. *Photo: Ian Lawson, courtesy of Irwell Sculpture Trail*

LEFT: *Waterwheel*, David Kemp, 1996. Painted steel and stone. Located in Burrs Country Park. *Photo: Alison Stace*

RIGHT, TOP: *The Lookout*, Tim Norris, 2001. Clifton Country Park, green oak and Hogton grit stone. *Photo: courtesy of Irwell Sculpture Trail*

RIGHT: *Seed*, Andrew McKeown, 2002. Chapel Street, Salford. Cast iron. *Photo: Nick Harrison, courtesy of Irwell Sculpture Trail*

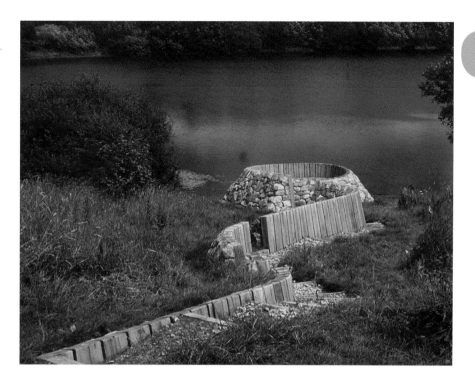

# THE MIDLANDS

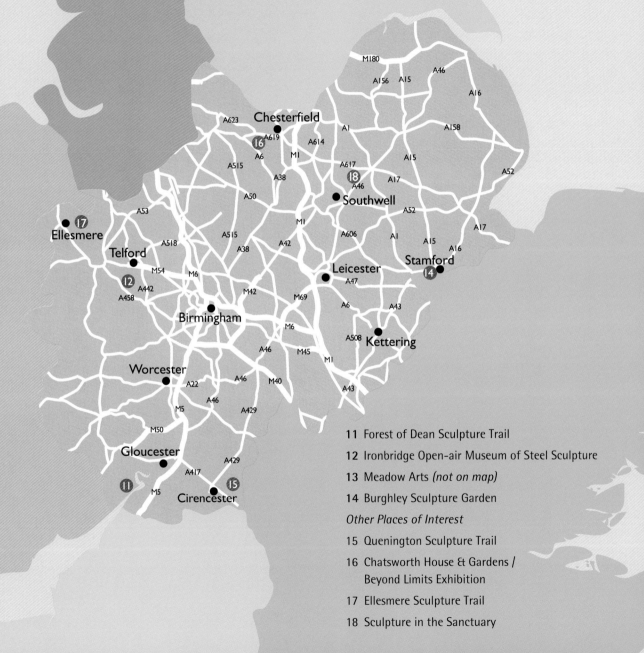

11 Forest of Dean Sculpture Trail

12 Ironbridge Open-air Museum of Steel Sculpture

13 Meadow Arts *(not on map)*

14 Burghley Sculpture Garden

*Other Places of Interest*

15 Quenington Sculpture Trail

16 Chatsworth House & Gardens /
   Beyond Limits Exhibition

17 Ellesmere Sculpture Trail

18 Sculpture in the Sanctuary

# 11  Forest of Dean Sculpture Trail

Beechenhurst Lodge
Speech House Rd, Broadwell, Coleford
Gloucestershire, GL16 7EG
Tel: 01594 827357
www.forestofdean-sculpture.org.uk

**Facilities:** Toilets, café serving hot and cold drinks, sandwiches and hot meals, and selling maps of the sculpture trail.
**Open:** Tail open dawn–dusk. Visitor centre open daily, Easter–Oct, 10am–6pm, Nov–Mar, 10am–5pm
**Admission:** Free (car park £3 Nov–Feb, £3.50 Mar–Oct)
**Time needed:** 3 hours
*(See Getting There on p. 54)*

## OVERVIEW

The Forest of Dean Sculpture Trail is one of the oldest outdoor sculpture venues. A great combination of trees and art, this trail is a manageable length, although there is a fair walk between sculptures. The Forest of Dean itself is an ancient royal forest with a long history. Still a working forest, it has also been designated a National Forest Nature Reserve, meaning that some areas and trees are protected. First opened in 1986, the trail was originally initiated by Martin Orrom (from the Forestry Commission) in partnership with Rupert Martin and the late Jeremy Rees (from the Arnolfini Gallery in Bristol). The main idea was to allow artists to express their interpretation of the forest and its history, rather than for the forest to be a beautiful gallery for pre-designed pieces. All the invited artists first come to the forest to choose a site for their work, before planning their sculpture. The work is therefore very much site-specific, a response from the artist to the forest, the hope being that the sculpture will encourage the public to venture further into the woods and to think about the forest itself. This is different from Grizedale Forest, where work is often conceived beforehand and then placed in suitable locations (although this is changing). Setting up a sculpture trail has also changed the character of the Forest of Dean, as it involved setting up proper paths with signposts in order to help people to find the work. Carolyn Black from the Sculpture Trust feels it is important to remind people that, despite the new emphasis on destinations that the signposts obviously bring, the journey between the works – the experience of the forest itself – is as important as the sculptures.

Naturally, the forest changes massively from season to season, and sculptures can look completely different amongst bluebells or autumn leaves or bare windswept trees. The trail being one of

*Hanging Fire*, Cornelia Parker, 1986. *Photo courtesy of the Forest of Dean Trust*

the oldest, some of the original works that have fallen apart or become too dangerous to leave have been removed or replaced. However, new works are being commissioned, most recently *Hill33* by

# Getting there

## BY ROAD

**From the south:** take the M4 towards Wales as far as Jct 20, then the M48 towards Chepstow. Cross the Severn Bridge (toll is approx. £5). Over the bridge turn left at the junction towards Chepstow (A466). • At the roundabout on the edge of Chepstow turn right onto the A48 towards Gloucester. Drive through Chepstow and once over the bridge take the next sharp left turn towards Coleford (up the steep hill into Tutshill). • At the mini-roundabout turn right towards Coleford on the B4228. • In Coleford you come to a crossroads with traffic lights and the King's Head Hotel; turn right here (signposted Cinderford, Speech House, Gloucester). About 300 yards along turn right again (signposted Cinderford, Speech House) onto Bakers Hill. • Go up the hill and down again – pass the recycle centre and Hopewell Colliery on your left. Go straight over the crossroads at the bottom and as it climbs again take left turn signposted Sculpture Trail and Beechenhurst Lodge.

**From the north:** take the M5 south, and at Jct 11a take the A417 to Gloucester, then follow the A40 to the A48. • Follow A48 and take right turn signposted Cinderford (with petrol station at corner). • Go up hill to Littledean, and right at mini-roundabout. • Continue out of Littledean up the hill and take left turn on middle of the bend (signposted Speech House and Coleford) onto the B4226. • Follow this road through residential area and on towards Coleford. Pass Dikes Hospital on your right, and further on Speech House Hotel on your left. The road dips down with a bend and the Beechenhurst Lodge entrance is on the right side just after the big bend.

## BY TRAIN

Lydney station, and 15 minutes by taxi.

## BY BUS

The no. 30 bus from Coleford-Cinderford-Gloucester passes Beechenhurst; official stop is at Cannop Crossroads.

David Cotterrell (2011), and *Echo* by Annie Cattrell (2008), (see p.56 for details).

The Forestry Commission and the Sculpture Trust work as a partnership, the Sculpture Trust overseeing the planning and commissioning of works, and the Forestry Commission maintaining them. Most of the sculptures here are permanent works, though the Trust has held some innovative temporary events over the years including Light Shift (2001) and Reveal (2006) two night-time exhibitions using light and sound. On a more regular basis, however, smaller events are held, and guided walks have been introduced, often led by a featured artist or another guest speaker – check the website for updates on these.

## FINDING YOUR WAY AROUND

The café sells maps of the sculpture trail, and although the way is clearly marked, without a map you may miss a few sculptures as they are sometimes off the path and not immediately noticeable amongst all the trees. There are currently 22 sculptures spaced out on a circular walk. The trail starts in front of Beechenhurst Lodge (which houses the café and toilets) and is clearly marked with a large post. The map currently sends people around the trail in one direction, starting with the enormous chair (Place) that can be seen away in front of you as you head up the path from the Lodge. All the paths for the sculpture trail are clearly marked with posts – the tops of these are painted blue, with arrows on the sides indicating which direction to go in. Make sure you follow only the blue posts for the sculpture trail, as other posts with different colours are markers for other walks! The only path where this system seemed to fail was at a junction after *Hanging Fire*, where suddenly some new paths appear, leading off to the right – do not take these paths as they lead back into the forest (there is a somewhat hidden marker pointing the right way). The whole walk takes about three hours (as always this depends on your speed, stamina and the time spent looking at each work) but you can cut off about 20 minutes at the end if you wish by backtracking slightly after *Melissa's Swing* and then turning right at the corner to take a short cut back to the Lodge.

There are some new interesting technological options available from www.forestofdean-sculpture.org.uk/resources, such as sound walks.

## THINGS TO SEE

The 22 sculptures currently featured are all permanent, and some have been there since the trail first opened. Gradually over the years, a few sculptures have disintegrated and a few more have arrived.

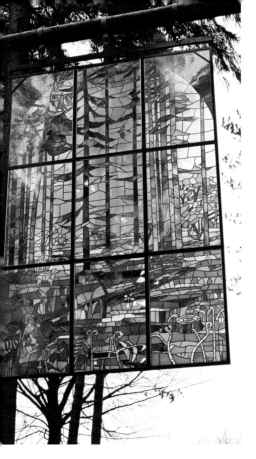

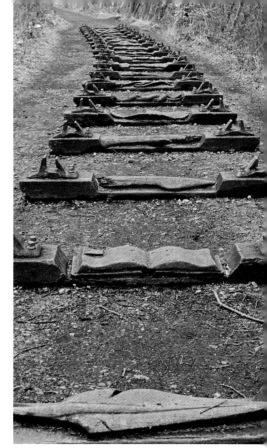

*Cathedral*, Kevin Atherton, 1986. *Photo by Alison Stace, by permission of the Forest of Dean Trust*

*House*, Miles Davies, 1988. Steel. *Photo by Alison Stace, by permission of the Forest of Dean Trust*

*Iron Road*, Keir Smith, 1986. Jarrah wood sleepers. *Photo by Alison Stace, by permission of the Forest of Dean Trust*

Some were originally made from bracken and twigs and were never intended to survive. Some, however, are now over two decades old. Magdalena Jetelova's *Place*, for instance, was installed in 1986. This has become the sculpture trail's iconic piece, and the one that everyone remembers and recognises. Its monumental structure seems a fantastic viewpoint from which to survey the landscape. Standing next to it makes you feel you have been transported to Lilliput, and that whoever owns the

chair, has just gone off to roam the woods and could return at any time. Suddenly, it is human beings that don't belong here. This piece, however, may now be usurped by the new *Hill33*.

The most recent commission, *Hill33* by David Cotterrell (2010), is a giant earthwork made up of coal contained in special containers, linking back to the history of the forest, its industrial past and coal spoil. Cotterrell was also inspired by Mayan

temples hidden in the forests of Central America, which is apparent in the form, but the use of the special containers came from his time in Afghanistan where he saw these containers being used to create barriers in the deserts. Made from galvanised mesh and a kind of waterproof membrane, these were filled with sand and gravel to create barriers in the landscape. *Hill33* has been built from these HESCO container units and filled with coal spoil (left over from the forest's mining history). This enormous work (at 1300

*Echo*, Annie Cattrell, 2008. *Photo: courtesy of the artist*

tonnes and 11 metres tall) will remain here for many, many years to come, the idea being that it will 'find its place in the world' as it gradually settles and the forest grows over and around it. The aim therefore is to see what happens next as it changes, so it will never really be a finished piece. Instead the landscape around it will change it, and the forest will make this new piece of work its own. As the artist explains, 'Beneath the apparently natural landscape of the Forest of Dean lies the remains of blast-furnaces, coal mines and railway lines. The work was designed to eventually become part of the industrial archeology of the forest.'

The next most recent addition is *Echo* by Annie Cattrell (2008), a large piece with an intriguing surface, resembling a lunar landscape. In fact it is cast from 310 million-year-old rocks and, as the Forest of Dean information puts it 'evokes a sense of the subterranean'. It is a very

tactile experience. This was commissioned to celebrate both the life of Jeremy Rees (one of the trail founders) and also the 21st anniversary of the trail.

*Dead Wood – Bois Mort*, by Carole Drake, represents tombs in the forest – great slabs of stone hidden in the woods, some of which are marked and some not, reminding us of the unmarked graves of dead soldiers perhaps, and the use of forests as burial grounds, provoking the idea of forests as keepers of secrets and memories. The plaques on some of the stones have images etched into them of the French forests devastated during the Great War – perhaps a memorial to all the dead woods, wherever they may be. Keir Smith created *Iron Road* by laying 20 carved wood sleepers to replicate a railway on the site of what was once a railway line that ran through the forest; you can see the perfectly flat gentle curve

that it followed. As the sleepers are laid out on what is now the path, you are forced to engage with the forest's past – in fact you are walking along it; this sculpture simply focuses your attention on that fact. As you walk alongside the sleepers, you notice that each one has a different carving in its centre. These refer to the history of the forest, though some are clearer than others.

The tall and skinny form of *House*, by Miles Davies, rises up into the canopy of the trees, forcing you to look up at the tops of the trees surrounding you. One of my favourite pieces here, it engages the viewer on many levels. Its form replicates a forest mineshaft; normally a structure above ground with a roof providing cover, with the shaft going deep into the ground, in this case the whole structure has been brought above ground, so that the little house is among the treetops. The security and safety of the house has become the shelter offered by the forest. The tall, straight legs replicate the shape of the neighbouring trees so that it fits in perfectly with its surroundings, despite it also being a house removed from its usual context. An austerity and a stillness also seem to surround it, while its architectural qualities stand out well against the trees.

Bruce Allan's *Observatory*, from 1988, can be found next to the Cannop Ponds. This somewhat surreal staircase at first seems to lead nowhere, but is actually offering

a viewpoint in the tree canopy from which to look down on the woods and water – and as with House, forcing us to alter our perspective. It is a place simply to stop and absorb the surroundings. The forest has become the work we are to contemplate, while the piece itself is not so much a work to be seen – its form is not that important – but one to be used and experienced.

Neville Gabie's *Raw* (2001) is a giant cube made from a felled oak (one of the Navy oaks planted in the 1800s) cut into squared pieces and put together like a giant puzzle in order to make up the cube. As much of the wood as possible was used. The whole piece is held together in the old fashioned way by using wooden pegs, and the stump of the felled tree can be seen next to it. Gabie had become fascinated by the life and volume of a tree – how much water does it consume? How much wood does it contain? How do you measure the volume of such an irregular shape? *Raw* is the tree reduced to its essential element – wood. The cube itself has a fantastic pattern of squares and gives a lovely glow in the summer light. However, one should consider the irony of cutting down a 200-year-old oak in order to make art that draws the viewer's attention to the ancient forest and its trees.

# 12 Ironbridge Open-air Museum of Steel Sculpture

Moss House, Cherry Tree Hill,
Coalbrookdale
Telford, Shropshire, TF8 7EF.
Tel: 01952 433152
http://steelsculpture.go2.co.uk

**Facilities:** Toilets, educational workshops
throughout the year. (NB: there is nowhere
on site to buy food or drink, so remember
to eat first, or bring a picnic with you – as
long as you take away your litter.)
**Open:** 1 March–30 November, Tue–Sun,
10am–5pm. Open Bank Holiday Mondays.
Summer evening visits by advance booking.
**Admission:** £3 (£2.50 each for groups
of ten or more), £2 for children and
concessions (£1.50 each for groups of ten
or more), and £8 for a family (up to two
adults and three children).
**Time needed:** 2–3 hours.

## Getting there

### BY ROAD

Exit the M54 at Jct 4 onto the A442, then
turn off the A442 onto the A4169 shortly
afterwards. • At the next roundabout
go straight over, following signs for the
A4169. Ignore the signs directing you left
to Ironbridge Museums, but instead follow
signs to the Museum of Steel Sculpture.
• Pass Lightmoor Rd on your right, and
Brick Kiln Bank on your left (somewhat
hidden by bushes), then take the next
left onto Cherry Tree Hill (the museum is
signposted). Ignore the first turning on
your left. • You will see the Ironbridge
Museum on your right further down with
a large sculpture next to it. Park here or in
the overspill car park further down to your
left, open during busy seasons.

### BY TRAIN

Telford Central station then taxi (approx.
7 mins).

## OVERVIEW

If you like your sculptures larger than life
and made of metal, then this museum is
certainly the place for you. Set up by Pam
Brown and Roy Kitchin, two sculpture
artists, the project was from the beginning
a labour of love. Sadly, Roy died in 1997
(he is buried beside his sculpture Blake in
the grounds). Pam now has the task of
single-handedly running and maintaining
the grounds, as well as organising the
summer workshops, but everything runs
remarkably efficiently. Today the museum
operates as both a sculpture park and a
centre for education and creativity.

A long time in the planning, the open-air
museum was originally set up as a site on
which Roy and Pam could display their
work, instead of constantly moving work
around for temporary exhibitions, which
was both costly and time-consuming. Roy
felt that generally pieces were moved on
from a site 'before the landscape had a
chance to understand and accept them'. In
1980 they began looking for some unused
land, and their cry was answered by the
Telford Development Corporation. The site
finally agreed upon in 1984 had originally
been the Cherry Tree Hill brick and tile
works, and needed large amounts of
clearance and landscaping, much of which
was done by hand with wheelbarrows. The
museum gradually grew into a much larger
project, and other artists were invited to
include their work on site.

The museum's site in Coalbrookdale was
chosen because of its proximity to the
most recognisable structure in the area
where the iron industry really took off,
Abraham Darby III's Iron Bridge spanning
the River Severn, built in 1779. The
museum grounds stand on a ten-acre
site with wild woodland and open grass
areas, hidden enclosures and deep tree-
filled gullies. A large number of sculptures
(75 at the last count) are scattered
throughout the park; it is a strange
experience to be surrounded by so much
sculpture in one medium. The largest and
heaviest of these (the biggest weighs in at
four tons) can be found on the open grass
of the top field. Most of the sculptures
here are huge, and many are either on

permanent exhibition or long-term loan from the artists. There are also plans to hold some short-term exhibitions.

The museum and house have been built in the style of a factory from the time of the Industrial Revolution (NB: apart from the toilets, access to this building is only for those taking part in workshops). The museum holds many maquettes of the work on display outside, and combines workshop areas (such as the woodwork area upstairs) with a study and bedroom. Downstairs is the enormous steel workshop, which has double doors to allow for the movement of work, as many pieces and parts are built on site.

*Inclined Impasse*, Roy Kitchin, 1982. *Photo: Coral Lambert, courtesy of Ironbridge Open Air Museum*

The workshop also houses the equipment used for the steel workshops in the summer. These are the only educational steel courses in the country, and therefore always oversubscribed – so ring for details and book early if you're interested! A group of Americans made up of students and practising artists come over every summer to 'crew' the foundry. The sculpture in the grounds also functions as the focus of poetry workshops held at the museum, which are run by a professional creative writer over long weekends.

## FINDING YOUR WAY AROUND

The reception to the sculpture park is at one of the building's front windows. Tap on the window for attention, but if nobody is in, you are welcome to look around the grounds anyway; you'll find a wooden honesty/donations box for your payment and another with maps of the park. These boxes (located in front of and to the right-hand side of the house just off the car park) stand next to the small path leading into the woods, which is the entrance to the grounds. In fact, it doesn't hugely matter where you start as, although the gravel paths are marked on the map, there is no set route to follow. Do not try to follow the numbers of the sculptures in order, as you will see they are not sequential! The numbers you can see on the cast-iron plaques do correspond, however, to the list of sculptures on the back, and are also identified on the map, so you can use them to navigate by if your map-reading is up to scratch. Otherwise, this is really a place just to wander around

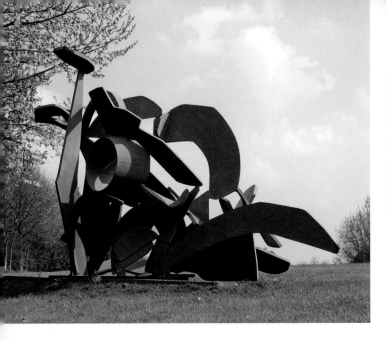
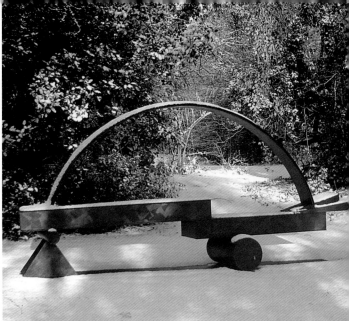

and see what catches your eye – or as Pam says, 'here you can be completely free'! This does mean you may miss work unless you concentrate, so be sure to see the top field which runs alongside the A4169 and is marked as the long open area in the top-left half of the map. This is where some of the most impressive sculptures can be found, although there are interesting pieces tucked away all over the place.

It took us several hours of wandering around to see every piece, though this involved walking slowly and discussing each one. If you want to see everything, allow time for meandering back and forth.

## THINGS TO SEE

As pieces come and go, the numbers given may change, so titles have also been included. If you decide to head off into the woods at the start of the path by the

post boxes, one of the first pieces you will find is *Roata* (50), up to your right. Look closely at this twisting and turning piece, and you will realise it is actually figurative; the head can be seen sticking out near the bottom. It was made by Katherine Gili, who hired a contortionist to pose for her while she drew her designs.

*Mechanical Arch* (12), by Roy Kitchin, is one of the larger sculptures in the park and entirely dominates its display area, even while surrounded by tall trees on three sides; you can almost see its chest puff out as you approach. Strangely, the thing that made this sculpture for me was the wonderful 'look at me' colour, a striking rusty orange-brown, which perfectly complements the surrounding greenery.

Up on the top field several of the large pieces are worth noting. In the far

right-hand corner is *Amphitrite* (14) by Michael Lyons, a funky arrangement of flat blue pieces of steel. Lyons always begins the design process using cut-out pieces of black card on white paper, and indeed this piece looks very different from front and back: if you go to the far side of it, by the hedge, you can see the fabulous silhouetted shape, and envisage how it must have looked at the concept stage. It is also, at four tons, the heaviest work in the museum's collection.

Tucked into a corner along the left-hand stretch is *Surveyor* (16) by Pam Brown. This enormous version of a viewfinder gives great vistas of greenery and the land beyond, framed and shaped by the intersection of the circle and the V. As you walk around it, this intersection and framed view shifts constantly, offering a great backdrop to these simple shapes,

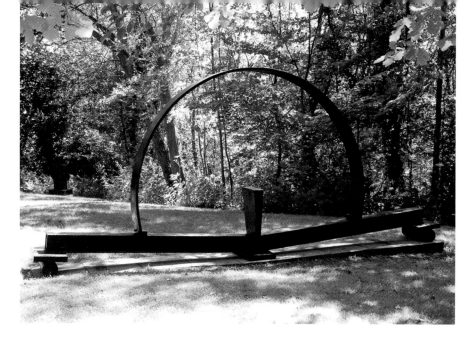

which seem to create their own changing composition. The piece does have echoes of a giant gun support, and Pam herself said that when it was installed a military helicopter flew over from the local base, came back, and lowered right down to check that it wasn't some giant piece of terrorist machinery.

In the middle of the left-hand side is the amazing *Swing Bridge* (71), the only kinetic piece of sculpture at the museum. The piece is purely wind-powered, and its perfect balance means the very steady, slow, even swing suggested by the title needs only a very slight breeze to work. The lovely cast wave-like forms at both ends of the piece just completed it for me. The artist, Gerry Masse, comes every summer to help with the workshops and is now setting up his own Sculpture Trails outdoor museum in Indiana (www. sculpturetrails.com).

FACING PAGE, LEFT: *Amphitrite*, Michael Lyons, 1993. *Photo: Alison Stace*

FACING PAGE, RIGHT: *E.X.P.*, Roy Kitchin, 1982. *Photo: Coral Lambert, courtesy of Ironbridge Open Air Museum*

ABOVE: *Blake*, Roy Kitchin, 1982. *Photo: photographer unknown, courtesy of Ironbridge Open Air Museum*

RIGHT: *A Flower in Flower*, Keir Smith, 2001. *Photo: Pam Brown, courtesy of Ironbridge Open Air Museum*

On the lower part of the grounds in a circular area of its own stands *A Flower in Flower* (67), a wonderfully peaceful sculpture that glimmers as it catches the light. It was made by Keir Smith, upon discovering he had leukaemia, as a sort of monument to Roy Kitchin, who died of the disease. Sadly, Keir Smith also died recently. As you look up, it seems entwined with the ivy and oak behind it.

# 13 Meadow Arts

**Office only:** The Stable House, Onibury,
Craven Arms
Shropshire SY7 9BE
Tel: 01584 891659
www.meadowarts.org

**Facilities:** Each exhibition is usually located
in the grounds of a large stately home or
similar, so generally speaking there are
toilets and sometimes a café on site.
**Open:** Depends on the venue, so ring or
check the website for details.
**Admission:** Depends on venue, so once
again check for details.

## Getting there

The location changes for every exhibition,
so ring or check the website for details.

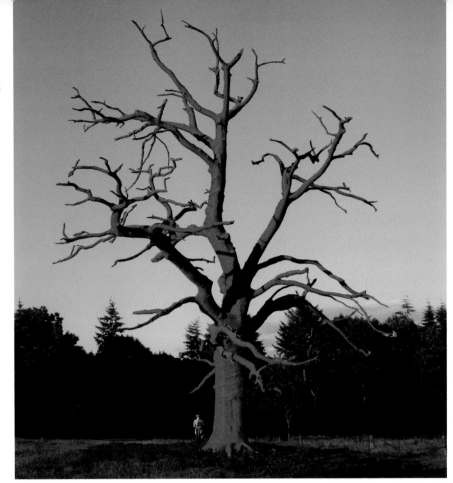

*Bound*, Philippa Lawrence, 2009. Meadow Arts Commission, from Tell It To The Trees exhibition at The
National Trust's Croft Castle. Cotton-wrapped, deceased oak. *Photo: courtesy of Meadow Arts and the artist*

## OVERVIEW

Before you go rushing out the door to
visit, stop! It is important to check the
details, because this gallery is actually
an organisation that puts on exhibitions
of contemporary sculpture in a different
location every year. Often housed in
the grounds of large stately homes,
historic gardens or heritage sites, and
always located in the Midlands – these
exhibitions are usually on for three or
four months every year over the summer
(although some may last for years). The
organisation operates as a sort of mobile
gallery, trying to present sculptures
outdoors while at the same time offering
an alternative to permanent sculpture
trails. The gallery aims to encourage
existing and established artists to try
making work for an outdoor setting,
which may be a new experience for them.
Meadow Arts is currently developing its
links with the National Trust for future
shows. The last few exhibitions were Still
Life, at Hanbury Hall, Worcestershire
(2007), Give me Shelter at Attingham
Park (2008–9), Tell it To the Trees at Croft
Castle in Herefordshire (2009–10) and
House of Beasts at Altingham Park, near
Shrewsbury (2011–12). Mappa Mundi
at Burford House featured sculpture
by Stephen Cox, who made *Granite
Catamarans on a Granite Wave*, at
Goodwood (see p. 98).

## THINGS TO SEE

The work changes with every exhibition, but is always of a high standard and generally features well-known artists. Past exhibitions have included work by Stephen Cox, Damien Hirst, Daphne Wright, Paul Morrison, Franz West, Des Hughes, Philippa Lawrence and Mariele Neudecker amongst many others. Check their website for a full list of past exhibitions, artists and work.

Meadow Arts is now strengthening its partnership with the National Trust, in order to place modern art into historic sites and gardens, the aim being 'to keep them inspiring and alive, draw links between the new and the old and encourage ways of looking at our national heritage through fresh eyes' (Mark Agnew, National Trust). The most recent exhibition along these lines is House of Beasts (2011–12), which looks at the role animals have played in the history of the house, and uses this as the basis for inspiration. The people, house and animals have all been connected in various ways, and this exhibition explores those links in 40 artworks through the stables, parkland and mansion.

TOP RIGHT: *Swan*, Daphne Wright, 2007. Cast marble. Meadow Arts Commission, from Still Life exhibition. *Photo: courtesy of Meadow Arts*

RIGHT: *Trappenkamp*, Juneau Projects, 2008. Tate Britain Commission, from Tell It To The Trees exhibition at The National Trust's Croft Castle. Water, jet-cut marine plywood, timber. *Photo: courtesy of Meadow Arts and the artist*

# 14 Burghley Sculpture Garden

## OVERVIEW

Burghley House is a stately home with beautiful gardens and a lake. The sculpture gardens have been reclaimed from Capability Brown's lost lower gardens, with work carefully scattered throughout to make the most of all areas.

Pick up the leaflet with the map of the gardens, as more work is added every year – often after the summer exhibitions. The sculptures marked on the map are all permanent (25 pieces currently), but every year from mid April to October there is also an exhibition in the gardens of work for sale (showing 20 to 30 sculptures). Some of these temporary pieces have subsequently been donated as permanent

fixtures. The temporary exhibits are not featured on the map. There are some great pieces in the permanent collection, and Burghley is a sculpture garden that seems to be evolving and improving all the time, while the wonderful surroundings set off the sculpture to its best.

## FINDING YOUR WAY AROUND

The maps at the entrance kiosk show a plan of the gardens indicating where the various pieces are sited (temporary exhibitions are not marked on this map). There is no set route, but, broadly speaking, the path takes you alongside the lake and around the gardens in a big

circle – although there is also work to be found in the middle. It takes about an hour and a half to see everything – and you do need to wander back and forth a bit to get your bearings and to find certain things – but you could easily stay longer just to enjoy the grounds and the other things on offer.

---

Burghley House, Stamford,
Lincolnshire,
PE9 3JY.
Tel: 01780 752451
www.burghley.co.uk

**Facilities:** Toilets, café (in summer), educational programmes, brewhouse (visitors' centre), 'Gardens of Surprise'
**Open:** mid-March–end Oct, 11am–5pm daily. House closed on Fridays.
**Admission:** Gardens only ticket, adults £7.20, children £4.80, concessions £6. Time needed: 1½ hours.

## Getting there

### BY ROAD
• From the north take A1 south. After passing Grantham turn left onto A43 towards Stamford. See details below from Stamford.

From the south take the A1 heading north, continue along as it becomes the A1(M) past Jct 17, and then, after you pass the junction with the A47, you will come to a roundabout (with Stamford marked straight ahead). Turn right onto the B1081 and continue past stone gates on your right. • You will come into a pretty village (Stamford) full of old stone-built houses,

and see a pub called the Bull & Swan. Turn into the small road that runs down the left-hand side of this pub. • Continue along this road until you see a blue sign saying 'Visitors' Entrance'. From the car park, two curved halves of a tree trunk with 'sculpture garden' written along them will guide you to the sculpture entrance.

### BY TRAIN
Nearest large station is Peterborough, then 20 mins by taxi. Or change at Peterborough by train to Stamford station and walk through park (30 mins) or 5 mins by taxi.

## THINGS TO SEE

*Vertical Face*, by Rick Kirby, is a giant face in a lovely rusty colour, made from small pieces of steel attached to a larger framework. The face is not complete: the back is open so that you can see the framework and the edges of the face are not finished – it is almost a rough drawing in 3D, showing enough of the features to give you a broad idea of the whole face, and letting your brain fill in the rest. It has great presence and drama, and currently stands a little way from the edge of a large circular area, which at the time of visiting was marked out by tall black vases, suggesting an arena or an amphitheatre. Viewed from the bench at the other side of this dip (which may be the remains of an old pond), you feel as if the lions and entertainers will arrive at any minute.

Above the path that runs alongside the lake is a huge tree with a large branch stretching overhead, along which three wooden figures appear to balance. The appropriately named *Balance*, by Sophie Dickens, has movement and poise, conveying the exact feeling of someone walking nervously along a narrow branch, precariously balancing above the path. I loved it, but as it is so high up it was hard to see the figures against the light and through the leaves, although this could

LEFT: *Hybrid Infusions 4*, Taz Lovejoy (detail). From the temporary exhibition in 2012. *Photo: courtesy of Burghley House & Gardens*

RIGHT: *Vertical Face*, Rick Kirby. *Photo: courtesy of Burghley House & Gardens*

be more or less of a problem depending on the time of day or year. It is also true that the figures need the height to convey the sense of fear. (Sophie Dickens also has work at Pride of the Valley Sculpture Park.) The *Five Carved Oak Trunks*, by Giles Kent, that span the lake were one of Burghley's first pieces and look better in real life than in images – they really integrate with their location and environment, their simple organic forms reflecting well in the water and echoing the shapes of reeds nearby.

By the path is a large disc of slate suspended in glass – *Untitled*, by Martyn Barratt. The piece itself I felt was fascinating, but the way it was displayed needed rethinking, or at least perhaps softening with plants to hide the distracting, heavy framework that supports it.

There are always some interesting pieces in the summer exhibitions, and now one of these is usually kept every year as part of the collection.

LEFT: *Balance*, Sophie Dickens. *Photo: courtesy of Burghley House & Gardens*

OPPOSITE, TOP LEFT: *Organic Forms*, Peter M Clarke (detail). Copper. From the temporary exhibition in 2012. *Photo: courtesy of Burghley House & Gardens*

OPPOSITE, BOTTOM LEFT: *Red Deer*, Sally Matthews, 2009. Steel and bracken. *Photo: Anthony Carr, courtesy of Burghley House and Garden*

FAR RIGHT: *Five Carved Oak Trunks*, Giles Kent. Oak. *Photo: courtesy of Burghley House & Gardens*

# OTHER PLACES OF INTEREST
## 15 Quenington Sculpture Trust

### OVERVIEW

The Quenington Sculpture Trust holds the 'Fresh Air' exhibition every other year, its aim being 'to educate, foster knowledge, understanding and appreciation of the arts'. The Fresh Air shows began in 1997 and are organised by the owners, Lucy and David Abel Smith. They always display a range of media including bronze, ceramic, glass, metalwork, woven willow, marble and wire. The work is of a very high standard (and in 2007 included some works on loan by very well-known artists such as Lynn Chadwick and Graham Williams).

The Trust was set up following the success of the Fresh Air exhibitions, and now focuses on trying to 'generate interest, excitement and pleasure in the visual arts and sculpture in particular'. It also offers bursaries to artists to help them realise their plans, and it supports local schools by putting on workshops for children with disabilities.

The gardens are a delight to wander around and have many different little areas, which helps with the placing of the work according to what shows it off best. There are a great many artists exhibiting, and always plenty of fantastic things to see. Past shows have included a fabulous music installation, activated by people taking a seat under a lovely wooden pergola covered over with roses.

Although this is a selling show, it isn't full of work on plinths: pieces are carefully sited to fit in with the beautiful gardens, which have both a river at one end and a small mill race running through to a sluice. It took about an hour and a half to wander round and see everything. Each biennial exhibition is only on for a short time (several weeks), but during this time Quenington is well worth a visit.

Quenington Old Rectory,
Quenington, Cirencester,
Gloucestershire, GL7 5BN
Tel: 01285 750379
www.freshair2013.com

**Facilities:** Toilets & refreshments available
**Open:** 10am–5pm daily. One changing exhibition every other year for a few weeks in June and July (next one 16 Jun–7 Jul 2013, then 2015 – check dates).
**Admission:** Adults £2.50, children under 18 free
**Time needed:** 1½ hours

### Getting there

**BY ROAD**
From Jct 15 of the M4, take the A419, turn right onto the A361, and left onto the A417. • The A417 runs from Gloucester to Reading. • At Fairford, turn right (from Reading) or left (from Gloucester) towards Quenington and then follow signs to the exhibition.

*Contour Spheres*, Colin Hawkins, 2011. Blown clear glass. Photo: Steve Russell, courtesy of Quenington Sculpture Trust

ABOVE: *Fledge*, Rebecca Newnham, 2011. Fibreglass and mosaic. *Photo: Steve Russell, courtesy of Quenington Sculpture Trust*

BELOW: *Armour Girl*, Carol Peace, 2011. Bronze resin, life-size. *Photo: Steve Russell, courtesy of Quenington Sculpture Trust*

ABOVE: *Three Graces*, Rick Kirby, 2011. Stainless steel life-size figures. *Photo: Steve Russell, courtesy of Quenington Sculpture Trust*

BELOW: *New Riders*, Terence Coventry, 2011. Bronze. *Photo: Steve Russell, courtesy of Quenington Sculpture Trust*

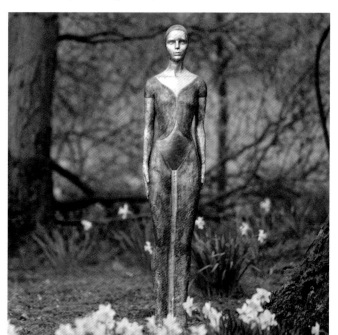

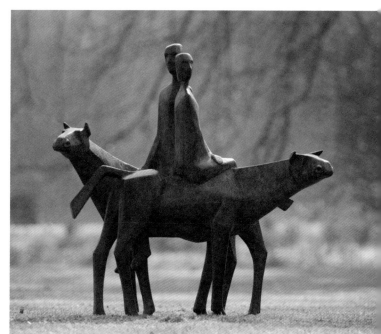

# 16 Chatsworth House and Gardens & Beyond Limits Exhibition

Chatsworth
Bakewell
Derbyshire DE45 1PP
Tel: 01246 565300
www.chatsworth.org

**Facilities:** Café, toilets, gift shop.
**Open:** Summer: 10.30am–5pm, otherwise check for exact dates. Beyond Limits exhibition Sep–end Oct, check for exact dates. Gardens only, 11am–6pm, house 11am–5.30pm.
**Admission:** (garden only, includes exhibition) Adult £10, concessions £8, child £6, family £28 (with house included approx. £4 extra). Parking £3.

www.chatsworth.org/whats-on/events/beyond-limits-sculpture-exhibition-in-the-garden

www.sothebys.com/en/auctions/2011/beyond-limits-chatsworth/overview.html

## Getting there

### BY ROAD
Take M1 to Jct 29, then A617 towards Chesterfield, then A619 towards Baslow and Bakewell. Then take B6012 towards Rowsley & follow brown signs.

### BY TRAIN
From Chesterfield station Chatsworth is a 30 to 40-minute bus ride then a 2-mile walk, or 25 minutes by taxi. From Sheffield station, 1 hour by bus or 30 mins by taxi.

## OVERVIEW

Chatsworth House is mainly known for its gorgeous house and gardens, but it also has many pieces of great sculpture, and it now has a regular partnership with Sotheby's, who hold their Beyond Limits exhibition in the grounds annually during September and October. Chatsworth House Trust and the Devonshire family have continued to acquire and commission contemporary sculpture for permanent display in the garden and park since 1974, when they bought the first work by Dame Elisabeth Frink (there are now three pieces of her work). The collection has grown over the years and they now have 32 pieces of permanent contemporary work located throughout the grounds, and as the grounds and gardens cover 105 acres, they are fairly spread out. It is entirely possible to see them all, however, and in fact some of them are placed in the less used areas of the garden deliberately to encourage visitors to explore those areas. The gardens were originally established 450 years ago and subsequently adapted by various head gardeners; they now feature a huge cascading waterfall and an amazing rock garden, not to mention a fabulous lake among many other things. Most of the work is by modern British artists, including Dame Elisabeth Frink, Angela Conner, Barry Flanagan, Emily Young, David Nash and Allen Jones, with recent additions by Gary Breeze and Laura Ellen Bacon. The work and the grounds are both fantastic, and the Sotheby's show always has plenty to see and is set at a very high standard, so if you are making a special journey it is worth combining the two (although allow plenty of time to do both). You can see all the work in the grounds in about an hour and a half if you don't get distracted, but you probably need the same again for the Sotheby's show.

## THINGS TO SEE

Amongst the work in the permanent collection, there are three works by Dame Elisabeth Frink (from 1974, 1981 and 1991), and two by Barry Flanagan, the most recent of which is *Drummer*, added in 1996. Other notable pieces include *Lion Woman*, by Emily Young, from 1991; *Screen*, by Allen Young, featuring the shapes of figures in an almost 3D line drawing made from painted black stainless steel; *Figure of a Man* by William Turnbull (1988); and a water sculpture by Angela Conner, added in 1999.

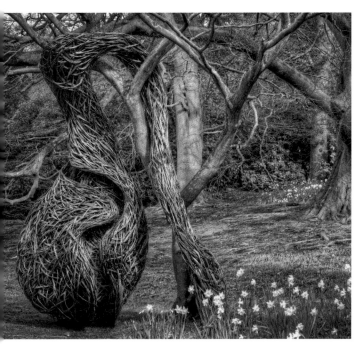

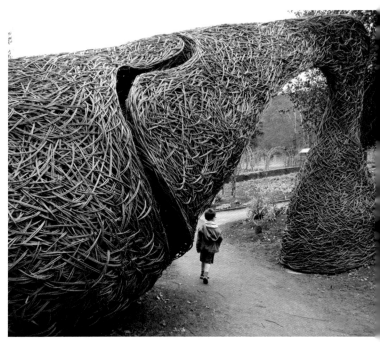

ABOVE LEFT: *New Growth Forms* (small), Laura Ellen Bacon, 2012. Located in Chatsworth's Kitchen Garden. Woven willow and bamboo. *Photo: Chris Elliot, © Chatsworth House Trust*

ABOVE RIGHT: *New Growth Forms* (large), Laura Ellen Bacon, 2012. Located in Chatsworth's Kitchen Garden. Woven willow and bamboo. *Photo: Chris Elliot, © Chatsworth House Trust*

RIGHT: *Walking Madonna*, Dame Elisabeth Frink, 1981. *Photo: Alison Stace, courtesy of the Frink Estate*

FAR RIGHT: *War Horse*, Dame Elisabeth Frink, 1991. *Photo: Alison Stace, courtesy of the Frink Estate*

Recent additions to the collection include a series of woven sculptures created by Laura Ellen Bacon, known for her enormous organic and undulating forms, which often creep up the side of buildings or through trees. In this case, a large arch (four metres high) woven from Somerset willow and bamboo from the

*Drummer*, Barry Flanagan, numbered edition 4/5, 2004. *Photo: © Devonshire Collection Chatsworth, by permission of Chatsworth Settlement Trustees. © Estate of Barry Flanagan, courtesy Plubronze Ltd*

Chatsworth estate draws people towards the Kitchen Garden, along with three other smaller forms, which all lean along with the slope of the ground. *Forms of Growth* took three months to create in situ in 2011. *Timepiece*, by artist Gary Breeze, was also installed in 2011, and designed specifically for its location, looking out at the more modern clock tower on the stables façade. The artist explains in his statement for Chatsworth that because of the view, the sundial was also part 'folly', but the overall idea was 'that the sculpture should be a sundial, bringing two ways of understanding time, one ancient and one relatively modern, together in one space'. The very complicated sundial has markings on every face, telling us not only the time according to GMT but also the time according to the sun and the distance to 42 ancient stone circles and earthworks throughout Derbyshire.

You could see everything in about an hour and a half if you have limited time and do not get lost in the maze, distracted by Joseph Paxton's amazing rock garden, or diverted by the treasures inside the house! You'll find a map showing locations of sculptures on the garden leaflet.

## BEYOND LIMITS EXHIBITION

The Beyond Limits show began about seven years ago, with Sotheby's organising a huge exhibition of outdoor work in the grounds at Chatsworth. This proved to be hugely successful, and so has continued annually. The work is always of a very high standard, by leading artists, and is generally larger than life. The exhibition in 2011 showed work by more than 20 artists from around the world including René Magritte, Nadim Karam, Takashi Murakami, William Turnbull, Marc Quinn, Ju Ming, Jaume Plensa and Barry Flanagan. Many artists, such as Marc Quinn and Jaume Plensa are regular exhibitors, and the exhibition has become firmly established in the art calendar. The 2012 exhibition also included work by many artists who have not previously shown here. Works included several by Lynn Chadwick, amongst them *Walking Woman*, with her coat billowing out behind her; Charles Hadcock's twisting stone *Torsion II* and Nadim Karam's abstract but figurative man/beast *Desert Sand* (made in rusted steel contrasted perfectly with its surroundings and looked quite tribal in design). Yayoi Kusama's *Flowers That Bloom Tomorrow* was shocking in its bright assorted pattern of colours, in stark contrast to its location on the cascading waterfall while Ju Ming's architectural *Taichi Arch* would not have been out of place as an entrance to the rock gardens.

Damien Hirst's *Myth and Legend*, a unicorn and a huge winged white horse with shocking sections of blood-red bone and muscle painted on stood out regally on their plinths framing the end of the water in front of the house. David Breuer-Weil's *Visitor 2* consisted of enormous feet disappearing into the lawn, while Marc Quinn's *Burning Desire* was of course a scandalous and lush giant red orchid head. Ji Yong-Ho had constructed the fabulous prowling *Lion 2* from stainless steel and used tyres, resulting in a cross between lion and dragon. With too many good artists and works to comment on here, Richard Hudson, Jedd Novatt, William Turnbull, Zadok Ben-David and Manolo Valdes were amongst some of the other artists featured, all with very interesting pieces, as you would expect from a Sotheby's show at Chatsworth.

# 17 Ellesmere Sculpture Trail

Ellesmere Tourist Information Centre
(& Boathouse Restaurant)
The Mere's Visitor Centre, The Mere,
Ellesmere
Shropshire SY12 0PA
Tel: 01691 622981
www.ellesmeresculpture.co.uk

**Facilities:** The Boathouse Restaurant
(attached to the visitor centre) has toilets,
parking and a café/restaurant.
**Open:** 1 Apr–1 Nov, daily 10am-5pm,
2 Nov–31 Mar, daily (apart from weds)
10am–3.30pm, shut 25 Dec.
**Admission:** Free
**Time needed:** 2–2.5 hours

## Getting there

### BY CAR
From north and south (Wrexham or
Shrewsbury), take the A528 to Ellesmere,
and look for the mere, visible from the
road. The visitor centre is next to The
Boathouse and is clearly visible from
the road.

### BY PUBLIC TRANSPORT
Coach and bus stops next to the visitor
centre and Boathouse Restaurant, and
also at the end of Cross St (10 min walk to
visitor centre). Buses run from Shrewsbury
or Oswestry.

## OVERVIEW

On the English side of the border with
Wales, Ellesmere is quite well situated
for access from both countries. The
sculpture trail at Ellesmere is quite a
recent addition, set up by a small group
of people with help from the Arts
Council. Since 2009, a symposium has
been run every year with an international
assortment of artists, and the sculptures
then placed in groups together in suitable
areas around the edge of the town.

Every year the emphasis is on a different
theme using different materials, with
the overall theme of the trail as a whole
being a response to the environment.
The first year (2009) was based on the
theme of glacial deposits (relevant to the
area), with glacial material in the form of
enormous boulders scattered across the
landscape. Having taken a tour of the site
and surrounding countryside, artists were
allowed to choose a boulder – mainly

*Net Form*, Ben Carpenter (UK), 2010. Steel and
wood. *Photo: Helen Downhill*

*Pattern*, Rosemary Terry (UK), 2010. Local beech wood. *Photo: Alison Stace*

granite, slate or sandstone – and had just two weeks to complete their pieces, from concept to finished work. Consequently, the pieces themselves are a mixed success, though the project as a whole is very interesting and makes for a very nice walk to find the work.

The first group's work is not so varied because working with stone does impose obvious limitations. In 2010 the theme was based around the canal (built by Telford) which was historically a very

important part of Ellesmere, and in particular the canal maintenance and repair yard. Still a functioning repair yard with a forge and all the original machinery, the artists could choose to work with materials or machinery found at the yard. The work is mainly made up of timber and metal but is a bit more varied in terms of form and ideas. The symposium in 2011 was a woodland based walk, intended to work for the local community who use the woodland walk. The developments for 2012 involved the artist Jason Hinklin, who is based in Ellesmere, creating some etched steel panels with an interpretation of the landscape, sited at five different points along the canal. 2013 brings willow plantings by the canal, along with woven willow courses and finally some willow sculptures to link with the trail.

## FINDING YOUR WAY AROUND

The visitor centre is the ideal place to start. It is found on the A528 and adjoins the Boathouse, which has toilets, does good food and has great views of the mere. The visitor centre has useful maps of the town and the sculpture trail (although you can download the trail from the website, currently there are no street names on their map). The trail map also has pictures of the pieces and short quotes by the artists. The first year's work is located in Castle Fields, on the opposite side of the A528 to the Boathouse and visitor centre, while the pieces made in 2010 are situated alongside the canal that runs from the

wharf underneath Birch Road and on past the marina. The work from 2011 is located along the woodland trail on the opposite side of town, stretching out past Cremorne Gardens. From the visitor centre, cross over the road and turn right, walking back along the road towards town until you find a small entrance in the hedge with a signpost to Castlefield Arboretum (you want the circular walk). Following this path brings you out into a big open flat field, where you will start to see the boulders. Follow these through the field, which then leads you onto a path and across a small road, to what is called the 'Plantation' – in reality a nature trail running alongside a fence. This leads you across another field to the canal.

Once on the canal you can't get lost as you simply follow it along, finding the sculptures alongside it. Amongst this group of sculptures are also some pieces commissioned by British Waterways, also shown on the map. Two of the pieces are located in a field next to the repair yard, but you may need to backtrack to find a bridge in order to see these close up.

Following the map after this, you can continue along the canal to the wharf, which brings you out fairly centrally (at the end of Wharf Road turn right onto St John's Hill, and then left onto Church Hill to get back to the A528). Or you can take the bridge onto Birch Road (going towards town), and then cut down Love Lane and (bearing left) Church Lane to bring you back onto the A528.

# THINGS TO SEE

There are six works from the 2009 symposium, my favourites being *Rotation 2* by Trevor Clarke, where repetitive grooves have been cut into the rock, emphasising the form through this repeat pattern. *Puerta del Agua* by Emiliano Sacco is a sandstone work with a window cut out of it that changes the form completely and frames the view behind. *Dialogue* by Pal Lakatos has an amazing surface which can only really be appreciated up close. From the sculptures alongside the canal, just beside a bridge is the *Shoal of Fish* by Tom Gilhespy. Made

from wavy steel forms, it has a great connection with the water, resembling not only fish but seaweed or plants waving in the water. *Net Form* by Ben Carpenter is also suited to the environment with the suggestion of being both a net for catching fish and a fish form, complete with eye and tail shape. *Pattern* by Rosemary Terry has a great perfection and symmetry, while the two forms in the field by the repair centre, *Boat Form* and *Framework*, both looked very interesting but are harder to access; sadly, I ran out of time for a close inspection.

BELOW LEFT: *Rotation 2*, Trevor Clarke (UK), 2009. Granite. *Photo: Alison Stace*

BELOW RIGHT: *Puerto del Agua*, Emiliano Sacco, (Argentina), 2009. Sandstone. *Photo: Alison Stace*

RIGHT: *Shoal of Fish*, Tom Gilhespy (UK), 2010. Steel. *Photo: Alison Stace*

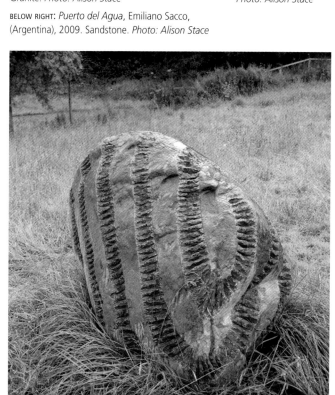

# 18 Sculpture in the Sanctuary

The Swannery
Hill Farm Nurseries Ltd
Normanton
Southwell
Nottinghamshire NG25 0PR
Tel: 01636 813184
www.regtaylors.co.uk

**Facilities:** Cafés, toilets
**Open:** Biennial, next open in 2013 and in
2015 for 5–6 weeks around August (check
website for dates).
**Admission:** Adults £5, OAPs £4.50, children
under 16 free.
**Time needed:** 2 hours

## Getting there

From the A1 towards Newark-on-Trent,
take the A617 towards Mansfield. Go
to Normanton and at the crossroads of
Normanton Rd and Corkhill Lane turn onto
Corkhill Lane and look for a signpost (a bit
faint and small).

RIGHT: *Tyre Alligator*, Donna Bramall, 2011. Recycled
tyres. *Photo: Alison Stace*

FACING PAGE, TOP LEFT: *The Spirit*, Carlos Dare, 2011.
Spray-painted aluminium. *Photo: Alison Stace*

TOP RIGHT: *Apples*, Graeme Ritchie, 2011. *Photo:
Alison Stace*

BOTTOM: *Glass Lilllies*, Jenny Pickford, 2011. Glass
and steel. *Photo: Wayne Hawkes*

## OVERVIEW

Inaugurated in 2009, this biennial
show features a very large assorted
collection of sculpture, spread out over
an extensive area and set around a series
of small lakes which are normally a swan
sanctuary. There are also two very large
greenhouses housing an assortment of
sculpture when the show is on. This is
very much an exhibition in a garden
centre. The sculpture is all for sale and
is aimed at people with gardens of all
sizes who may be looking for work.
Consequently, there are a lot of small or
medium-sized animal pieces, plus quite a
few impressive larger pieces.

The work is a mixed bag of standards
and themes, and also rather too much
to look at – despite the space, it feels
quite cluttered – though from a selling
perspective there is certainly something
for everyone. The show is short-lived, so
there is not as much thought put into the
placement of works as at some parks or
trails, but it is a nice afternoon out with
attractive grounds to walk around, and
a small section of woodland with some
larger and stranger (but sometimes more
interesting) artworks.

There is a main café at the garden centre
doing proper meals, as well as caterers
near the lake doing snacks and teas or
coffees, etc., so if you just wanted an
easy afternoon out you wouldn't be
disappointed. In the 2011 show, the work
ranged from spiralling wooden sculptures
which hung in the trees and twisted in
the wind to large alligators made from
rubber tyres, glass botanic forms, and
cockerels made from sheet steel. As the
grounds are fairly accessible and flat on
the whole, the Sanctuary is a good option
if you want a family day out.

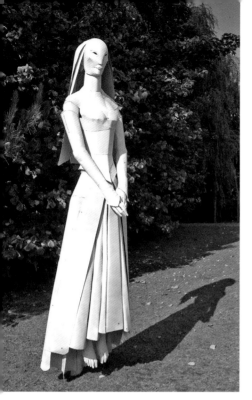

## FINDING YOUR WAY AROUND

The route is pretty straightforward as from reception you simply walk down towards the sculpture park entrance, past the two large greenhouses of artworks, past the caterers' marquee, to the little cabin with double doors; this serves as a gateway into the Sanctuary and also prevents the swans and ducks from escaping. The path then leads you around the various lakes and through the small woodland area. You can't really get lost, as the route is essentially two small circular trails leading you back on to the main path.

# THE SOUTH-EAST

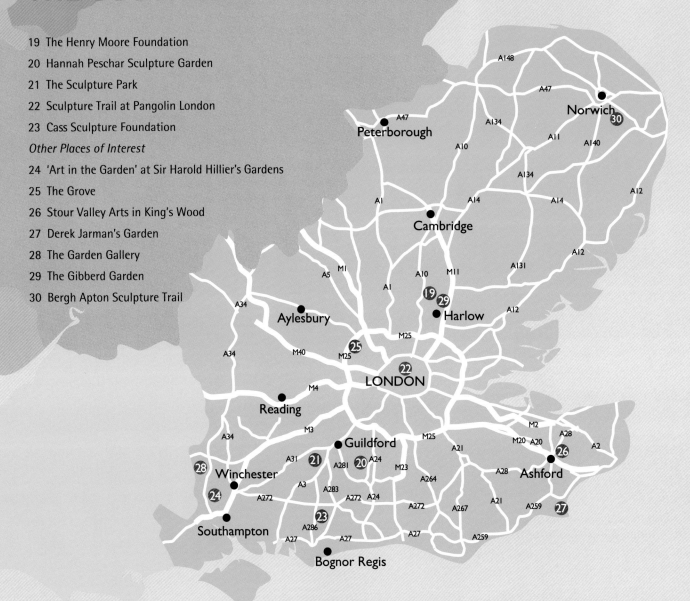

# 19 The Henry Moore Foundation

Dane Tree House, Perry Green,
Much Hadham
Hertfordshire, SG10 6EE
Tel: 01279 843333
www.henry-moore.org

**Facilities:** There are toilets on site and
virtually next door (a 2 min. walk) is The
Hoops Inn, also run by the Foundation,
which has a beer garden and serves food.
**Open:** April–mid-Oct. It is no longer
necessary to book a visit, although it is
recommended to ring for a timed slot t
o see inside the house, Hoglands.
**Admission:** Adults £12, concessions £10.
**Time needed:** 2½ hours

## Getting there

### BY ROAD
• Take M11 to Jct 8, then take the A120
towards Hertford. • Go straight over two
roundabouts and at the third follow signs
for Much Hadham. • After 3 miles, turn left
opposite Great Hadham Golf Course down a
lane signposted to Green Tye (this suddenly
appears around a corner). Cross straight over
the next crossroads. • Go through Green
Tye into Perry Green, bearing left at the
church (the road curves round it). • Continue
for about 1/4 mile to a green with a
telephone box on the left. The Henry Moore
Foundation is signposted on the green.

### BY TRAIN
To Bishop's Stortford then taxi to Perry
Green (approx. 15 minutes). (Trains run
from Liverpool Street Station, London).

## OVERVIEW

Henry Moore (1898–1986) lived at
Perry Green from 1940 until his death
in 1986, and began by moving into
the house, known as Hoglands, and
gradually buying up other bits of land
and buildings as they became available.
In 1977 he gave the estate to the
Foundation. The final estate covered 70
acres with various different studios being
used for specific things. Moore's house
has now been restored and is open to the
public, along with the studios, galleries
and of course the grounds.

Moore is perhaps the most widely exhibi-
ted British sculptor, and all exhibitions
of his work are coordinated from here.
Therefore at any given time certain
pieces may have been loaned out (for
example, the Yorkshire Sculpture Park
always has a few pieces). There are
currently 30 pieces of work here, which
is four more than most exhibitions
feature. The sculpture displays change
annually.

Henry Moore is famous for his large-scale
bronze sculptures, but is less well-known
for his printmaking, drawings, lithography
and textiles. Some of these are displayed
in the recently restored house and
exhibitions are also put on intermittently.
Everything in the grounds has been well
placed to allow lots of space around each
piece, many of the pieces having been
sited by Moore himself.

Hoglands and Top Studio, Perry Green, renovated and restored in 2007. *Photo: Jonty Wilde, The Henry Moore Foundation archive.*

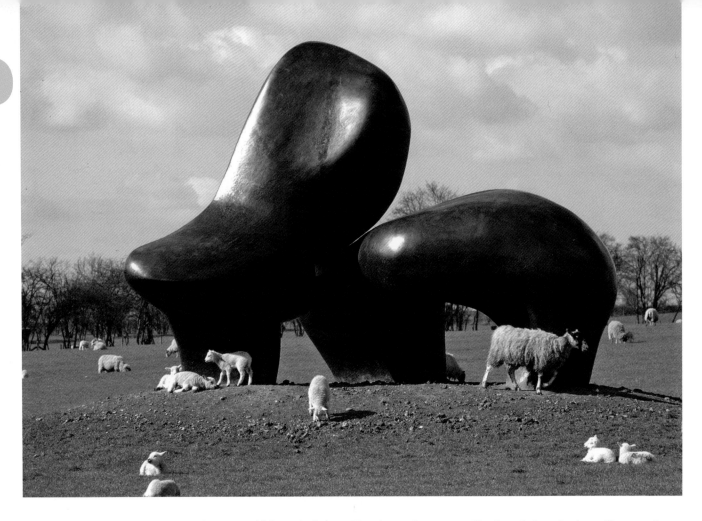

As well as the beautiful and very spacious grounds, the studios remain much as they were left. The Yellow Brick Studio, used by Moore for carving in, now holds several pieces in marble and plaster, and also has a very useful video and models of the lost-wax method of bronze casting for those interested in the technical aspects of his work. The Aisled Barn (a relocated medieval structure) and the Sheep Field Barn are used to display tapestries and changing exhibitions. My personal favourite, however, is the Bourne Maquette Studio,

which was built in 1970 to house the ever-growing collection of natural found objects gathered by Moore over the years, which he used sometimes for inspiration and sometimes as the actual starting point of a maquette. As well as modelling simply in plaster or clay, he would take a small stone or piece of driftwood that suggested a shape to him, and add to it with plaster or clay. For me this fascinating assortment of strange objects gave a clear insight into his work, and seemed more illuminating than many of his drawings.

The Foundation also has a library and archive which serious students can ask to use. Anyone interested can make an appointment in advance with the very helpful librarian, Michael Phipps.

## FINDING YOUR WAY AROUND

The sculptures are all well sited, and the grounds are very carefully maintained (but wear walking shoes, as, depending of the season, a couple of the large pieces are located in a very muddy

field). Much of the land that was not used during Moore's lifetime has now been made accessible to visitors to enable more works to be displayed. The continuous programme of loans to other exhibitions means the map given out to visitors is changed annually. The map numbers the pieces and locates them within the grounds for you, but there is no recommended route for viewing them. It took us about an hour and a half to see everything – although if you want to study the indoor exhibitions more closely and visit the house, it could take much longer.

## THINGS TO SEE

As the sculptures are prone to being moved around, and many have the same or similar names and themes, I have also included the catalogue number (LH number) to make it clear which piece is being discussed. As always with sculpture parks, not everything mentioned will necessarily be on display. Sadly, there is now one piece missing from the collection, *Reclining Figure* (LH 608), which was stolen in December 2005 and has so far not been traced.

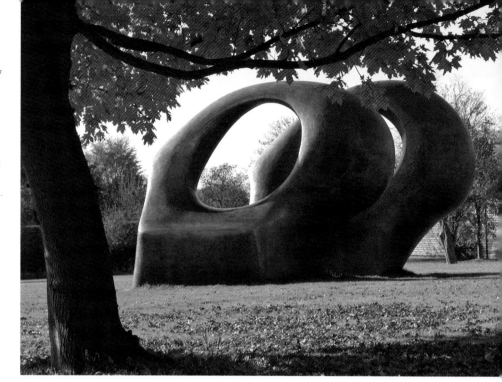

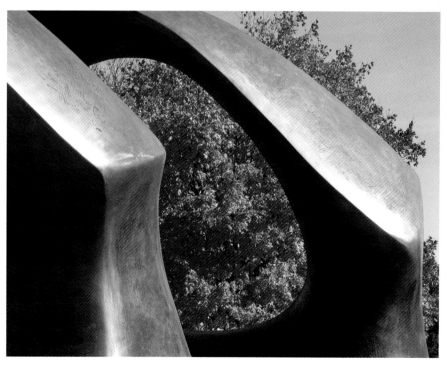

A cast of *Knife Edge Two Piece* (1962–5, LH516) stands outside the Houses of Parliament (this is the original) and is often used as a backdrop by reporters. This piece is particularly striking because the view of it changes radically as you walk around it, so that side on the two pieces seem as if they are very sharp and angular – the knife edge – while straight on they appear wide and flat. It almost looks like two separate sculptures. The careful balance of this large, heavy form with the fine edge forces you to think more closely about the appearance of forms and the nature of three dimensions. Moore chose the site for this work very carefully – it can be seen from the back of Hoglands.

*Double Oval* (1966, LH560) is my current favourite work by Moore. This sculpture is a set of two forms, and one seems to echo the other, although Moore's dislike of symmetry makes them unlikely to be identical. The use of the hole to pierce the form, begun in the 1930s, is here taken to extremes. The sculpture is as much hole as form, opening the forms right up, and the elegant shapes change dramatically as you walk around them.

It is clear from the title what is represented by *Three Piece Sculpture: Vertebrae* (1968, LH580). The inspiration and the forms are obviously organic bones, but having been enlarged so much they lose their natural context and become simply abstract shapes. They work so amazingly well together, however, that walking round you get an ever-changing assortment of forms. The golden colour of the bronze comes from a lacquer intended to weatherproof the surface.

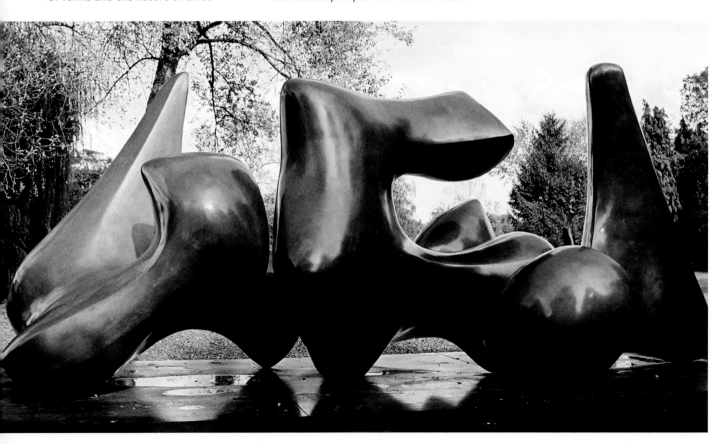

*Goslar Warrior* (1973–74, LH641) was made by Moore as a commission for the town of Goslar in Germany, the result of winning a prestigious art prize. He had made several previous warriors in the 1950s, and had returned to the theme around 1970. Each one has elements of tragedy, defiance and resignation in varied amounts, as they fight or die despite injuries and missing limbs. The warrior figure was thus something he developed gradually over many years, with the result that this one seems to be the resigned summation of all the others. Some of the warriors have a missing arm or a missing leg; this one has no limbs beside the leg that the shield rests against.

*Large Reclining Figure* (LH192b) is located dramatically on top of a hill that looks as if it was built specifically for the purpose, and in fact it was; originally a pyramid of gravel, Moore got a bulldozer to flatten it off, creating the perfect location. This piece was commissioned by the architect I.M. Pei for the Chinese Bank in Singapore. The top half and bottom half are almost separate works – but the arms seem to join and steady the whole piece, drawing it together. This figure was enlarged in 1983 from a tiny maquette made in 1938.

ABOVE LEFT: *Knife Edge Two Piece*, Henry Moore, 1962–5 (LH 516). *Photo: Michael Phipps, reproduced by permission of the Henry Moore Foundation*

ABOVE RIGHT: *The Arch*, Henry Moore, 1969. *Photo by Suzanne Eustace, reproduced by permission of the Henry Moore Foundation*

FAR LEFT: *Three Piece Sculpture: Vertebrae* (detail), 1968. *Photo: Alison Stace, reproduced by permission of the Henry Moore Foundation*

# 20 Hannah Peschar Sculpture Garden

Black & White Cottage, Standon Lane, Ockley, Surrey, RH5 5QR.
Tel: 01306 627269
www.hannahpescharsculpture.com

**Facilities:** None at Hannah Peschar, but some good pubs serving lunch (usually 12–3pm) and coffee in the village of Ockley, so time your visit accordingly.
**Open:** May–Oct, Fri & Sat 11am–6pm, Sun & Bank Hols 2–5pm, Tue–Thu (no concessions) by appointment for groups of four or more; Nov–Apr by appointment only.
**Admission:** Adults £10, children £7, concessions £8.
**Time needed:** 2 hours

## Getting there

### BY ROAD
Take A24 (which runs from near Worthing up to Ewell), and at Beare Green turn onto the A29 towards Ockley. At Ockley, turn into Cathill Lane by The Old School House pub, then turn left at the end into Standon Lane. Once over the bridge, the entrance is on your right. Pay close attention in order to spot the green sign against the green trees.

### BY TRAIN
Ockley train station then 10 mins by taxi (NB: Ockley station shut on sundays).

*FisherMan (Blue)*, Christopher Marvel, exhibited in 2012. Bronze, oak plinth, mild steel base. *Photo: courtesy of Hannah Peschar Sculpture Garden*

## OVERVIEW

This gorgeous garden is amongst the most established and renowned of the sculpture gardens, its beautifully arranged grounds matched by a high standard of sculpture. The varied selection of work has been carefully positioned to bring out the best in both sculpture and surroundings. It operates as an outdoor gallery, with exhibits for sale, so work is always changing.

The garden started life as part of an estate laid out between 1915 and 1920, which was later sold off in parts. Hannah Peschar bought a neglected 10-acre section of the original garden, including the 15th-century cottage, and over the last 24 years the garden has been redesigned and gradually nurtured back to life by landscape designer Anthony Paul. The twisting moss-covered paths lead you through wooded areas and alongside the many ponds, which are fringed by unusual giant-leaved plants and colourful flowers. A fairytale ambience pervades this garden, with its little wooden bridges across the ponds, hidden paths and clearings, and Hansel and Gretel-style tiny wooden lodges tucked away amongst the trees.

## FINDING YOUR WAY AROUND

A leaflet with small pictures, which you can get at reception, guides you around every sculpture in the garden, giving instructions on where to turn and which path to follow. The images help you to orientate yourself if you lose the thread.

The garden at first glance looks quite small, but this is deceptive, as the paths weave their way into hidden areas which continually open out and lead on to further spaces – allow a couple of hours.

## THINGS TO SEE

Hannah Peschar operates as an outdoor gallery, meaning work comes and goes and moves around. The following pieces are simply current ones, though featured artists will often replace work sold with something similar.

Hannah Peschar always has a good range of work, but some of the things it often shows well include glass and figurative pieces. Recent pieces included Rick Kirby's *Torso*, made from steel coins, which means that while the form is clearly defined you can also see through it to the space inside. He often works in this way, but this is more fragmented than many of his usual figures. He also has a very large piece of work here, entitled *Broadside*, also made from steel with an orange hue that is very striking in the green surroundings. This enormous mask is hollow, its empty eyes allowing glimpses of sky and greenery to peak through, giving you the eerie feeling of a giant's death mask. Emily Young has exhibited many fabulous heads here in the past, and currently has *Sienna Torso*, a piece that combines simplicity of form with the striking colour of the marble. Pat Volk's very calm and angular ceramic

*Enceladus Fossa: Alpha, Beta, Gamma, Delta,* Sarah Blood, exhibited in 2012. Redwood. *Photo: courtesy of Hannah Peschar Sculpture Garden*

heads were also featured, as well as Jilly Sutton's very melancholic bronze ones.

Amongst the more organic forms shown were some of Walter Bailey's pieces. He often has work here as one of the featured artists; in the past he has shown *Journey's Work*, an enormous sculpture of figures weaving their way through standing monolithic oak slices with intermittent holes. More recently his work shown here has featured *My House Has Many Chambers*, with a very atmospheric and melancholy figure with square holes cut out of it and the gorgeous grain of the wood very clear. Also shown recently was *On Stream*, with the same recognisable curving and

**ABOVE:** *My House Has Many Chambers*, Walter Bailey, exhibited in 2012. Redwood. *Photo: courtesy of Hannah Peschar Sculpture Garden*

**LEFT:** *Broadside*, Rick Kirby. Mild steel. *Photo: courtesy of Hannah Peschar Sculpture Garden*

**RIGHT TOP:** *Wind*, Yke Prins, exhibited in 2012. Bronze, anröchte chalkstone. *Photo: courtesy of Hannah Peschar Sculpture Garden*

**FAR RIGHT:** *Silent Figure*, Yke Prins, exhibited 2012. Bronze, edition 3 of 7. *Photo: courtesy of Hannah Peschar Sculpture Garden*

undulating shapes to it, but in a more abstract fashion. In harmony with its surroundings, stands Howard Boycott's *Into The Mountain*, appearing as if an entrance in Welsh slate, it has a tomb-like quality to it. In total contrast, Rebecca Newnham's various *Pollen* forms are very spikey and striking, large and colourful interpretations of this natural material.

Amongst other individual works were Gail Olding's brilliant piece, *A Long Way Down*, this is a table and chair on incredibly tall, thin and spindly legs, looking as if it has fallen from Alice in Wonderland. Somehow it fits in well with the garden's overall feel. In a very different and unique style is Xandrien Thiel's *Two Women and a Man*, abstract works in mild steel, while

Julianne Long has created *Ice*, suspended in a tree from an intriguing assortment of recycled materials including fishing-line, CDs, plastic tubing and cable ties.

The temporary exhibition for the summer of 2012 focused on the work of Yke Prins, a noted Dutch sculptor, with many abstract bronze forms from a strong body of work that gave a good overall feel for his style.

The work here does change so obviously things may not still be there at the time of visiting, but the work is always very good and varied, and there is never a shortage of beautiful and interesting things to see.

# 21  The Sculpture Park

Jumps Rd, Churt, Farnham, Surrey,
GU10 2LE.
Tel: 01428 605453
www.thesculpturepark.com

**Facilities:** None in the park, though the Pride of the Valley Inn opposite serves good food, and has a nice beer garden. The entrance to the sculpture park is through the small gate just opposite the pub, but the reception is a large wooden shed situated a little way inside the park (follow the small signposts).
**Open:** Daily, 10am–5pm.
**Admission:** Adults £6, children & senior citizens £3, under 5s free.
**Time needed:** 2–3 hours

## Getting there

Finding this park was a little tricky – but provided you are on the A287 and ask for Churt if lost, you can't go far wrong.

### BY ROAD

From the direction of Hindhead on the A287, which runs between Farnham and Hindhead, turn right onto Jumps Road after the shop Miscellanea – the shop is easy to miss, but is on your right after the crossroads at the Devil's Punchbowl. At the end of Jumps Road, turn left into Tilford Road. On the corner is the park, conveniently located opposite the Pride of the Valley Inn.

From Farnham direction, again on the A287, just after you pass Frensham Great Pond and Pond Lane on your right, turn left onto Jumps Road. (If you miss this turning and find yourself on Old Brick Kiln Lane, driving to the end of this road and turning right will bring you onto Jumps Road.) At the end of Jumps Road, turn left into Tilford Road. On the corner is the park, opposite the Pride of the Valley Inn.

### BY TRAIN

Farnham station and 10–15 minutes by taxi.

## OVERVIEW

Eddie Powell, an artist himself, opened this park in 2003, and runs it as a business, along with the help of his gardener/technician and handyman Nick. Previously it was called The Pride of The Valley Sculpture Park. Most work is for sale, although some pieces are permanent. The areas in the park vary a great deal: some open spaces have enormous pieces while other paths and terraced areas have lots of smaller sculptures. In a similar way to the Hannah Peschar Sculpture Garden, this park looks deceptively small yet continuously opens out into bigger areas. The gardens have recently undergone more landscaping, and some areas are now much more considered while other parts have been left wilder and more natural. The recently planted island now displays a colourful work (powder-coated stainless steel) by Thomas Joynes, entitled *Flight*, while bronze hippos by Rupert Merton cavort in the lake behind. There are small paths around the lake, winding through enormous bushes, over ponds, into wooded areas and up bankings, often going back and forth through an area so that you see the same piece from the back as you go past again. There are sculptures everywhere (at the last visit 184), and often the sheer quantity of the work combined with all the vegetation around is a bit overwhelming, making it hard to concentrate on individual pieces. As my friend commented, it was a bit like going through someone's cluttered attic and finding treasures amongst everything. However, although a bit too crowded for me, this is also part of its appeal – the sculptures vary massively in style and are tucked away everywhere you look. There is certainly something to suit every taste, and the materials used also vary greatly, to include bronze, glass, wood, stone, even wax. The variety of work will certainly keep children entertained while exploring – but remember to keep them under supervision.

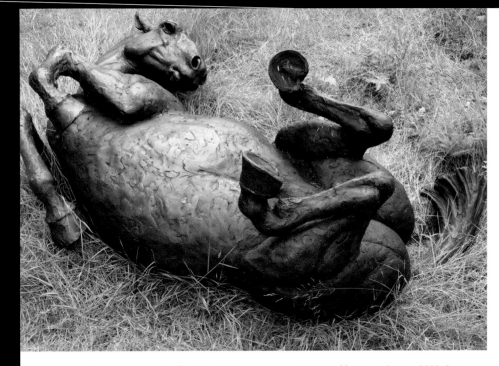

ABOVE: *Rolling Horse*, Lucy Kinsella, 2004. Bronze.
Photo: Eddie Powell/The Sculpture Park

RIGHT: *Two Worlds*, Martyn Barrett, 2002. Stone.
Photo: Eddie Powell/The Sculpture Park

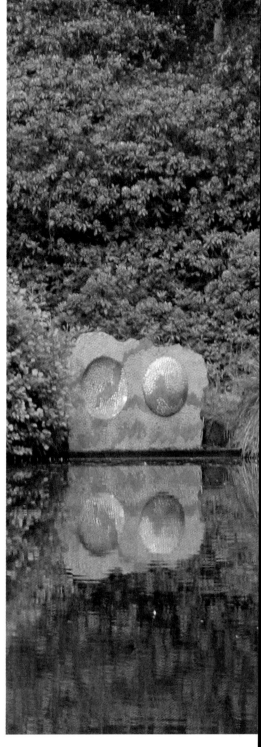

The park is big enough to house many enormous pieces of work, and if you like your sculptures big, then this is the place for you. But make sure, if you want to see everything, that you have the time and energy to devote to the search. Alternatively, if you are just interested in a nice day out, then a random stroll looking at whatever catches your eye would be an approach well suited to this park. Eddie Powell says with dramatic finality, 'The park is now full', and then undermines himself by promptly following it up with 'unless it's a really good one'. So having filled his seven acres he is now (trying) to be much more rigorous in selecting new pieces. Work changes as pieces are sold. Eddie was also involved in sourcing a variety of great pieces for the

Olympic Village in 2012, amongst them *The Diver* by Jill Berelowitz and Halliday Avray-Wilson's *Running Man*, where the negative space from the block is the sculpture.

## FINDING YOUR WAY AROUND

The trail is about a mile and a half, and takes most people 2–3 hours, but as always this depends on the speed you walk at and how many things you stop to look at properly. The park has printed directions to help you navigate the paths, and a colour-coded system has been worked out according to the length of route and the time it will take to go round. Different coloured wiggly arrows point the way depending on which

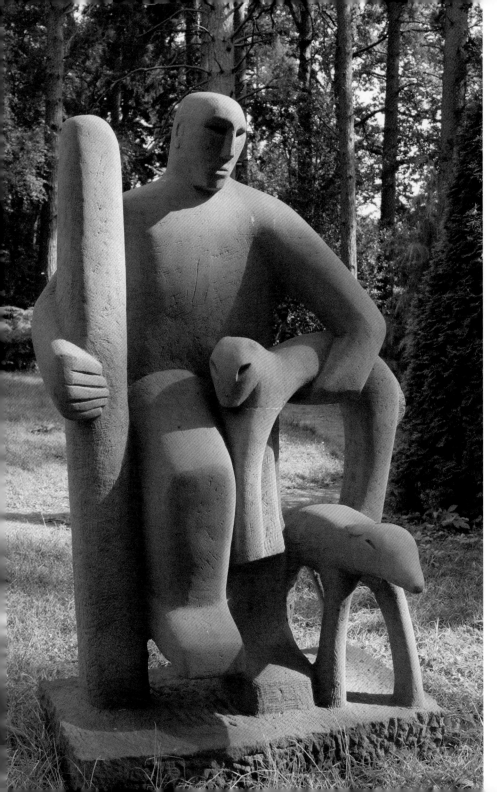

route you follow. It works quite well providing you keep a close eye on which way you are going. Broadly speaking, the yellow and red routes take you around the perimeter, while the blue and green routes are the inside of the park. The yellow and red arrows eventually bring you back past the reception part-way through anyhow, so if you are short of time you can always stop at this point.

## THINGS TO SEE

There is so much to see at this park that it's hard to narrow down the list to just a few pieces. However, in the biggest part of the park, in the grassy open area, there are some larger-than-life sculptures, which dominate the space and are worth visiting.

There are several artists who exhibit here regularly whose work is worth looking out for, amongst them Lucy Kinsella, known for her animal sculptures, who has shown in the past a rolling horse, gorilla, baboon and fighting hares, and will nearly always have something in the park. Sophie Dickens has in the past shown a series of cartwheeling figures in the open grassy area, but now has four figures climbing some trees instead, which are harder to spot as they blend in well. Also in this area are *The Four Horses of the Apocalypse* by Anthony Haywood, a superbly inventive piece made out of recycled materials – including everything from old dolls and telephones to plastic bottles. I thought these were great – though sadly they have needed repairs after being eroded by unruly children.

*The Cork Eagle* by Robert Bradford, hidden amongst the trees on a hillside, is quite an astounding size, although not one of the best pieces. It was commissioned by the RSPB to draw attention to the fact that the wine industry is switching over to plastic corks. The cork forests in Spain are also the habitat of eagles and other creatures and with the decline of traditional wine-bottle corks these are now in danger (as many were planted to harvest corks). On close inspection you can see that the bird's underside is constructed from hundreds of corks attached to a steel framework.

Near the start of the park is another giant piece, an enormous *Spider* by Wilfred Pritchard, made from flat pieces of metal, interlocked, which manage to enthral and menace simultaneously.

On the lake are the very vivid and eye-catching *Speed Skaters*, which have the look of cartoon characters; they are very cleverly weighted down just enough to be caught by the wind and are thus constantly moving across the water, appearing to skate. The mournful-looking *Dame Kind*, by Sean Crampton, holds her arm out for a bird of prey and is both expressive and considered. In short, there is enough here to offer something for everyone.

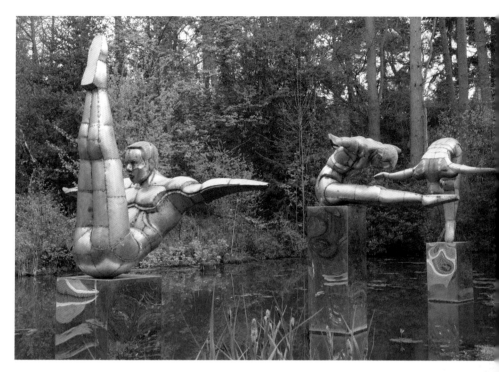

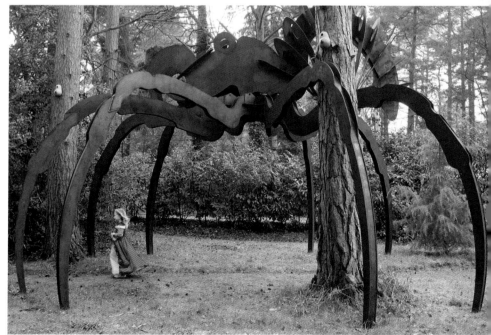

....................................................................................

FAR LEFT: *Shepherd*, Richard Laurence, 2007. Forest of Dean stone. *Photo: courtesy of The Sculpture Park*

TOP RIGHT: *Divers*, Nicholas Ruffe, 2008. Stainless steel. *Photo: courtesy of The Sculpture Park*

RIGHT: *Giant Tarantula*, Wilfred Pritchard, 2005. Cor-Ten™ steel. *Photo: courtesy of The Sculpture Park*

# 22 Sculpture Trail at Pangolin London

Pangolin London
Kings Place, 90 York Way
London N1 9AG
Tel: 0207 520 1480
www.pangolinlondon.com

**Facilities:** Toilets and café within Kings Place
**Open:** Tue–Sat, 10am–6pm, Mon by appointment only, closed between exhibitions (check website for details).
**Admission:** Free

## Getting there

### BY CAR
It can be found on the A5200 (York Way), which leads in from Tufnell Park (from the north), or turn onto it from Euston Road/Pentonville Rd (A501).

### BY PUBLIC TRANSPORT
A much easier option: come out from King's Cross main station and turn left and left again onto York Way. Kings Place is 5 min walk up the road on your right, in a glass-fronted building.

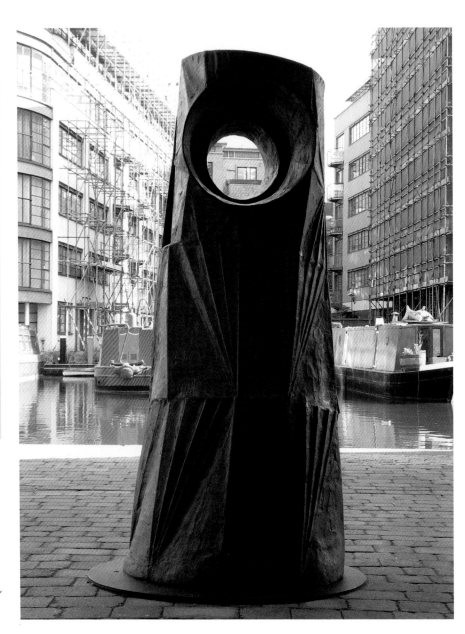

RIGHT: *Monitor*, Lynn Chadwick, 1965. Bronze, edition (unknown) of 4, height: 180 cm (71 in.). *Photo: courtesy of Steve Russell/Pangolin London*

OPPOSITE, TOP: *Monumental Avian Form*, Terence Coventry. Powder coated steel, unique, height: 133 cm (52½ in.). *Photo: courtesy of Steve Russell /Pangolin London*

FAR RIGHT: *Dark Line*, Ann Christopher, 1985. Bronze, edition (unknown) of 3, height: 113 cm (44½ in.). *Photo: courtesy of Steve Russell/Pangolin London*

## OVERVIEW

Pangolin London is a gallery in the large glass-fronted complex of Kings Place at King's Cross in London. The sculpture is located at the back of the building, alongside the canal. This very prestigious gallery has a changing schedule of exhibitions indoors, while the sculpture outside also changes from time to time.

The collection of sculpture is always fantastic, an unexpected find in a busy part of London where space is at a premium. The works on display represent an assortment from the cream of the sculpture world, and feature some very well-known names as well as newer artists; Lynn Chadwick, William Pye, Anthony Abrahams, Peter Randall-Page, Ralph Brown and William Tucker were among those on display. The works are spread out beside the canal behind the gallery, beside the water and canal boats of the picturesque harbour area, while at the edge of Kings Place people sit having lunch.

The gallery is linked with Pangolin Editions, a well-known foundry, and there is also a resident artist working with the gallery. Set up in 2008, the Pangolin has a great reputation and a fabulous collection of sculpture to see.

## FINDING YOUR WAY AROUND

Public transport is recommended over driving to the Pangolin, as parking in King's Cross is nigh on impossible without

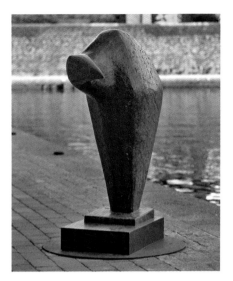

going much further afield and walking back. York Way is literally round the corner from King's Cross station (see details in the information box). The works themselves are set around the back of the building and are all located right by the canal so you cannot get lost. Ask for the trail map and sculpture list from the gallery.

## THINGS TO SEE

Obviously the work changes, so there is no way of knowing exactly what will be there at the time of visiting, although they do draw on work by a stable group of artists. Amongst the pieces that stood out when I visited were *Diamond* by Lynn Chadwick, whose seated couple in Chadwick's distinctive angular style seemed bizarrely suited to their location beside the canal. *Man with Raised Arm* by Anthony Abrahams is strangely fascinating and unsettling at the same time: a raised arm he might have, but it's his only limb.

William Tucker's *Greek Horse* is a large horse's head at a strange angle, which appears as if severed at the neck and set at this angle as a threat. Ralph Brown's *Ox-Carriers* show every lump, bump and detail of their original modelling, giving a fantastic impression of a live sculpture and a great sense of movement as the two figures lug the heavy carcass. Even in bronze it is somehow dramatically gruesome. There were many others that caught my eye, but the best thing is to go and see the current work for yourself.

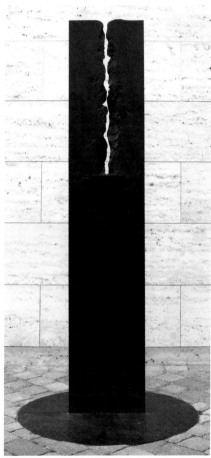

# 23 Cass Sculpture Foundation

Sculpture Estate, Goodwood
West Sussex, PO18 0QP.
Tel: 01243 538 449
www.sculpture.org.uk

**Facilities:** Unexpectedly for such a large
and high-profile park, there are no facilities
other than some toilets in the deer hut
(about halfway round), but as always
several trusty British pubs serving food can
be found in nearby villages.
**Open:** Apr–end Oct, Tue–Sun (& Bank
Holiday Mondays), 10.30am–4.30pm.
**Admission:** Adults £10, children under 12
half-price, children under 5 free (separate
conditions for school groups).
**Time needed:** 2½ hours

## Getting there

### BY ROAD
The estate is well signposted, so if in
doubt follow brown signs to Goodwood
House until you see signs for Sculpture at
Goodwood.

**From the north**, take the A3 south, and
turn left onto the A283 to Petworth. • At
Petworth take the A285 towards Chichester.
• After going through Duncton, turn right
towards Goodwood racecourse/Singleton
and follow the road for about 2 miles until
you reach a small crossroads. Turn left
between two lodge gates, and the sculpture
estate is 1 mile down the road on the left.

**From the south**, take the A285 towards
Petworth, follow signs to Goodwood Motor
Circuit, and after passing it on your left,
at the next roundabout take the third exit
for the Marriott Hotel (ignore signs to the
racecourse here). • Take the next left and
follow the road past the hotel up the hill.
The sculpture estate is on the right.

### BY TRAIN
Take the Portsmouth Harbour/Bognor Regis
line to Barnham (trains run from Victoria,
London), or a train on the Brighton/
Portsmouth line to Barnham. From Barnham
station it's about 10 mins by taxi.

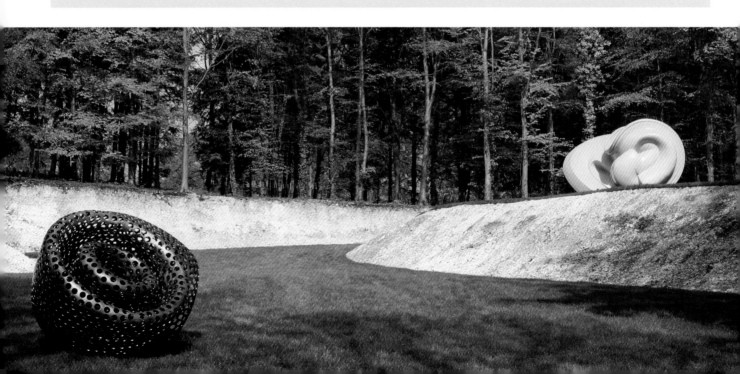

## OVERVIEW

Goodwood is one of the very well-known, high-profile sculpture parks. It is very well maintained and run to an impressively high level of efficiency. The Foundation is a registered charity, set up specifically to promote and exhibit British sculpture. The extensive grounds are home to a vast number of large and impressive sculptures by well-known sculptors. The idea is to engage the public and display works for public viewing, although works are also sold or loaned out on a part-time basis. As with most parks, the work does change, opening up space for new commissions. Goodwood is one of the best places to go to see work by the most prominent and established artists (along with Yorkshire Sculpture Park and Roche Court). One whole area has been devoted just to Tony Cragg in the largest exhibition of his outdoor work so far. Each piece is perfectly positioned in the landscaped grounds to show it at its best.

The Foundation is currently in a stage of major change, with various things happening behind the scenes. Involved in the cultural Olympiad excitement, Cass Sculpture Foundation helped place five Tony Cragg works along Exhibition Road in London in 2012 as well as in various museums. They are also getting involved in several new international partnerships with other cultural institutions, new sculpture parks in both India and China, using their expertise to commission 60 new works, which will be situated in the new Yellow River Arts Center development in China

OPPOSITE: *Tongue in Cheek*, Tony Cragg, 2002. Bronze. *Declination*, Tony Cragg, 2005. Yellow bronze. *Photos: courtesy of Cass Sculpture Foundation*

*The Return*, Rodney Bender, 2012. *Photo: Katie Martin, courtesy of Cass Sculpture Foundation, Goodwood*

and India. One of these new partnerships is with the State Hermitage Museum in Russia, which is also launching new galleries with a Tony Cragg work.

On arrival, head for the large reception and visitors' gallery, to pay admission and be given a guide to the sculptures on show in the park. The gallery was designed by award-winning architects Studio

Downie, who also designed the impressive Foundation Centre in the heart of the park, though this is not open to the public.

## FINDING YOUR WAY AROUND

The estate is very large, with many open areas, although much of the park is located in wooded areas which provided a shady relief on the scorching-hot

ABOVE: *Sketch of a Blue Whale*, David Brooks, 2012. Enlarged to scale 23m/75 ft, 154 tonnes. *Photo: Katie Martin, courtesy of Cass Sculpture Foundation*

ABOVE RIGHT: *Fish on a Bicycle*, Steven Gregory, 1998. Bronze. *Photo: courtesy of Cass Sculpture Foundation*

OPPOSITE: *Regardless of History*, Bill Woodrow, 2000. Bronze. *Photo: courtesy of Cass Sculpture Foundation*

day we visited. It took us about 2½ hours to see everything (approx. 70 sculptures), though this did involve a certain amount of backtracking to reach a hidden piece (as per the instructions), so nothing was missed. Goodwood uses a set of instructions combined with colour images of all the works to guide you round the park (the same system as at Hannah Peschar), which works very well. It helps to see what you are looking for next and, if you stray from the directions, to locate yourself again by the images of work. When things become more confused in the woods towards the

end (with sculptures listed as 'through the trees' and paths leading off in every direction), a bright-yellow wiggly arrow stuck in the ground often points you in the right direction. But be warned – in the woods towards the end of the sculpture park route, some of the paths lead up to the private house and are barred only by a few small signs. On the day we visited some unfortunate visitors overlooked the signs and set off a very loud alarm, causing Foundation staff to come scurrying.

# THINGS TO SEE

The standard of work at Goodwood is very high, and it is hard not to appreciate the thought and careful creation of most pieces even if you don't personally like them all, and there is always plenty to see.

Directly in front of the visitors' gallery, *Scylla II*, by William Pye, I found utterly captivating. An incredibly simple combination of an acrylic tube filled with water and a twisting mechanism at the bottom, the effect was a speeded-up process of water wanting to drain down a plughole, but, not being able to escape, squeezing upwards into an ever-tighter rising spiral.

Amongst the most recent pieces on display is work by Eilís O'Connell, with a series of twisting and curving white forms, soft and undulating they almost appear to melt in places. These forms are O'Connell exploring various aspects of the relationship between nature and society, or as the foundation puts it, 'a society that clips its gardens, is one which values repression and control, whereas, a society that permits unrestrained growth is one that values freedom and liberty. Stem's production grew out of O'Connell's appreciation of the latter.' The form evolved from a sprouting onion which O'Connell found fascinating in its expression of growth and vitality, so she cast the onion in plaster, and so began the start of the series. Bill Woodrow's enormous *Regardless of History* shows a huge metal tree growing over and out of a giant pile of books and the suggestive

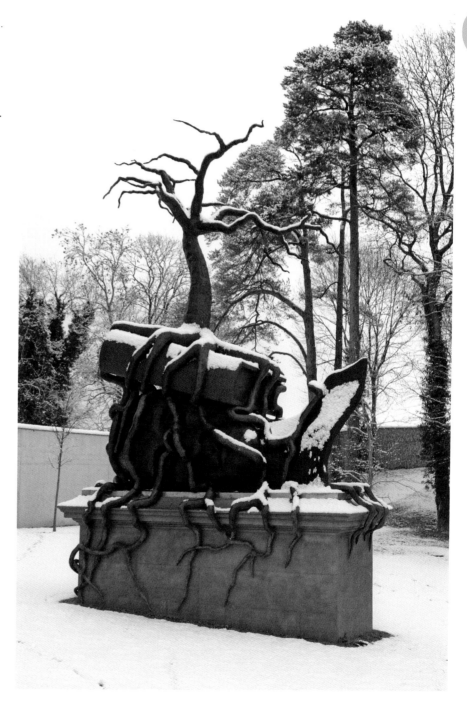

form of a tomb (actually a reproduction of its original Trafalgar Square plinth), conveying the message that time and nature neither wait nor care for any man.

One of the hazards of sculpture parks is that things change and move about. However, though there may be a couple of disappointments, these are usually swept aside by some unexpected discoveries. A large area has been put aside for Tony Cragg, which certainly does not disappoint. The area has been carefully landscaped to show various sculptures at their best. My favourites were two carved and twisting sculptures, *Here Today Gone Tomorrow* and *Bent of Mind*. *Here Today Gone Tomorrow* consists of two columns made of stone whose haunting, unbalanced forms seem to have been naturally formed by a sandstorm. Eerie faces appear and disappear as you get closer or walk around the twisting columns. *Bent of Mind* is a bronze in the same style,

but this one piece has two faces on opposite sides, whose misshapen features look like nature's true forms trying to escape from the metal. Further along the path leading out of this area is Cragg's *Tongue in Cheek*, a bronze form with pierced walls, which offers a teasing play on words and ideas, as the shapes turn themselves inside out and fit one inside the other.

There were a couple of interactive pieces that really engaged us: Gavin Turk's *Golden Thread*, an aluminium and glass maze, which you walk through seeing both your own reflected image in the glass and at the same time (in the summer) a beautiful field of poppies beyond; and William Furlong's visually unassuming *Walls of Sound*, towards the end of the park, more aural experience than aesthetic object. Made up of two walls of steel, the piece invites you to walk along the narrow alley between

them while sounds of a tropical jungle are played along with some faint music. The effect is brilliant, and ties in really well with the surroundings, as all you can see are the walls and the trees overhead.

Steven Gregory has several sculptures in the park, but for me the most impressive of his works was the *Samurai Warrior*, an amazing bronze which looks like a cross between origami and a shadow puppet. The whole figure seems to have been cut out of a giant piece of bronze sheeting, and then rearranged and pushed through to make it 3D. It simply has to be seen to be comprehended.

Other large-scale works to mention, among many, include Stephen Cox's *Granite Catamarans on a Granite Wave*, which genuinely captures the sense of movement of boats at sea – impressive for something made of granite.

Towards the end was Peter Burke's *Register*, a large collection of seemingly rusted hands, which had unnerving associations with Auschwitz and was both eerie and moving.

Finally, not to be missed is Sean Henry's *Lying Man*, resting on its own specially built mound of earth. Unusually made of bronze painted with oils, this fantastically realistic and larger-than-life sculpture seems perfectly at home.

# 24 'Art in the Garden' at Sir Harold Hillier's Gardens

Jermyns Lane, Ampfield, Romsey,
Hampshire, SO51 0QA.
Tel: 01794 369 317
www.hants.gov.uk/hiliergardens/
artinthegarden.htm

**Open:** May–end Oct (check for exact
dates), 10am–6pm daily.
**Facilities:** Toilets, two cafés, educational
events.
**Admission:** Adults £8.95, concessions
£7.95, children (under 16) free.
**Time needed:** 3–4 hours (to see everything)

## Getting there

### BY ROAD
From the M3, at Jct 11 take the A3090 past
Hursley and Ampfield towards Romsey,
then look for a right turn (follow the brown
signposts).

### OR
From the M27, take Jct 3 onto the A3057
towards Romsey, turn right onto the
A3090, then look for a left turn (follow
brown signposts).

### BY TRAIN
From Romsey station take a taxi (approx.
10 mins), or bus 32/33, which stops in
Braishfield Rd (10 min walk), or bus 35
(Wilts & Dorset Bus Company) which will
stop in Braishfield Rd on request.

## OVERVIEW

'Art in the Garden' at Sir Harold Hillier
Gardens, now in its fourteenth year, is
an interesting collaboration between
the gardens and Underground Art &
Design, who use the fantastic location as
a venue for an annual selling exhibition.
The enterprise is supported by Hampshire
County Council and various commercial
sponsors. The extensive gardens (180
acres) were begun in 1953 when Sir
Harold and his family moved into
Jermyn's House. In 1977 Hillier gave
the arboretum to Hampshire County
Council to be used as a charitable trust.
The sculptures are spread out across the
beautifully kept gardens and land, which
varies enormously as you go round, and
includes fields with wild grass, a formal
and carefully planted 'winter garden' with
winding paths, a large pond, an avenue
of magnolias, and the centenary border
– a grass walk with a very tidy array of
colourful plants and flowers on either
side. Sculptures are also to be found on

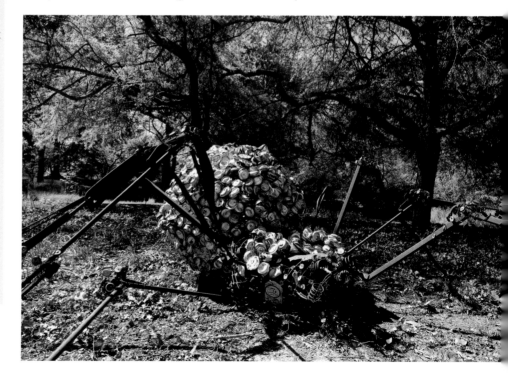

*Giant Spider*, Fiona Campbell, 2012 exhibition.
Mixed media. *Photo: Nigel Barker, courtesy of
Harold Hillier Gardens*

the vista, a large and open area sloping downhill, offering lovely views. In all this abundance there are some 100 sculptures – and even though this is less than in some past shows it's still a challenge to find all of them in one visit. There is a printed list of artists and their work, but the sculptures are not located on the map, which in any case is a challenge to follow. There is no set route, although occasionally a small sign will point you onwards, and the list does include an area code to help you navigate (for example, OF is Oak Field). But you are unlikely to see everything in one visit, so resign yourself to a giant sculpture treasure hunt. Some works are large pieces located in the oak field, which involves a fair amount of walking, while at other times you can find many small works hidden together in flowerbeds. Allow three to four hours to see as much as you can, depending on your speed, and leave extra time for refreshments at the very modern reception building or, better still, have tea on the lawn at the attractive Jermyn's House.

## THINGS TO SEE

The show is curated by Elizabeth Hodgson of Underground Art & Design, a non-profit organisation aimed at promoting artists. Overall, the work here is very modern, using a wide variety of media. (including wood, glass, recycled materials, cold-cast bronze, stainless steel, ceramics and marble resin). The exhibition in 2012 had a great many more plants and animals than some years, but this is befitting of such large and varied gardens. About 100 sculptures by 29 different artists are placed in the water, under trees or semi-hidden in flowerbeds.

A large assortment of fantastic steel plants seemed to creep into the smaller areas, while ducks, swans and toucans hid amongst the bushes and lakes. Elsewhere, still nude figures sat under trees or even waded quietly through the rushes in the water. Under the trees a giant spider by Fiona Campbell stalked, tightly covered with an assortment of recycled waste such as tin cans and old cartons. This exhibition often had several pieces by each artist, (such as Steve Blaylock) with his gorgeous *Agapanthus* and *Bullrushes and Dragonflies*, meanwhile Cheryl Howeld's *Spiral of Gulls* rotate upwards towards the sky, and cast lovely reflections on the water.

Ian Marlow was a featured artist, with several pieces, amongst them a very tall plant form entitled *Empowered*, which stood directly in view of Jermyn's House, as well as a very nice sculpture of a lily which appeared to float on the water.

All in all, a comprehensive collection from a wide range of both established and up-and-coming artists.

ABOVE: *Pebble*, David Smith, 2012 exhibition. Wood. *Photo: Nigel Barker, courtesy of Harold Hillier Gardens*

OPPOSITE, TOP LEFT: *Spiral of Gulls* by Cheryl Howeld, 2012 exhibition. *Photo: courtesy of Underground Art & Design*

TOP RIGHT: *Lily*, Ian Marlow, 2012 exhibition. Steel. *Photo: Nigel Barker, courtesy of Harold Hillier Gardens*

CENTRE: *The Only Way is Up*, Ian Marlow, 2012 exhibition. Glass and steel. *Photo: Nigel Barker, courtesy of Harold Hillier Gardens*

BOTTOM LEFT: *Landing Ducks*, Diccon Dadey, 2012 exhibition. Rusted steel. *Photo: Nigel Barker, courtesy of Harold Hillier Gardens*

BOTTOM RIGHT: *Toucan*, David Cooke, 2012 exhibition. *Photo: Nigel Barker, courtesy of Harold Hillier Gardens*

'Art in the Garden' at Sir Harold Hillier's Gardens  **101**

# 25 The Grove

## OVERVIEW

This fabulous sculpture show is set in the well-maintained grounds of a 5-star hotel, with manicured lawns, formal gardens, ponds and a huge field area used for helicopter landings amongst other things. There are two lovely restaurants so some of the areas are given over to outside dining (although prices do not encourage an impromptu lunch, one is very formal and gets very busy so book ahead, while the stables restaurant is a little more casual). The grounds are lovely and a walk around them is enjoyable regardless of the artwork. The brothers that own the hotel are very interested in art and indeed there are many pieces within the hotel itself, so the sculpture exhibition is a new extension of that interest.

The first exhibition, in 2012, was curated by an art organisation called Art Contact on behalf of the hotel. The standard of work was very high, and in honour of the Olympics themed around the idea of 'Expressions of Movement'. As a result, there were many figurative and dynamic pieces this time around – figures running, jumping, diving and even fencing, and even one that mimicked Usain Bolt's trademark stance. In the main, each piece had been carefully placed to make the best of its situation in the grounds, either framed by a view or leading you around

the grounds. Both *Pont de Lune*, by Pierre Diamontopoulo, and *Commitment*, by Mike Speller, exhibited perfect symmetry and were aligned to look down the straight lines of the pond.

## FINDING YOUR WAY AROUND

Ask at reception for the leaflet including a map of the gardens with all the work marked on it. In fact, the map is a very schematic representation and was not a great help, but the numbered list is useful as neither titles of works nor artists' names were marked on the plinths. There is no set route, so the simplest approach is just to wander round. The area is contained enough that you can't get lost, and there is work to see at every turn, though, confusingly, some pieces are permanent and therefore not listed.

## THINGS TO SEE

Several artists had a few pieces of work here and some names certainly stood out, such as Rick Kirby, Stephen Charlton, Dorothy Brook, and Pierre Diamontopoulo with several very pared down, white action-packed figures. Amongst these were a couple that really jumped out at you: *Funky Run* located outside the hotel, has a white figure

London's Country Estate,
Chandler's Cross,
Hertfordshire, WD3 4TG
Tel: 01923 807807
www.thegrove.co.uk

**Facilities:** Restaurants, toilets
**Open:** May–Sep (most likely as a biennial, check website for details)
**Admission:** Free
**Time needed:** 1–1½ hrs

## Getting there

### BY CAR
Sat nav users should use postcode WD17 3NL. From the M25 (clockwise): Leave at Junction 19, following the signs to Watford. At the first large roundabout take the third exit (A411 towards Watford). After half a mile, you'll see the entrance to The Grove on your right-hand side. From the M25 (anti-clockwise): Leave at Junction 20, following the signs to Watford. At the first large roundabout take the second exit (A411 towards Watford). After half a mile, you'll see the entrance to The Grove on your right-hand side.

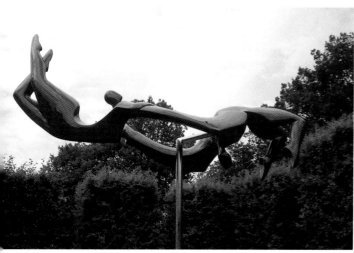

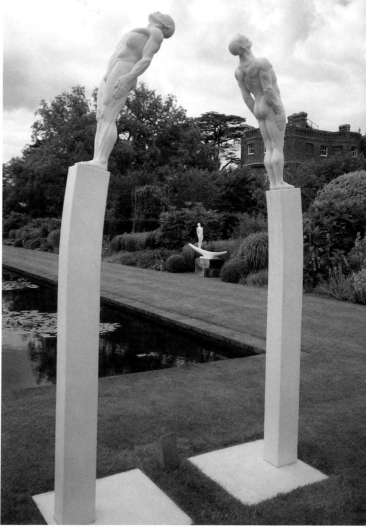

TOP LEFT: *Mouse On A Ball*, Stephen Charlton, exhibited 2012. *Photo: Christian Trampenau, courtesy of The Grove & Art Contact*

TOP, CENTRE: *Pin Ball Wizz*, Pierre Diamantopoulo, exhibited in 2012. *Photo: Alison Stace, by permission of The Grove & Art Contact*

ABOVE: *Caught in Time*, Dorothy Brook, exhibited in 2012. *Photo: Alison Stace, by permission of The Grove & Art Contact*

RIGHT: *Pont de Lune*, Pierre Diamantopoulo, exhibited in 2012. *Photo: Alison Stace, by permission of The Grove & Art Contact*

running through and over black blocks as they leap and tumble around him, while *Pin Ball Wizz* has a figure gripping onto large colourful balls which are also supporting his body. But there is no relaxing here: every muscle is taut with action. Dorothy Brook's *Caught in Time*, two red angular figures holding hands while one swings up and the other down, does exactly what it says; the action is caught mid-swing at the point where they are in perfect balance. Her *Ready Steady Go* was also very engaging, the three figures at various stages of readiness – a satisfying shape to each form, with each complimenting the others well. Overall it was a great exhibition in attractive surroundings and is certainly one to look for if you are in the area. The plan going forward is to make the show a biennial, so check the website for details of future events.

# 26  Stour Valley Arts in King's Wood

King's Wood, Challock, Kent

**Information only:**
Stour Valley Arts, King's Wood Forest studio,
Buck Street, Challock, Kent, TN25 4AR
Tel: 01233 664987
www.stourvalleyarts.org

**Facilities:** None, but there is a nice pub with a garden called the Halfway House at Challock.
**Open:** All year. Gallery in Ashford open (Elwick House, Elwick Rd, TN23 INR) 11am–5pm, Wed–Sat, during exhibitions.
**Admission:** Free
**Time needed:** 2½ hours

## Getting there

**BY ROAD**
Exit the M20 at Jct 8 onto the A20 towards Harrietsham. At Challock turn right at the crossroads onto the A251, then first left (signposted King's Wood). The car park is on your left.

**BY TRAIN & BUS**
Faversham station and bus 666 from station, or Ashford station then bus 666 from Park Street. Or from Canterbury station then bus 667 from bus station.

RIGHT: *Coppice Cloud Chamber*, Chris Drury, 1998. *Photo: Alison Stace*

OPPOSITE LEFT: *Score for a Hole in the Ground* (detail), Jem Finer, 2006. *Photo: Alison Stace*

OPPOSITE RIGHT: *Stalin*, part of *Super Kingdom*, London Fieldworks, 2008. *Photo: Bruce Gilchrist, courtesy of Stour Valley Arts*

## OVERVIEW

King's Wood is a large forest – 1500 acres – with a sculpture trail that has been open since 1994. (It sounds huge, but in fact the trail is only 3½ miles long and takes about two and a half hours to walk.) Stour Valley Arts commission all sorts of artworks including photographs, pieces of music and films, some of which are performed or shown in the forest for short periods. In 2012 they also expanded into a gallery and office space in Ashford, allowing their educational programmes to expand, as well as shows linked to work in the forest. The forest is beautiful, and the walking very nice, but the sculptures vary a great deal,

and the map (which can be downloaded from their website) is quite confusing. The trail is essentially a big loop and it took us longer than expected to find our way around and locate works. The trail is marked by posts with green footprints. There are 14 works marked on the trail, but some of them are off the beaten path along small tracks, and some have fallen apart over time, so they can be hard to find. Look hard for the posts that point to artworks – extremely unobtrusive wooden fence posts with small bronze plaques. The play and picnic area has some fantastic insect-shaped seating for lunch with children.

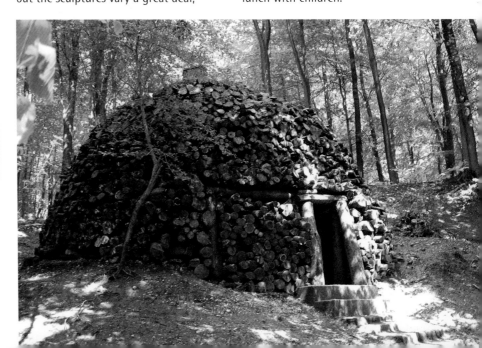

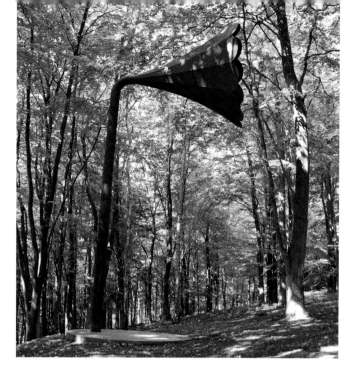
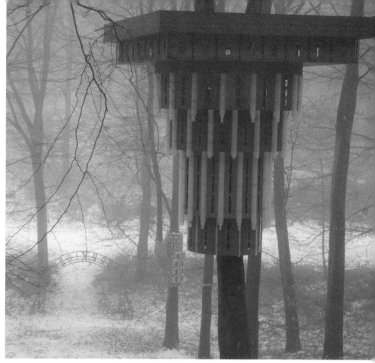

Before you visit, it is worth looking at the 'commissions' page on the website for more thorough background information on current sculptures, especially as some are more complicated than they first appear (such as *Score for a Hole in the Ground*, which has won several awards), and others which are more interesting with the background information.

## THINGS TO SEE

There were a couple of pieces by Richard Harris that we never found, but eventually we realised that the large open flat area is the outdoor studio. Also, the long and odd-looking ballet rail/fence is *The Last Eleven Years* by Peter Fillingham, which does not separate anything from anything else, but winds its way through the trees to nowhere

in particular (presumably symbolic!). The best sculpture, in my opinion, was *Coppice Cloud Chamber*, by Chris Drury, which looks like a little wooden hut, made with all the logs stacked in a domelike shape with their ends pointing out. Through the small doorways inside you come into a dark chamber, with only a tiny hole in the ceiling letting light in, acting as a camera obscura. Once your eyes become accustomed to the light it's actually lovely. The roof has also been constructed very carefully using small planks in a square formation.

Nearby is Jem Finer's *Score for a Hole in the Ground*, comprised of one enormous horn and, opposite, the hole in the ground. This is actually a very subtle musical piece, depending on good conditions and your patience to listen.

There were two quite obscure sculptures – both in location and content. Lukasz Skapski's *Via Lucem Continens* is an avenue of yews planted in alignment with the sunset on the longest day of the year, the date of an annual picnic now held to observe it. *B52*, by Rosie Leventon, is a cleared area of forest floor in the shape of a B52 bomber. Recent commissions include *Super Kingdom*, a series of nesting boxes in the style of luxury homes and modelled on the palaces of Stalin and Mussolini. An accompanying film, entitled *Monarchy*, has also been created by London Fieldworks, featuring the *Super Kingdom* works along with a specially commissioned sound work. The artists used their 3-dimensional work as a starting point from which to develop the ideas behind *Super Kingdom*.

# 27 Derek Jarman's Garden

Prospect Cottage,
Dungeness, Kent.

**Facilities:** None.
**Admission:** Free (private garden)

## OVERVIEW

Dungeness is windswept, bleak and desolate. If it's sunny, there is no shade anywhere, and if it rains or blows a gale, you'd better be properly dressed. It's a bizarre end-of-the-world kind of place, and this impression is exaggerated by odd local fixtures such as the Romney, Hythe and Dymchurch miniature railway. Nearby, and dominating the horizon, is the nuclear power station that is visible for miles around.

Derek Jarman's garden is a private garden belonging to a private residence. It is also quite small – although it looks larger in the photos because there are no boundaries and so it appears to stretch out into the surrounding shingle. Derek Jarman bought Prospect Cottage in 1986, looking for some peace and quiet, and created this unique garden, which has widely influenced garden designers in the last decade or so. Since Jarman's death in 1994, the garden has been tended by his partner Keith Collins.

The term 'sculpture garden' is a broad one. I wanted to include Jarman's garden as an example of an alternative sculpture garden – a quiet, intimate setting as opposed to a large commercial venture. However, for this reason I can't in good conscience encourage people to go

and see it. Keith and his neighbours are being driven slowly mad by the number of visitors, not to mention that people knock things over, tread on plants and generally disrupt the careful arrangements of things. People live in Dungeness because it is so secluded; it is on the way to nowhere. However, the garden remains a tribute to Derek Jarman and for that reason Keith has agreed to it being featured. My suggestion would be to enjoy the pictures, be inspired, and perhaps go and set up your own sculpture garden somewhere else.

Derek Jarman was a well-established, highly individual filmmaker before his illness and premature death. His films included *Caravaggio* (1986), *The Garden* (1990) and *Blue* (1993). The cottage was bought from a fisherman who used to sell crabs and shrimps. A keen gardener since childhood, Jarman began the garden in a small way, hoping that at least some plants would survive the strong winds and lack of soil. With time and care, the garden grew and blossomed in surprising and unlikely ways. Against all the odds, a fig tree thrives at the back of the cottage. The sculptures are very much collections of things found on the beach, put to new uses or arranged in patterns. Large stones are laid out into circular flower

beds, or form small stone islands in the shingle. Large wooden posts are planted at intervals with rusty metal cappings, breaking up the horizontal beach with slightly phallic-looking vertical shapes. Pebbles punctured by holes are threaded onto metal poles. Old broken and rusting tools have been reinvented as sculptural pieces whose fascinating surfaces can be seen amongst the plants. My favourite things are the small wigwams of twisted metal poles, which apparently were once posts for anti-tank fencing put up during the Second World War. Wild red poppies, foxgloves and cornflowers are amongst some of the flowers that bloom at various times, throwing a splash of colour against the green sea kale and the endless expanse of shingle. Dungeness is a strange place with an otherworldly charm of its own, and perhaps this is why the garden has such allure as a little haven at the end of the world.

OPPOSITE: Wooden posts, stones and rusty tools are used to create sculptural arrangements. *Photos: Alison Stace*

FAR RIGHT, TOP: *Daffodils in Spring*, Derek Jarman. *Photo: courtesy of Keith Collins*

FAR RIGHT, BOTTOM: Sculptural arrangement of old anti-tank fencing posts. *Photo: Alison Stace*

# 28 The Garden Gallery

Rookery Lane, Broughton, Stockbridge,
Hampshire, SO20 8AZ.
Tel: 01794 301144
www.gardengallery.uk.com

**Facilities:** None
**Open:** Mid-May to July (check for exact
dates) or at other times by arrangement.
**Admission:** Voluntary donation for local
charity – Wessex Children's Hospice Trust
**Time needed:** 45 mins–1 hour

## Getting there

### BY ROAD
• From Jct 8 of the M3 take the A303,
then take the A30 to Stockbridge. • Go
through Stockbridge village and follow the
A30 towards Salisbury. • Turn left before
Lopcombe Corner onto a lane signposted
to Broughton. • At Broughton go through
the village, turning left past the church and
shop, then left onto Rookery Lane. The
gallery is the fifth house along on your left
(called 'Grandfather's House').

### BY TRAIN
The nearest stations are Winchester (best
from London Waterloo), Salisbury (from
the West Country) and Romsey (for the
south coast – Brighton, etc.). Winchester
and Salisbury are 20 mins away by taxi and
Romsey is 15 mins.

## OVERVIEW

The Garden Gallery is based in a classic
English country garden, complete with
small orchard, pond and summerhouse, as
befits the pretty and traditional village it is
located in. The sculpture gallery has been
open for 18 years, with work changing all
the time. As well as the summer exhibition,
work is shown throughout the year so
there is always plenty to see (but you need
to arrange a visit in advance). The garden
is divided up into various 'rooms' and work
distributed amongst them. These rooms are
in fact different pockets and areas of the
garden loosely divided by hedges or shrubs.
The garden and most of the sculpture is
relatively domestic in scale, with only a few
really large pieces, and the work is all of
high quality. There is also a paddock, which
is home to the resident friendly horse.

The majority of the work here (and also
the strongest) is abstract, making a nice
change from many of the smaller venues.
Every year, a variety of established artists
(approximately 50) are represented —
though they do not all show every year —

*Luna*, Charlotte Mayer, exhibited in 2012. Bronze,
edition (unknown) of 8. *Photo: Rachel Bebb*

usually with a mix of assorted new artists. Pieces are numbered with small ceramic buttons (look closely for these) which correspond to a list of names of works and artists. The garden is not big enough to need a map or get lost in, and sculptures are not positioned numerically. It really is a case of wandering around and seeing what catches your eye. Allow about 45 minutes to an hour.

## THINGS TO SEE

The Garden Gallery has a stable of regular artists, some 50 well-established names, and there is always a good variety of media including glass, stone, ceramic, bronze and wood. Amongst them, you can expect to see work by Elizabeth Herkstroter-Postma in marble and stone, bronzes by Charlotte Meyer, glass by Sally Fawkes and Richard Jackson, and ceramics by Carolyn Genders. Work is carefully placed to show it at its best and thought is also given to the plinths.

The Garden Gallery also take commissions for specific projects and many interesting pieces have been made for private gardens via the gallery working with the artists.

LEFT: *From Past Memory IV*, Richard Jackson, exhibited in 2012. Hand-polished cast glass with carved details, stainless-steel base. *Photo: Rachel Bebb*

CENTRE: *Whispering Moon*, Elizabeth Herkstroter-Postma, exhibited in 2012. Carrara marble. *Photo: Rachel Bebb*

RIGHT: *Spring Skies Vessel & Wealden Garden Vessel*, Carolyn Genders, exhibited in 2012. Ceramic. *Photo: Rachel Bebb*

# 29 The Gibberd Garden

Marsh Lane, Gilden Way, Harlow,
Essex, CM17 0NA.
Tel: 01279 442112
www.thegibberdgarden.co.uk

**Facilities:** Café, toilets, educational
workshops
**Open:** Easter–end Sept, 2–6pm Wed, Sat,
Sun & Bank Hols
**Admission:** Adults £4, concessions £3,
children under 6 free, children 6–16 £1.
**Time needed:** 1½ –2 hours

## Getting there

**BY ROAD**
• From M11, take Jct 7 onto A414 towards
Harlow and Hertford. • Turn right onto
B183 after Church Langley. • Go over two
roundabouts and then look for the brown
sign on your right (turn into Marsh Lane on
left) before you reach Sheering.

**BY TRAIN**
Harlow Mill station then approx. 7 mins by
taxi, or Harlow Town station then 10 mins
by taxi.

RIGHT: *Bifurcation Inflation*, Alistair McClymont,
2010. Stainless steel. *Photo: courtesy of Gibberd
Gardens Trust*

OPPOSITE, TOP LEFT: *Lucinda*, Gerda Rubenstein, Stone.
*Photo: courtesy of Gibberd Gardens Trust*

CENTRE: Salvaged columns from Coutts bank on the
Strand, London. *Photo: Alison Stace*

RIGHT: *Owl*, Antanas Brazdys. Stainless steel. *Photo:
Alison Stace*

BOTTOM RIGHT: *Bird*, Hebe Comerford. Welded mild
steel. *Photo: Alison Stace*

## OVERVIEW

Sir Frederick Gibberd was Harlow's chief
town planner and lived for the rest of
his life in the town he designed. When
he died in 1984, he left the garden to
the people of Harlow 'for recreation
and education'. Situated on a gently
sloping hill, at the bottom of which
runs Pincey Brook, with a little 'castle'
and moat, the garden's different areas
are divided from each other by careful
planting and paths. There is also a pond,
gazebo and small waterfall. Now run by
the Gibberd Trust, which has carried out
an extensive programme of restoration,
the garden plays host to an eclectic mix
of sculpture, most of which was chosen
and placed by Frederick Gibberd and his
second wife, and is permanently located
here. Work is not for sale. The house was
originally built in 1907. Gibberd bought
it in 1957 and, despite being the town
planner, was denied permission to rebuild
it. Instead he set about improving and
extending it, designing and redesigning –
a pattern that continued throughout his
landscaping project.

## THINGS TO SEE

Most of the 80 or so sculptures here
are classic and traditional, though
there are also more modern pieces.
Along more traditional lines were the
simple stone torso on the lawn by John
Skelton, and the very unexpected stone
columns and urns from Coutts Bank

in the Strand, which Gibberd acquired while redesigning it. On a more abstract level, by the pond the welded steel bird by Hebe Comerford is very good, as is the copper-pipe fountain by the house, by Raef Baldwin, which looks like the ingenious construction of a mad scientist. On a more contemporary note, the large shining silver *Owl* by Antanas Brazdys stands out against a dark hedge, and Monica Young's coiled pot is set off by a 'Zen garden' of carefully laid pebbles. Other artists with work here include David Nash, Gerda Rubenstein and Zadok Ben David. A new sculpture was installed in the garden in Autumn 2010, commissioned by a 'friend of the garden' to commemorate his fifty years of living and working in Harlow. *Bifurcation Inflation* by Alistair McClymont also describes the method of construction: two identical sheets of stainless steel are joined on all sides, creating a sort of pillow, but leaving one small gap into which air is blown at high pressure. The steel inflates to resemble a cushion, with dents and folds. The shiny material reflects the environment, so that while standing out in contrast to it, it simultaneously blends with its surroundings. The garden is 16 acres, although some of this is given over to the brook, so allow about an hour and a half to look around.

# 30 Bergh Apton Sculpture Trail

Village of Bergh Apton
Email: sculpturetrail@berghapton.org.uk
www.berghapton.org.uk

**Facilities:** Toilets and refreshments available
**Open:** Several weekends in May & June, once every three years. The next show is in 2014, check website for details.
**Admission:** Adults £10 (2 day ticket £15), children free.

## Getting there

**BY ROAD**
Bergh Apton is just off the A146 which runs between Norwich and Beccles.

**BY TRAIN**
An hour by bus or 20 minutes by taxi from Norwich station.

## OVERVIEW

This sculpture trail is unusual in being put together only every three years by the village of Bergh Apton – a community effort to bring art and sculpture out of the city galleries and into a rural community – and comprises work by invited artists displayed throughout gardens in the village. The first event was organised in 1997, with the 2005 show featuring 75 artists showing about three pieces each. The 2008 show, Balance, involved 12 gardens in a four-mile radius around the village, with access only on foot or by bicycle, and was on the theme of conservation of the environment. The trail route changes every show depending on how many gardens are included. The exhibition is organised by the Bergh Apton Community Arts Trust, and any leftover money is ploughed back into the village (for the school, village hall, church and conservation trust). Selected sculptors are invited by agreement of the committee, and then visit the village for ideas. The 2011 show, The Journey, was focused around the construction of a medieval church, for a different approach.

*Standing Mare*, by Stuart Anderson, 2011 exhibition. Bronze. *Photo: courtesy of Bergh Apton Community Arts*

ABOVE LEFT: *Angel Wing*, Mel Fraser, 2005. *Photo: Derek Blake, courtesy of Bergh Apton Community Arts Trust*

ABOVE RIGHT: *The Painter*, Neal French, 2005. Bronze resin. *Photo: courtesy of Bergh Apton Community Arts Trust*

RIGHT: *Pelegrinus Per Agrum*, John Behm, 2011 exhibition. Hardwood and steel. *Photo: courtesy of Bergh Apton Community Arts*

# THE WEST COUNTRY

31  New Art Centre Sculpture Park & Gallery

32  Broomhill Art Hotel & Sculpture Gardens

33  Barbara Hepworth Museum & Sculpture Garden

*Other Places of Interest*

34  Sculpture by the Lakes

35  The Mythic Garden

36  Tout Quarry Sculpture Park & Nature Reserve

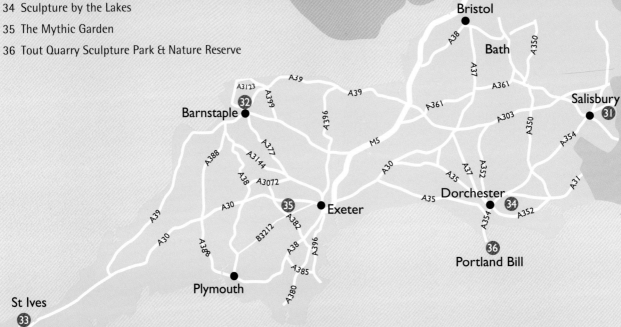

# 31 New Art Centre Sculpture Park and Gallery

Roche Court, East Winterslow, Salisbury,
Wiltshire, SP5 1BG.
Tel: 01980 862244
www.sculpture.uk.com

**Facilities:** There are toilets, but no café
here. As always, local pubs provide food
and facilities.
**Open:** 11am–4pm daily
**Admission:** Free
**Time needed:** 1½–2 hours

## Getting there

### BY ROAD OR HELICOPTER

As cannot be said for most parks, this
one offers a helicopter landing area! • If
your helicopter is currently out of action,
however, and driving or cycling seems more
likely, coming by road from Salisbury on
the A30 you will pass the Pheasant pub on
your left. • The road you need is signposted
about a mile further along on your right.
Follow the signs for Roche Court. • Coming
from Stockbridge along the same road,
shortly after Lopcombe Corner, where the
A30 meets the A343, turn left onto the
small road signposted to Roche Court. • A
lane leads you to an unobtrusive car park,
and suddenly it is not at all clear that you
are in the right place. The park begins at the
house, which you can see from the car park
lower down through the trees. At the side
of the house is a gateway into the grounds.

### BY TRAIN

From Salisbury station, it's about 20
minutes by taxi.

## OVERVIEW

This prestigious sculpture park has a long
list of artists associated with it, including
many famous names that have exhibited
here over the years. It always has an
impressive array of work, and though
the grounds are much smaller than, say,
YSP or Goodwood, they are beautiful.
However, as with both of these parks, the
standard of work is exceptional. All works
shown are for sale, and thus the inventory
of pieces is liable to change. Artists to
have displayed work here include William
Turnbull, Antony Gormley, Richard Long,
Richard Deacon and Antony Caro. The
centre is also the sole representative of
Barbara Hepworth, managing both her
estate and any exhibitions of her work
around the world, and there are always a
few of her pieces on display. The website
is very informative and new work and
exhibitions are well documented.

The New Art Centre was founded by
Madeleine Bessborough in 1958, originally
as a gallery in Sloane Street in London.
In 1994, it relocated to Roche Court, a
19th-century house (not open to visitors)
and gardens in a beautiful and secluded
setting perfect for wandering around.
The views are also worth taking in. The

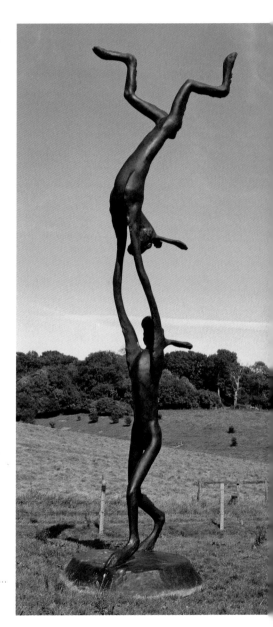

*Acrobats*, Barry Flanagan, 2000. Bronze. *Photo:
courtesy of New Art Centre*

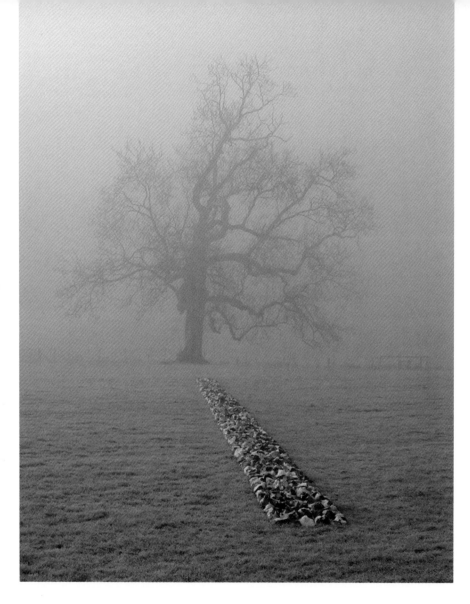

staff at the centre are very enthusiastic, helpful and knowledgeable about all the artists on display. When we arrived on a very wet afternoon, we were greeted at the door of the house with enormous umbrellas that they keep handy for visitors on these occasions. The award-winning gallery, designed by architects Munkenbeck and Marshall, part of which was originally the orangery, has one side made entirely from glass. Exhibitions in the gallery change about four times a year. Educational programmes are also run check the website for details of these.

The centre has also added to the estate by building a small house behind the original building. This impressive piece of modern architecture, also designed by Stephen Marshall, is built from frameless glass, oak and stone, and was designed as an artist's residence for visiting artists working on projects in the park. It holds further artworks, including pieces by Lucian Freud, Nina Saunders and Barbara Hepworth, and three fantastic large ceramic jars in the hidden courtyard by Rupert Spira. It is always nice to see large-scale ceramics in a sculptural context, and these are perfectly suited to the calm, monastic atmosphere of this setting. However, it is important to note that the artists' house can only be viewed by appointment arranged in advance.

## FINDING YOUR WAY AROUND

Maps of the garden are provided with numbers locating the position of sculptures, along with a sheet listing all the corresponding numbered pieces. If nobody is in the house or office, maps are available from the shelf on the porch of the house. The map system works well as the park is a manageable size. There were approximately 50 sculptures on display in the grounds, and it took us about an hour and a half to see everything. The furthest flung piece is Barry Flanagan's *Acrobats*, located over the stile and across a field, and well worth the walk. Be careful not to miss the rest of the sculptures on your return, as some of them are located just inside the small wooded area and are harder to spot.

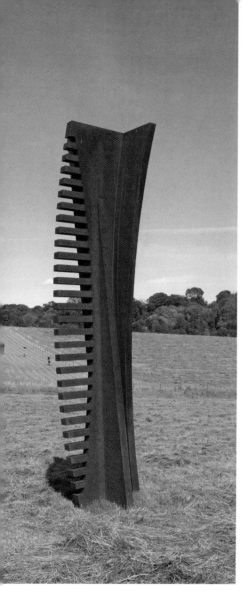

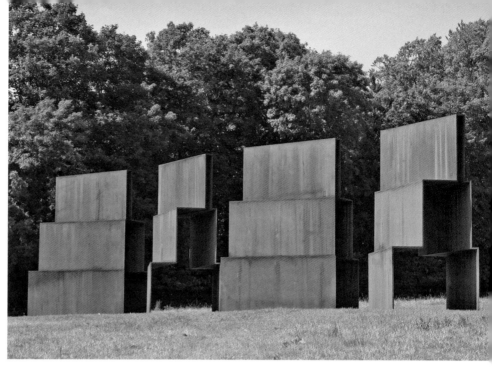

FAR LEFT: *Tame Buzzard Line*, Richard Long, 2001. Flint. *Photo: courtesy of New Art Centre*

LEFT: *Stretched Diagonals*, Nigel Hall, 2003. Cor-Ten™ Steel. *Photo: courtesy of New Art Centre*

ABOVE: *Millbank Steps*, Anthony Caro, 2004. Steel. *Photo: courtesy of New Art Centre*

RIGHT: *Umbrella (Blue)* and *Umbrella (Orange)*, Michael Craig-Martin, 2011. Powdercoated steel, edition 1 of 3 + AP. *Photo: courtesy of New Art Centre*

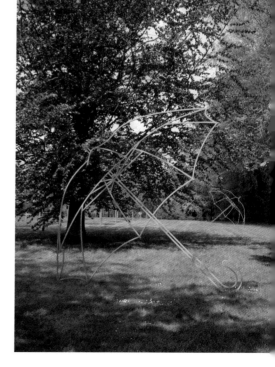

## THINGS TO SEE

Sculptures at the New Art Centre are always likely to change, but there are always pieces worth seeing. A few worth mentioning are Barry Flanagan's fantastic *Acrobats*, Richard Long's impressive land art in the form of *Tame Buzzard Line*, a line of stones leading your eye towards a large tree at the bottom of the field. David Nash has had work here: in 2006 he showed *Three Humps*, and in 2007 *Two Eggs*. Both Nash and Long work in natural

materials and their work blends in well with the surrounding landscape. Some of Anthony Caro's work is also on display here. Kenneth Armitage has had work here of abstract bronzes, as well as Laura Ford, whose surreal bronze *Bird*, a giant bird (possibly a crow) with a child's legs, is both unnerving and fascinating at the same time. It looks like a hybrid of bird/human that is struggling to resolve who or what it should be, and is instead trapped in between two forms. As previously mentioned, there are usually a few pieces of Hepworth's work on display. There are also impressive pieces inside the gallery. In other media, recent works have included ceramics by Jennifer Jones, and some of Laura Ellen Bacon's giant woven willow forms, which crept up the edge of the gallery, as if alive. New work is always arriving from the many well-known artists that show here, and if you are interested in specific artists you can check on their well-organised website for information on past pieces as well as current work before visiting.

TOP LEFT: *Toronto Flat*, Anthony Caro, 1974. From '12 Flats' series. Steel. *Photo: courtesy of New Art Centre*

LEFT: *Wrapt*, Eilís O'Connell, 1999. Bronze, edition 3 of 3. *Photo: courtesy of New Art Centre*

# 32 Broomhill Art Hotel & Sculpture Gardens

Muddiford, Barnstaple
North Devon, EX31 4EX.
Tel: (00 44) 01271 850262
www.broomhillart.co.uk

**Facilities:** Toilets, restaurant, gallery, hotel.
**Open:** Sculpture gardens – all year, Mon–
Sun, 11am–4pm. Closed 20 Dec–15 Jan.
**Admission:** Adults £4.50, children £1.50,
concessions £3.50, family group (2 adults,
2 children) £10.
**Time needed:** 1½ hours

## Getting there

### BY ROAD
Take M5 to Jct 27, then take the A361 to
Barnstaple. • From Barnstaple take the
A39 towards Lynton. Turn left soon
afterwards onto the B3230. The Broomhill
Art Hotel is on your left (signposted) before
you reach Muddiford.

### BY TRAIN
Barnstaple station then approx. 15 minutes
by taxi.

### BY COACH
Coaches run from London (Victoria) and
the Midlands to Barnstaple.

## OVERVIEW

Reminiscent of the Hannah Peschar
Sculpture Garden, with its many
twisty paths, ponds and hidden areas,
Broomhill is both a wonderfully stylish
modern hotel set in an old building and
a comprehensive sculpture garden. It
was a major undertaking to turn the
previously neglected building into a hotel
with restaurant and gallery, and the wild
grounds into a garden with staggered
terraces, paths and stairs. Built up over
the last 16 years by its enthusiastic and
charismatic owners, Rinus van de Sande
has put together an amazing array of
work by a wide variety of sculptors –
many of whom are unknown. Despite

this, the standard of work is very high,
and as Rinus points out, 'The English are
all obsessed with artists being known or
unknown, but there is often very little
difference between a known artist and an
unknown artist. A known artist is simply
someone who has been lucky enough to
be taken up and promoted by a wealthy
client or gallery.' Broomhill also has a
strong link with the Montgomery Trust
which was set up to promote outdoor
sculpture made by recently graduated
artists from the UK, Russia, Eastern
Europe and the former countries of the
Soviet Union, some of their pieces have
been donated to Broomhill for display.

*Flat Man*, Giles Penny, 1998. Resin for bronze.
Photo: *Bob Van de Sande*

LEFT: *The Shoe*, Greta Berlin. Steel and plaster, resin coat. *Photo: courtesy of Broomhill Art & Sculpture Foundation*

BELOW: *Fallen Deodar*, Jilly Sutton. Bronze resin. *Photo: Bob Van de Sande*

OPPOSITE: *Metamorph*, Ian Stoney, 2012. From the National Sculpture Prize exhibition. Gas cylinder and welded parts. *Photo: courtesy of Broomhill Art & Sculpture Foundation*

As with the majority of sculpture parks, all the art here is for sale, and therefore subject to change. It is quite bronze-dominated, with a strong element of figurative work. The hotel is situated at the top of the hill, and the winding paths divide the hill into several levels as they descend. At the bottom of the hill a river flows through the garden, lending the setting a peaceful soundtrack. The gardens are well managed, with most pieces carefully placed in prominent positions to make the most of their location, while others remain semi-hidden, surprising you as you round a corner.

As the Broomhill Art Hotel also serves lunch and tea, you can combine your visit with some refreshments. The very interesting mix of sculpture in this beautiful setting makes it well worth a visit.

## FINDING YOUR WAY AROUND

The many trees, but especially the steep hill, make this garden harder to navigate than some, so that descending lower than the top level is not for those with buggies or for anyone unsteady on their feet. As there is no set route around the park, it

is easy to miss interesting parts of the garden, making it necessary to criss-cross your path and backtrack occasionally in order to see everything. All the sculptures are labelled with small signs to tell you the name of the work and artist. It takes an hour or more to see everything.

## THINGS TO SEE

As with many sculpture gardens, work does change here (although less so with the larger pieces), but new work arrives all the time. The top level of the garden cleverly offers an even grassy terrace on which many small sculptures are displayed, a great idea as smaller sculptures can often get lost in large parks. There is a strong element of figurative work here. *The Three Graces*, by Joanna Mallin-Davies, cavort effortlessly in the nude, and look both rapturous and peaceful. They seem to create their own private world, and reminded me of a witch's coven. Anna Gillespie's small boy (ironically entitled *Strong Man*) looks lost in his own thoughts as he contemplates the ground. A quietly powerful emotional presence, it is also unusually constructed, initially from masking tape which creates the interesting surface, before a mould is taken in rubber and it is cast in bronze.

Three tall yellow oriental figures entitled *Artists of The Silk Road* by Laury Dizengremel stand at the bottom of the hill near the large pond, dominating the space and competing with the trees in height. The fascinating and beautiful faces were perfectly formed and frighteningly

realistic, while the shapes of their bodies could just be faintly made out through the roughly formed torsos, which resembled swathes of cloaks, kimonos or wrappings.

The Broomhill Art and Sculpture Foundation also offers a National Sculpture Prize annually of £15,000. A winner is chosen both by the public and a panel. The top ten sculptors have their work on display for a year, while the final winner's work becomes part of the Foundation's permanent collection. The National Sculpture Foundation's pieces make for an interesting and varied show, featuring many very up and coming young artists. Amongst the Foundation prize winners for 2012 was *Endless Curve*, the 'Public Speaks' winner from 2012. Also from the National Sculpture Prize is *Poise: Shifting Skies* (on display until 2013), which is made from a steel structure with porcelain rings. The rings move around creating a rhythmic visual pattern and are an unusual and interesting use of clay. The 2012 show also included *Metamorph* by Ian Stoney. This fabulous morphing form, part gas cylinder, appears to have grown roots and be trying to leave, while *Comet* by Richard Cresswell shows the artist's 'love of nature's curves, which appear everywhere I look'.

TOP LEFT: *Artists of the Silk Road*, Laury Dizengremel. *Photo: Alison Stace*

TOP RIGHT: *Strong Man*, Anna Gillespie, 2005. Bronze. *Photo: Alison Stace*

RIGHT: *Welcome to the Third Millennium*, Mike Roles, 2012. Detail from much larger ongoing exhibition. From mild steel, resin, wood. *Photo: courtesy of Broomhill Art & Sculpture Foundation*

# 33 Barbara Hepworth Museum & Sculpture Garden

Barnoon Hill, St Ives, Cornwall,
TR26 1TG.
Tel: 01736 796226
www.tate.org.uk/visit/tate-st-ives/barbara-hepworth-museum

**Facilities:** Toilets
**Open:** Mar–Oct, 10am–5.20pm every day,
Nov–Feb, 10am–4.20pm (closed Mon).
**Admission:** adults £5.50, concessions
£3.25.

## Getting there

### BY ROAD
• At the end of the M5 (Jct 31) pick up the A30 and continue west through Devon and Cornwall. • After signs for Redruth & Camborne turn right onto the A3074 into St Ives. • There are several car parks in St Ives, so if traffic is heavy, park at the first one with spaces and walk into the centre on foot (or park near the Tate). Small signs point you to the museum from the end of the main shopping street.

### BY TRAIN
St Ives station (from Paddington, London) and a 10 to 15-minute walk.

*Four-square (Walk-through)*, Barbara Hepworth, 1966. *Photo: Alison Stace, by permission of the Hepworth Estate*

## OVERVIEW

St Ives is a small but picturesque coastal town complete with bars, shops and cobbled streets, much like a miniature version of Brighton. Despite its size, it is easy to get lost among the maze of little roads, and since every other person is a tourist, it's hard to get directions too. The museum and garden are located a very short distance (a 10-minute walk) from Tate St Ives. The entrance looks like an old-fashioned door to a tiny town house, which is exactly what this building is. Step through the narrow doorway and you enter the house that Hepworth lived in. The garden is a considerable size in comparison to the house, and very well hidden. You would have no idea of its size from the outside, and indeed Hepworth herself wrote that she had been passing the walls for ten years with no idea that her perfect studio and garden lay on the other side. She acquired it in 1949 and lived there until her tragic death in a fire in 1975. The studios, which are built into the hill, one leading to the next, occupy at least as much space as the house, so it is easy to see what took priority in her life. 'Trewyn studio and garden' were once part of Trewyn House next door. The garden is well established now, and paths lead you around the small pond and impressive trees. The garden seems a strange hybrid, with parts giving off the air of a Mediterranean garden with a seated area against a painted wall and tall exotic trees, while the rest is an English country garden, with roses and a stone bridge leading over the pond. Although a private space, Hepworth also used the garden to display her works, both for her own creative purposes and for visiting gallery owners and buyers.

## FINDING YOUR WAY AROUND

The museum and garden are pretty small, so no map is needed, and the sculptures are all identified with numbered plaques. A leaflet lists all the works with corresponding numbers. Firm, constructed paths lead you easily around the well-maintained garden, which although on a hill is relatively flat, aside from a few steps here and there. Pieces have been situated with great care to relate to other forms and textures within the garden. Well-placed benches allow you to sit and enjoy the tranquility of the space.

## THINGS TO SEE

It is easy to see everything here, and indeed you should, in order to get a well-rounded view of Hepworth's work as it changed over time. The elegant, curved and natural shapes reflect her love of the landscape, while her use of strings described the interior of forms in a different way. Listed below are a few of the pieces in the garden that I particularly

LEFT: *River form*, Barbara Hepworth, 1965. Bronze. *Photo: Alison Stace, by permission of the Hepworth Estate*

RIGHT: *Conversation with magic stones*, Barbara Hepworth, 1973. Bronze. *Photo: Marcus Leith,* © *Bowness Hepworth Estate*

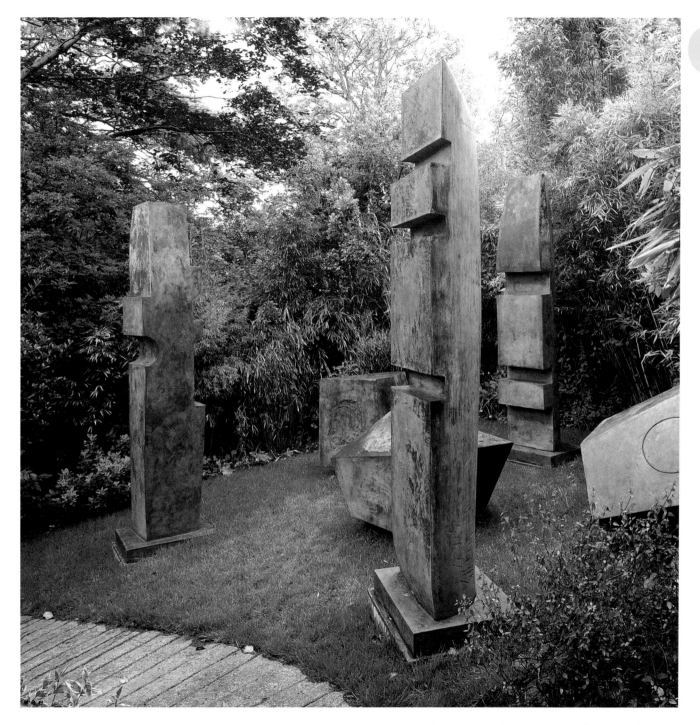

liked, although every piece is worth reflecting upon. Her work is occasionally out on loan for exhibitions, so some pieces may be missing.

*Four-square (Walk-through)* is one of the largest pieces, and also one of the first things you see on the lawn as you come out of the house. Hepworth made it in 1966, almost as a reaction to being diagnosed with cancer the year before. The viewer was originally invited to engage with the sculpture by passing through its centre. The squareness of this vast piece is broken up by the circles that allow glimpses of sky and garden as the viewer walks through and round, offering all sorts of combinations of shapes and framed views. Its strong architecture is also softened by the interaction of the viewer with the garden.

*Two forms (Divided circle)*, is another large and perfectly balanced form – perfectly balanced with itself and the landscape, because the holes and the two halves themselves are not identical at all: one has another oval cut around the circle within, giving more depth to the form. Originally, the inside faces of the holes would have been a polished gold colour, drawing more focus to the edges and the spaces themselves. What makes the circle join is the viewer's perception.

*River form*, also situated on the grass area, collects water within its hollow interior, while the holes in the sides suggest water flowing in and out. The painted inside also hints at water and lightens the interior. One of my favourite pieces, it has an essentially soothing quality about it. This work was actually cast from a carved wooden mould.

*Sea form (Porthmeor)*, located inside one of the studios, is actually the plaster mould that was used to cast an edition of seven bronzes. It has been painted a deceptive bronzed colour – perhaps to give an indication to a buyer of how the finished work would look. This natural form evokes the sea – Porthmeor is the name of a local beach – and the shape is reminiscent of both a breaking wave and a seashell.

*Conversation with magic stones* is a very large piece consisting of three large upright works and three smaller ones, all standing in relation to each other. The three larger upright pieces seem to represent figures, an impression based both on their appearance and on things Hepworth wrote about her work. The relationship between them reflects human interaction, while the smaller stones (the 'Magic' stones) obviously represent mystical forces. Hepworth was fascinated by standing stones found in the landscape, and obviously felt drawn to them, as this work seems to express. Lovers of Hepworth will also enjoy visiting the new Hepworth museum in Wakefield.

TOP LEFT: *Sea form (Porthmeor)*, Barbara Hepworth, 1958. Bronze. *Photo: Unknown photographer, © Bowness Hepworth Estate*

LEFT: *Two forms (divided circle)*, Barbara Hepworth, 1969. Bronze. *Photo: Bob Berry © Bowness Hepworth Estate*

# OTHER PLACES OF INTEREST
## 34 Sculpture by the Lakes

Pallington Lakes, Pallington,
Dorchester
Dorset, DT2 8QU
Tel: 07779 712298
www.sculpturebythelakes.co.uk

**Facilities:** Toilets
**Open:** All year by appointment (max. 30 people per day, so be sure to book)
**Admission:** £10 per person (no children under 12)
**Time needed:** 1½ –2 hrs

## Getting there

### BY CAR
From the A35 take the B3390 towards Briantspuddle and Affpuddle, then turn off this road at the sign for Dorchester and Tincleton. As you drive through Pallington, look for black security gates on your left with a discreet black stone in front of them reading 'Pallington Lakes'. Press the buzzer to enter.

### BY PUBLIC TRANSPORT
From Dorchester train station it is approximately 7½ miles (about 15–20 minutes by taxi).

## OVERVIEW

These rugged and beautiful sculpture gardens are set out over a wide area. As you might suspect, much of it is water, with currently some 27 sculptures placed in and around the lakes, and more to be added over time. Although well maintained, these are not formal gardens but landscaped paths and walkways alongside the water. There are even a few small rowing boats (life jackets are provided) which you can use to get across to the tiny island to see some more sculptures. The work varies a little but is all by one artist, Simon Gudgeon, and in keeping with the rural landscape the theme is largely one of nature and wildlife. All the work is bronze, and pieces have been carefully placed to show them off to their best advantage, with in some cases specific plantings grown around them. The owners, Simon and Monica Gudgeon, have decided not to allow small children to visit – partly because there is so much water everywhere, which could be dangerous, and partly because they want to keep the tranquillity of the place and encourage the more serious art enthusiasts.

TOP RIGHT: *Eve*, Simon Gudgeon, 2011. Bronze. *Photo: Richard Budd, courtesy of Sculpture by the Lakes*

RIGHT: *Embrace*, Simon Gudgeon, 2007. Bronze. *Photo: courtesy of the artist*

It is worth having a look at the gallery, where you'll find many smaller works. This is currently in a barn, with metal sheets cleverly creating a partitioned semicircular space within it, though there are plans to build an entirely new structure.

## FINDING YOUR WAY AROUND

There is no set route around the sculpture gardens, but there is a good map with all the work marked on it, and you really can't get lost.

## THINGS TO SEE

Occasionally, a piece looks better from one angle than another, and for that reason it is worth taking the rowing boat to the tiny island because the large head of *Eve* has much more atmosphere close up, while the head of *Adam* can only be seen properly once you are on the island. Looking as if it is a death cast of a large face, this eerie head sits in an unsettling position on the small table under the pagoda. Nearby the giant *Fallen Apples* lie on the ground. On the way back to return the boat to the small jetty, there is a much better view of the *Leaping Salmon*.

A few of the works that stood out for me were *Duel II*, of two fighting cock pheasants, perfect in its symmetry and placement beside the lake, and surrounded by a semicircle of plants. The *Ravens* looked suitably menacing on their granite perch, while the *Pelicans* sit perfectly within their figure of eight (the number is made up by its reflection of the circle in the water). The two heads gazing at the heavens, aptly named *Enlightenment*, were also a highlight, and their hollow forms looked great against the landscape.

ABOVE: *Search for Enlightenment*, Simon Gudgeon, 2011. Bronze. *Photo: courtesy of the artist*

TOP RIGHT: *Disappearing Worlds*, Simon Gudgeon, 2012. Bronze. *Photo: Rolant Dafis, courtesy of Sculpture by the Lakes*

BOTTOM RIGHT: *Pelicans*, Simon Gudgeon, 2008. Bronze. *Photo: courtesy of the artist*

FAR RIGHT: *Duel II*, Simon Gudgeon, 2010. Bronze. *Photo: courtesy of the artist*

# 35 The Mythic Garden

## OVERVIEW

Every year for around five or six months Stone Lane Gardens becomes the Mythic Garden sculpture exhibition, run privately by June Ashburner. The Stone Lane Gardens were started in 1971 by Kenneth Ashburner, and have gradually been cultivated as part of a scientific project. The arboretum is now protected by the Stone Lane Gardens Trust. Set within five acres of a larger woodland of birch and alder trees (officially designated as national collections), the landscaped gardens and woodland have several ponds, three of which feed water by a stream from one to the next. Garden paths of woodchip twist and turn, winding off amongst bushes and trees into hidden corners or over tiny bridges. It is a beautiful place which takes about an hour and a half to wander round.

## THINGS TO SEE

The exhibition, curated by June Ashburner, has been running since 1992. Every year it features new work by a small constant core of West Country artists plus a changing roster of other contributors. With approximately 120 pieces, the exhibition is pretty varied, with plenty of interesting pieces and a strong quota of ceramic work. As the title of the garden exhibition might suggest,

the work leans towards being, as June puts it, 'sympathetic to what the garden is trying to achieve'. This means that much of the work has a 'natural' or even 'mystical' theme, although obviously with the introduction of new themes these are more tailored to fit the current year.

Amongst the large variety of work, pieces from recent exhibitions have included *Icarus* (by Hilary Luce), lying dramatically on a large stone, a very inquisitive owl by George Hider, (who has also made a fabulous roaring stag from steel), and from past exhibitions a wire unicorn by Ed Netley, a giant stalking spider in copper and steel and a more abstract piece called *Forest Guardians* by Peter Clarke, which kept watch over the forest with twenty or more eyes, all growing out of poles amongst the trees. The work is always a good mix of things to see and fits in well with the very beautiful surroundings, which have an extreme air of calm and tranquillity. If you are in the area you should certainly make sure you visit.

TOP LEFT: *Roaring Stag*, George Hider, 2008. Mild steel. Photo: *courtesy of The Mythic Garden*
TOP RIGHT: *Unicorn*, Ed Netley, 2009. Wire. Photo: *Alison Stace*

BOTTOM LEFT: *Forest Guardians*, Peter Clarke, 2007. Chestnut/oak/glass. Photo: *Alison Stace*
BOTTOM RIGHT: *Icarus*, Hilary Luce, 2012. Ceramic. Photo: *courtesy of The Mythic Garden*

Stone Lane Gardens, Stone Farm, Chagford, Devon, TQ13 8JU.
Tel: 01647 231311
www.stonelanegardens.com

**Facilities:** None
**Open:** Daily from 2–6pm, May–Oct (check for exact start and end dates).
**Admission:** Adults £5, students & children (aged 5–16) £2.50, children (under 5) free; family £13 (max. 2 adults).
**Time needed:** 1½ hours

## Getting there

### BY ROAD
Come off the A30 at Whiddon Down onto the A382 towards Moretonhampstead, then turn left at the roundabout (following A382). • Take the third left after Chapel Hill and Turnpike Lane, down a narrow lane signposted Drewsteignton. • Pass a right turn for Spinster's Rock and take the next right turn. The car park is through the working yard on your left. Then follow signs on foot.

### BY TRAIN AND BUS
From Exeter St Davids station, take bus 173 from Exeter bus station to Chagford (1 hr) then 172 from Chagford to Whiddon Down, and walk (1.5 miles).

# 36  Tout Quarry Sculpture Park and Nature Reserve

Office address: The Drill Hall,
Portland, Dorset, DT5 1BW.
Tel: 01305 826736
http://learningstone.org

**Facilities:** None on site, but check out the wonderful Sugar Loaf Café in the nearby village of Easton (with an extensive range of great food). Summer workshops.
**Open:** All year
**Admission:** Free
**Time needed:** 2–2½ hours

*Still Falling*, Antony Gormley, 1983. Incised into rockface in situ. *Photo: courtesy of Portland Sculpture Quarry Trust*

## Getting there

Tout Quarry Sculpture Park is located in a disused quarry on the strange Isle of Portland, a spit of land off the coast of Dorset. This odd sculpture park is actually quite hard to find, but there are signs pointing you to the Tout Quarry Sculpture Park. All roads seem to lead back to either the main road or Portland Bill, a viewing point at the far end of the island. The quarry is signposted from one direction only.

### BY ROAD
Take the A354 via Weymouth to the Isle of Portland across the narrow spit of land joining it to the mainland. • Once in Portland, drive through the residential area of Fortuneswell. The road takes you up a steep hill with hairpin bends, past sculptures of a fisherman and quarry worker, and one of the huge structures used for lifting stone. • At the roundabout at the top of the hill, take the third exit along Wide Street, then turn right into what looks like an industrial park (known as Tradecroft) with a Royal Mail office on the corner. • At the end of this road, bear right onto a newly laid road. It looks unlikely, but eventually you will come to some laminated boards on the left, bearing a map of the park; you can park opposite in the new car park. • (There is another entrance opposite Heights hotel with tramper vehicles to access the quarry if needed).

### BY TRAIN
Weymouth station and then 15 mins by taxi or a bus ride (bus X10, approx. 30 mins, frequent buses in summer, reduced service in winter).

## OVERVIEW

At the first laminated board along the gravel road a tiny unmarked path leads off to your left between the bushes, and takes you down towards the quarry. On arrival, the whole place looks as if it hasn't been visited for 1000 years; in reality, the quarry has been disused for about 75 years, but it was not until 1983 that artists were invited to create works here in order to keep the site active. Portland stone is world-famous, used in architecture and sculpture in cities everywhere, and the skills and knowledge needed to work the stone by hand were passed down through many generations of local men. At the centre of the quarry is the workshop where sculpture courses are now held, on both the outdoor stone carving terrace and in the well-equipped workspace, and the students make use of the leftover stone to create new pieces, so the amount of sculpture is always increasing (see website for details on booking workshops).

It has to be said that the sculpture here is not always the most exciting you will

ever see, although there are some good pieces. It is a great example, however, of a truly integrated land-and-art concept, where the artists come to make the work in situ from the material found on site (as opposed to making work in a studio from other materials and then transporting it for display). It gives a direct meaning to the notion of art in landscape. The place is also worth a visit just for the experience of visiting the atmospheric disused quarry. There are now about 80 sculptures here, and at the time of our visit the laminated maps were in the process of being redesigned to mark them all on the route. However, as they are made from the same stone that surrounds them, you need to vigilant. Suddenly you will realise that a strange-looking boulder is actually the figure of a crouching man, or that drawings have been etched into a rock you are leaning against. It is part of the enjoyment of the place that many of the sculptures are almost hidden, waiting to be discovered.

## FINDING YOUR WAY AROUND

The Tout Quarry Sculpture Park is essentially unmanned, so there are no paper maps provided, but regular information points using laminated boards show you where you are and where the sculptures are located. These show the locations of many sculptures hidden amongst the stone. Most are found away from the main path, but these detours are well worth the trouble, as there are so many carvings on stones in unexpected places. Although the quarry seems vast,

you can't go very far wrong with the sea on one side and the road on the other. The workshop area is also a good landmark.

## THINGS TO SEE

Amongst the official sculptures, Shelagh Wakely's *Representation of a Baroque Garden* was one of the best and was also first on the route. Obscured by giant boulders on the quarry floor, it is best viewed from above by climbing the small raised path around it heading towards the sea. Tucked away inside the quarry and also quite hard to spot is Antony Gormley's *Still Falling*, which is perfectly situated, carved onto a bare patch of rock on the far side of a chasm. Half-floating and half-falling, the surreal figure heads down into a dip towards what looks like a natural hidden doorway in the rock. How Gormley managed to reach that spot to carve anything at all is a feat in itself. Nearby, *Hearth* is a beautifully carved, very realistic fireplace looking like it just needs some coal to get it started. I also liked *Crouching Figure*, which could so easily be a strange-shaped boulder until it suddenly clicks into place and the recognisable shape of a person emerges from the rock. The *Arena of Fools* was also quite intriguing, with its cave-like drawings on various boulders surrounding an open area. *Fallen Fossil*, *Be Stone No More* and *Ascent* are other interesting pieces which work particularly well with their surroundings. Finally, be sure to walk through the stone archway and look out for *A Tear for Stone*, a man's face carved into the face of the stone beside the path.

TOP: *A Tear for Stone*, anonymous carver. Photo: Alison Stace, with permission of Tout Quarry Sculpture Park.

ABOVE: *Lizard*, John Roberts. Photo: courtesy of Tout Quarry Sculpture Park.

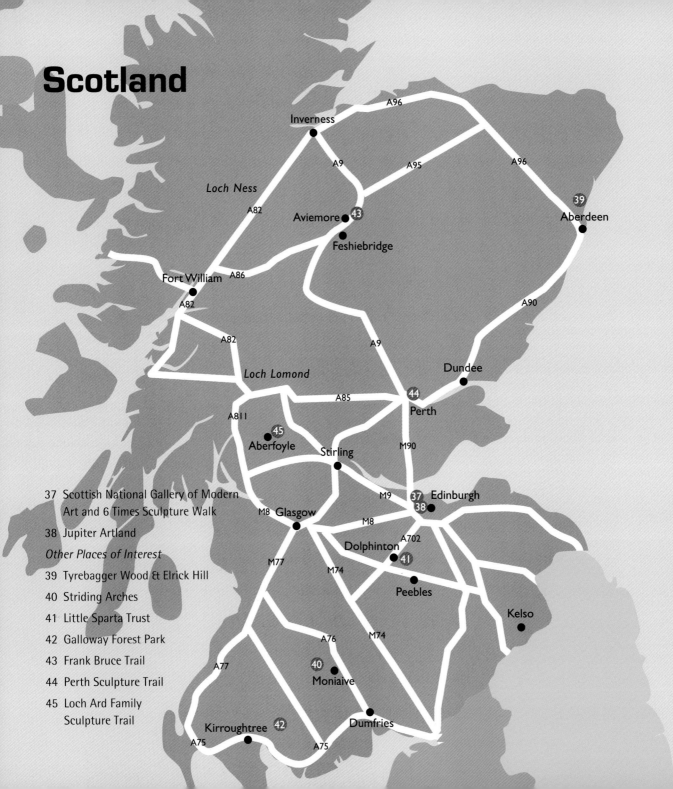

# Scotland

Loch Ness

Loch Lomond

Inverness

Aviemore ④③
Feshiebridge

Aberdeen ③⑨

Fort William

Dundee

Perth ④④

Aberfoyle ④⑤

Stirling

Glasgow

Edinburgh ③⑦ ③⑧

Dolphinton ④①

Peebles

Kelso

Moniaive ④⓪

Kirroughtree ④②

Dumfries

A96
A9
A95
A96
A82
A86
A82
A82
A9
A90
A811
A85
M90
M8
M9
M8
A702
M77
M74
A76
M74
A77
A75
A75

37 Scottish National Gallery of Modern
   Art and 6 Times Sculpture Walk
38 Jupiter Artland
*Other Places of Interest*
39 Tyrebagger Wood & Elrick Hill
40 Striding Arches
41 Little Sparta Trust
42 Galloway Forest Park
43 Frank Bruce Trail
44 Perth Sculpture Trail
45 Loch Ard Family
   Sculpture Trail

# 37 Scottish National Gallery of Modern Art and 6 Times Sculpture Walk

75 Belford Road, Edinburgh
EH4 3DR
Tel: 0131 624 6200
www.nationalgalleries.org

**Facilities:** Parking, toilets, café
**Open:** daily 10am–5pm (later in Aug). Gate closes 6pm Apr–Sept, sunset Oct–March
**Admission:** Free for outside. Parking is £1 for 4 hrs
**Time needed:** Gallery grounds approx. 20 mins, walk 2½ hrs

## Getting there

### BY CAR
In central Edinburgh, Belford Road sits over the river, between the A8 and the A90 (Queensferry Road), which run into the city. Turn off the A90 at the roundabout onto Queensferry Terrace, or from the A8 turn onto Palmerston Place.

### BY TRAIN
Haymarket Station & 15 min walk. Follow Palmerston Place down onto Belford Road and across the Bridge. The gallery is a short walk along Belford Road.

### BY BUS
The Gallery is also a stop for Edinburgh coaches, service 13.

*Master of the Universe*, Eduardo Paolozzi, 1989. Bronze. Scottish National Gallery of Modern Art. *Photo © Antonia Reeve, courtesy of National Galleries of Scotland*

## OVERVIEW

The National Gallery is divided in two by Belford Road. Number One is the best one to visit as it has the most art in its grounds, both permanent and changing exhibits – at the time I visited it was Tony Cragg's fabulous morphing forms – as well as some impressive land art by Charles Jencks. However, the grounds at Number Two (over the road) are also worth a look as they have a few other pieces. The land art sweeps and curves in stepped terraces you can walk around, giving ever-changing views. A path leads down to it from the main building, hiding the clever metal shapes sunk into the stepped banking.

Number One is also the start of *6 Times*, the sculpture walk by Antony Gormley featuring six figures, which, as with most of his work, are bronze casts based on his own body. The figures start at the gallery (the first is eerily sunk into the ground at the entrance) and then stand in the river all the way down to Leith. At the start of the walk these figures are looking down into the water, but each one turns its gaze up a little more than the last as you proceed along this pleasant (if at times a little scruffy) walk. The last figure is on the pier behind the shopping centre at Leith docks, so although you get to Leith in about two hours, you need to go that

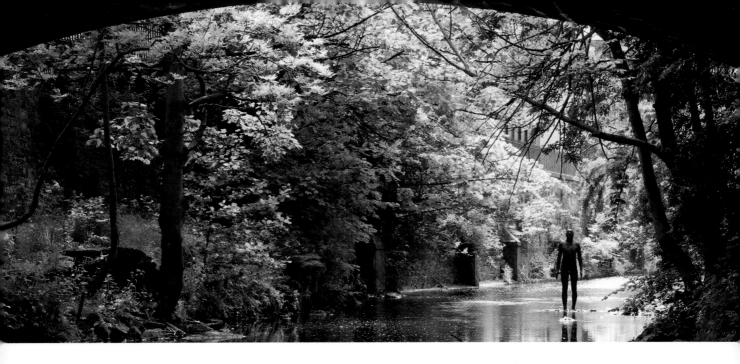

bit further to find the final work. It looks imposing, but is situated at the end of the disused pier, so you can't get close. The total walk is fairly long, so if you are not a big walker or a big fan of Antony Gormley, you might be happy to drive to the nearest figures instead, although buses and taxis are available at the end to bring you back to the gallery.

Gormley is keen to remove his figures from the confines of galleries and place them in the landscape, where people can have more interaction with them directly. In his talk for the National Gallery online he explains that as people come across them and think 'what the hell is this figure doing here?' the figure is equally asking the same question back at the viewer.

The National Gallery has some good information on their website if you wish to read up on the walk further (www. nationalgalleries.org/collection/6-times/ 19326), but the actual instructions on the route are a bit minimal, so see below for expanded information.

## FINDING YOUR WAY AROUND

It is recommended that you print out the instructions from the gallery's website, which are fairly minimal, or that you photocopy the ones below, which are slightly expanded. Either way, instructions are essential, as although you generally follow the river, the path does often leave it to cross a bridge or to detour down a road, or else it divides in two. If in doubt, follow signs for the Water of Leith Walkway. We had to ask several locals; luckily, everyone knew it.

1. To get started, make sure you have seen the first figure, buried up to its waist at the entrance.

2. To start the walk along the river, go around the right-hand side of the gallery towards the back and down the stairs, which lead all the way to the river. Crossing the river you will see a signpost to Leith, so turn left and follow this. In the river you will see the second figure standing in the shallows, looking down into the water. This section of the walk is very pretty. There is then a long stretch following the river for about 40 minutes.

At St Bernard's mineral well (the circular Roman-type structure), come off the higher path and descend to the walkway beside the river along the terrace. At the end of this, come up the stairs onto the bridge and go across,

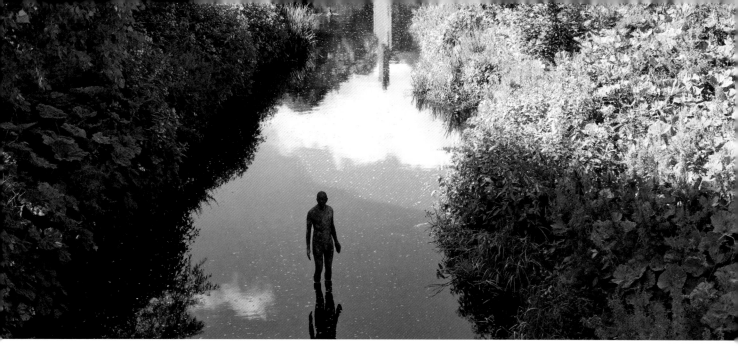

then turn right and continue on this road until you reach the next bridge shortly afterwards.

3. The third figure can be seen from this bridge, looking back the way you've come. The trees are quite overgrown here and obscure the view, but it can also be seen from the pavement on Saunders Street. After this, rejoin the path on the other side of the bridge by Pizza Express.

4. The fourth figure is easily visible in the water by a large wooden bridge at Powderhall, just downstream from the Warrington Road crossing. After this, the path takes you through some parkland, and you come to several signposts. The path divides in two and the one you are on carries on under a bridge, but follow the sign to 'Leith (following the river)', which takes you up some stairs to your right before continuing.

5. The fifth figure is sited at Bonnington, just before a bridge and under a willow tree. At the time of my visit it had been knocked over and was lying in the river, close to the surface. I hope it will be fully restored by the time this book goes to press.

6. At Leith just continue along the path, following the canal and moored boats, past the bronze figure of Sandy Irvine Robertson on a bench, until you find Ocean Way and the Ocean Terminal shopping centre. Bear right past Debenhams towards the back of the shopping centre, along Britannia Walk where there are picnic benches, and at the end of this you will find the abandoned wooden pier (no access) with the final figure at the end. From the front of the shopping centre you can get taxis or buses if you don't want to walk back again!

ABOVE LEFT: *6 Times SKY* from *6 Times,* Antony Gormley, 2010. Cast iron. Commissioned by the Scottish National Gallery of Modern Art, with support from the Art Fund, funds from the Gulbenkian Museum of the Year award 2004, and further support from The Patrons of the National Galleries of Scotland, Claire Enders and The Henry Moore Foundation. *Photo © Keith Hunter Photography, courtesy of National Galleries of Scotland*

ABOVE RIGHT: *6 Times RIGHT* from *6 Times,* Antony Gormley, 2010. Cast iron. Commissioned by the Scottish National Gallery of Modern Art, with support from the Art Fund, funds from the Gulbenkian Museum of the Year award 2004, and further support from The Patrons of the National Galleries of Scotland, Claire Enders and The Henry Moore Foundation. *Photo © Keith Hunter Photography, courtesy of National Galleries of Scotland*

# 38 Jupiter Artland

Bonnington House Steadings
Wilkieston
Edinburgh
EH27 8BB, UK
Telephone: 01506 889900
http://www.jupiterartland.org

**Facilities:** Café, toilets.
**Open:** May–Sep, Thur–Sun 10–5pm.
Time needed: 2 hours
**Admission:** Adults £8.50, children £4.50,
OAPs (Thur and Fri) £5, students £4.50,
family £23.50.

## Getting there

From Edinburgh, take either the Dalry/
Gorgie Road to Sighthill, or the City Bypass
(A720), following signs for Edinburgh North
& West, and then take the A71 signposted to
Kilmarnock. On the A71 at Wilkieston turn
right onto the B7015, signposted East Calder
and Camps. Jupiter Artland's gates are 20
yards on the right, just after Ashbank House.

**BY CAR (from the south)**
From the A74(M), take the A702 at Jct 13
and head towards Edinburgh. Turn left onto
the city bypass (A720), and follow signs for
Edinburgh N & W, taking the exit for the A71
to Kilmarnock. Follow directions as above.

**BY PUBLIC TRANSPORT**
35 minutes from Edinburgh by bus number
27 or X27. First Bus from Regent Rd or Dalry
Rd, Haymarket. After Wilkieston, the bus
turns onto the B7015, and will stop either by
the Jupiter Artland gates (just after Ashbank
House) or at the Coxydene/Jupiter Artland
bus stop, which is 50 yards further on.

## OVERVIEW

Jupiter Artland has a very high standard
of artwork set in amazing grounds. Once
through the beautiful silver gates (by
Ben Tindall) and along the drive, the
first thing to greet you is the stunning
landform *Life Mounds*, created by Charles
Jencks. These large mounds are terraced
earthworks which spiral upwards into
summits. Small shaped water areas
surround them, a little bridge crosses
over to them, and the angles constantly
change, rotate and evolve as you walk
around. The whole effect is amazing, and
sets the tone for the rest of the park,
which doesn't disappoint.

Run as a private enterprise, this stately
home (not open to the public) provides

a beautiful setting for the 23 works
found here. At the time of our visit, more
were being created, the aim being to
add gradually to the collection. All the
work is permanent and not for sale. The
grounds have a bit of everything, with
work scattered through some of the barns
in the Steadings area near reception,
through the forest and on the open grassy
fields. You can see everything in about an
hour and a half, but probably need two
hours to do it justice.

The artwork is very varied but of a high
level, with many of the pieces by well-
known artists such as Anish Kapoor,
Antony Gormley, Andy Goldsworthy
and Marc Quinn.

## FINDING YOUR WAY AROUND

Everything is very well organised. The car
park, beyond the earthworks, is clearly
signposted. From here you walk up to
reception at the Steadings, which sits
alongside some other buildings housing
artworks, plus toilets and also a café
in a silver streamlined Airstream-style
caravan. At reception you receive a map
in the form of a drawing showing the
route through the wood and parkland; it
is not entirely to scale, and although most
things come in sequence, occasionally
they don't. However, this is not a
hindrance, as on the whole things are
easy to find and the path is clear. The
map certainly helps so you know what to
look for.

## THINGS TO SEE

It's hard to know where to start when describing the work here, as there are so many wonderful things that make it worth a visit. Even as you leave the shop to start the trail, you'll see Jim Lambie's *Steading Wall* outside, which has an amazing surface made from tessellated, spray-painted chrome; this peels away in patches to reveal more colours underneath, while the chrome reflects the surroundings. This visual feast is almost too much for the eye to take in – I found I had to look at it several times to get a handle on its complex texture. Fairly close by is *Suck* by Anish Kapoor. The first work you see in the woods, this great piece really does give the impression of a black hole leading deep into the bowels of the earth. The cage around it emphasises the imagined danger of this abyss, while the hole at the top of the cage, which is open to the sky, suggests the possibility of everything being sucked in – sky and earth included.

Further on into Gala Hill Wood, in a clearing on the horizon is *The Firmament* by Antony Gormley, almost an androgynous, morphing form. Part figure, part abstract, it was inspired by an old star map; it represents a crouching figure but is one of those forms in which you can see many things as you walk round it.

*Life Mounds,* Charles Jencks, 2006–11. Terraced earthworks with paths from iron, red sandstone, concrete and Liesegang rock. *Photo: courtesy of Jupiter Artland*

The *Weeping Girls* by Laura Ford are brilliant: very lifelike but creepy little figures found unexpectedly amongst the trees, sobbing in a variety of poses.

Nathan Coley's very disturbing piece *In Memory* looks as if it had always been there. Tucked away in the forest, this very odd little graveyard comes complete with headstones, although closer inspection reveals that all the names have been erased. In total contrast, *Love Bomb*, a giant orchid by Marc Quinn, is found in a huge open space. Almost pornographic in its colourful lewdness, it is also beautiful – the kind of piece you either love or hate.

The *Stone House* in the wood by Andy Goldsworthy exhibits his usual disconcerting way of looking at nature; outwardly a traditional stone cottage such as you might find in such a setting, the interior reveals a floor area of rugged bedrock – the type of landscape that houses are built to keep at bay. It is a strange experience to go inside. A new Goldsworthy piece, the unnerving *Coppice Room*, a forest brought indoors, has also recently been installed in one of the lower barns.

.....................................................................

TOP: *Weeping Girls,* Laura Ford, 2009. Patinated and painted bronze. *Photo: courtesy of Jupiter Artland*

RIGHT: *A Forest*, Jim Lambie, 2010. Tessellated panels of spray-painted chrome. *Photo: courtesy of Jupiter Artland*

CENTRE: *Suck*, Anish Kapoor, 2009. Cast iron and hole. Photo: courtesy of Jupiter Artland

FAR RIGHT: *Love Bomb*, Marc Quinn, 2009. Digital image on polyflax canvas, stainless steel and resin. *Photo: courtesy of Jupiter Artland*

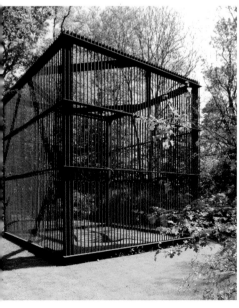

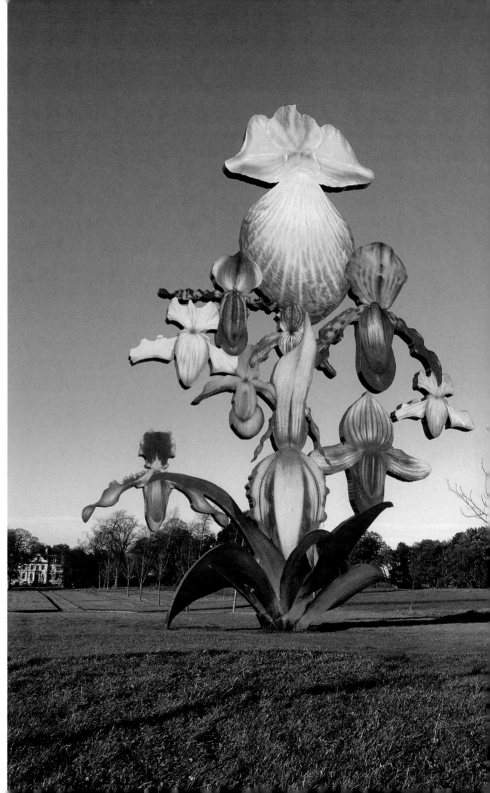

# 39 Tyrebagger Wood and Elrick Hill

SCOTLAND

**FOR INFORMATION ONLY**
Forestry Commission Scotland,
Aberdeenshire Forest District
Portsoy Road, Huntly, Aberdeenshire
AB54 4SJ
Tel: 01466 794161
www.forestry.gov.uk/scotland
www.forestry.gov.uk/pdf/
tyrebaggemap2010.pdf (map)

**Facilities:** None
**Open:** Daily
**Admission:** Free
**Time needed:** Approx. 2–3 hours
(depending on which trail(s) you choose)

## Getting there

### BY CAR
From the north or south, the A90 runs to
Aberdeen. Before Aberdeen (if coming
from the south, and after Aberdeen if from
north) take the B979 towards Peter Culter,
then left onto the A93 for a short distance,
then turn right back onto the A979
towards Kirkton of Skene. Take a left onto
the A944 then right again onto the A979
(at Kirkton of Skene), then look for signs to
Tyrebagger. There are two car parks along
this road, the second one being slightly
larger.

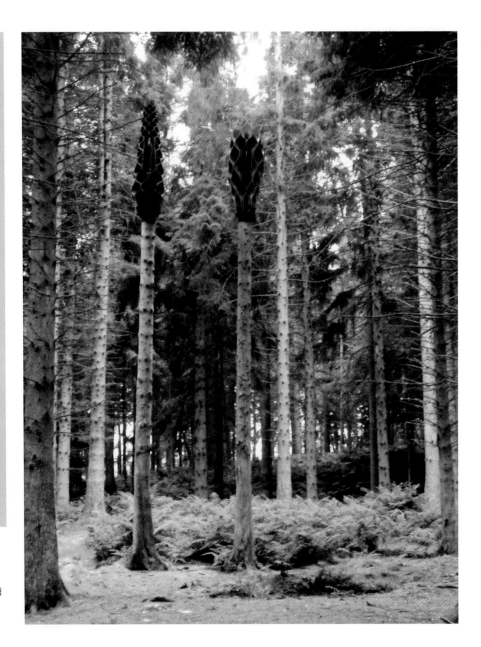

RIGHT: *Segmented Sitka*, Keith Rand, 1994. Carved
wood. *Photo: Alison Stace*

OPPOSITE PAGE: *Modern Nature*, Matthew Dalziel and
Louise Scullion, 2000. Metal, solar panels, sound
unit. *Photo: Alison Stace*

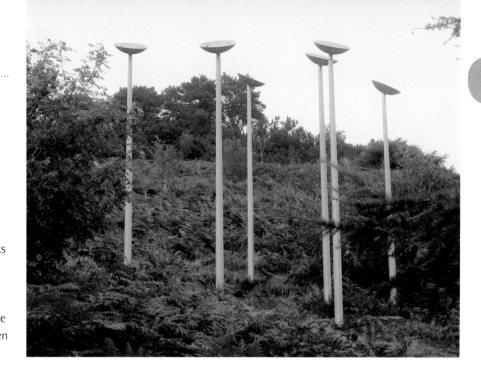

## OVERVIEW

Tyrebagger Wood and Elrick Hill cover a good-sized area, and there are several trails that you can take. The sculpture trails have been added to over a number of years, with works commissioned from 1994 up to about 2003. Some now look a little dishevelled and in need of maintenance, but most are in good condition given their age. The trail is not being regenerated, however, and as works disintegrate they are gradually being removed. There is certainly enough to see, but you do need to be prepared for a long walk overall, as well as a fair distance between pieces. As many things are hidden away just off the path, it is wise to print out the map that can be found on the Forestry Commission website (although you may have to search for Tyrebagger). The website also lists the names of works and artists. The distances given for the trails on the website do not take into account any hunting for sculptures you may need to do – many are off the main trail on small paths – including the inevitable blind alleys. The sculpture trails are the red and yellow routes, but only half the yellow trail has work on it, so to shave off some time we set out on the red route (anti-clockwise), then turned off and joined the yellow route (also anti-clockwise), and took a short cut back on the brown route (thereby cutting off half the yellow trail), rejoined the red route again and carried on. The whole thing took about 2 hours 45 minutes, but obviously you could do just the red trail if you prefer. (It sounds confusing, but it

is quite clear when you look at the map.) The yellow trail, although it does not have many pieces, does offer spectacular views and some large installations that work well against the landscape, but there is a lot of walking between them. You are very much in the forest on this trail, so come prepared with good walking shoes, water and provisions.

## FINDING YOUR WAY AROUND & THINGS TO SEE

It is pretty essential to print out and take the map with you (you can find it online at www.forestry.gov.uk/pdf/tyrebaggemap2010.pdf) if you want any chance of finding the sculptures. It is an interesting trail, but you need to be prepared to do some exploring and hunting for work in places. Follow the

way markers which have the coloured routes on them – though this can get a bit confusing when suddenly three bands of colour appear on some of the posts. Below is a summary of the route we took, with edited highlights.

Starting on the red route, if you have parked in the first (smaller) car park, you will quite quickly come to the first sculpture, *Moon Pool*, with strange words and phrases written on bands high up around the tree trunks, all set around a bronze circular pool. It all connects mysteriously somehow to tell a story, if only we knew what that was. If you want to do the red route and half the yellow, then turn off the red route after this at the waymarker, and cross the bridge, following the brown and yellow waymarkers. The path bends to the right;

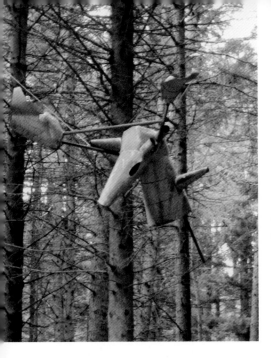

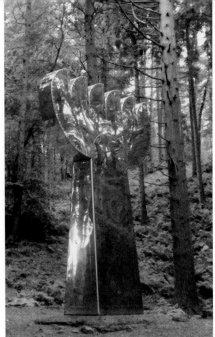

FAR LEFT: *Apparition*, Auke de Vries, 2002. Welded steel. *Photo: Alison Stace*

LEFT: *Beacon*, Allan Watson, 1994. Polished steel. *Photo: Alison Stace*

as you begin to climb up there is a small sculpture in the rock, one of many black and white stone creations called *Markers*, by Jon Aiken, which appear in many places. Follow the yellow route to the right, climbing up through trees until you come out into the open and find *Sky Line*, and then further on, *Modern Nature*. Both are very large-scale, vertical sculptures which work really well with the beautiful and contrasting horizontal landscape around them, but they are very different. When you reach the picnic tables under the trees, look for the next waymarker and turn left onto the brown route to head back again. There are no more sculptures along this bit until you rejoin the red route, though you do miss out No.7 by taking the short cut.

As you turn right back onto the red route, Auke de Vries's *Apparition*, an abstract

deer's head in welded steel, appears fairly soon among the trees on your left. Despite having aged a little, it still has great presence. It is reached by a small path off the main track leading up a set of stone stairs cut into the bank. Continue along this higher level if you wish, until you come to some steps leading down again to the next sculpture, Simon Ward's *Ghost*, which can also be found by coming off the main route at the next small pathway. This eerie, well-named piece turns out to be a fallen tree cast in porcelain.

Further on, before the path begins to bend round the corner, you will see to your right a large circular wooden fence with a very narrow entrance at the back. This meditative piece by Gavin Scobie, known as *Tyrebagger Circle*, is worth exploring, having something of the

atmosphere of a secret chamber where the world seems suddenly reduced to the sky, the treetops and you.

After another *Marker* in a stream, you will pass a small path on your left which appears to lead up a bank to nowhere. But look closely and tucked behind a very large rock you'll see a doorway leading you into *Earth Chamber* by Chris Drury. As your eyes adjust to the gloom, walk very slowly along the curved stone tunnel to a dark circular stone chamber, where you will see a tiny hole in the ceiling. The light admitted should be just enough to reflect the sky and trees onto the very large wooden circle on the floor.

After yet another *Marker* at the top of a large mound set into a big rock (with a wide track just beside it that you shouldn't take, leading down a fairly steep hill), the next sculpture is a very large silver tree set on a mound. *Beacon* by Allan Watson is made from stainless steel, and strangely its very shininess actually makes it work well in its dark pine surroundings. Finally, there is Keith Rand's *Segmented Sitka*, two trees whose tops have been removed and replaced with giant, cone-shaped wooden carved forms, looking like enormous alien seed pods. Because the colours blend in so well they are easy to miss, but they are very tall and on your left in a small clearing.

# 40 Striding Arches

## OVERVIEW

These four arches by Andy Goldsworthy stride out across the hilltops in Dumfries and Galloway. As a group, they form a sculpture trail of sorts, but to see all of them would require you to be pretty fit, and would take a day's walk. You can, of course, just walk to one or two. A good option is to start at the Byre, and look at the incredible arch built right through the window, linking the outside world to the indoor space. Then walk on, following the forest road up to either the arch on Colt Hill (a 6-mile round trip) or the arch on Benbrack (a 9-mile round trip) – or both, if you are feeling keen.

Both the Benbrack and Colt Hill arches start with the walk up the forest road. A gradual uphill climb, this road begins by offering some wonderful views, but as you get higher you can only see road and trees, and it becomes a bit of a slog. The road curves round towards the top, where a signpost points the way to Colt Hill (turn right) or Benbrack (turn left) along the Southern Upland Way. Colt Hill is described as 'strenuous', and it is, but it was worth the effort, as the arch looks spectacular at the top with the backdrop of amazing views on all sides. Once the road ends and you come to the large gravel area, there is no clear

path. Just head up between the forestry plantation and the fence. Be warned that as you climb, you cannot see the arch until you are literally upon it, so don't worry that you might have gone wrong. It took us much longer to do the walk than expected as it was a fair hike. We also foolishly decided to push a buggy as far as possible before hill walking with the baby in a sling; no doubt all of this slowed us down, so that the round trip took us over 2½ hours.

If you have the time and would prefer the less exhausting option, it is best to turn left at the signpost and take the longer but flatter route across the top of the hills to Benbrack. Alternatively, from the

Benbuie, near Moniaive,
Dumfries & Galloway
www.stridingarches.com

**Facilities:** None
**Open:** Daily
**Admission:** Free
**Time needed:** Varies from 2½ hours to a day (depending on your choice of arches)

## Getting there

### BY CAR

From the A76 which runs between Kilmarnock and Dumfries, take the B729 just before Dumfries towards Kirkland and Moniaive. Benbuie and Striding Arches are signposted from Moniaive, but be warned if your car is very precious, as it is a 7-mile road of increasingly rough terrain.

The arch at the Byre, Benbuie. *Photo: © Mike Bolam*

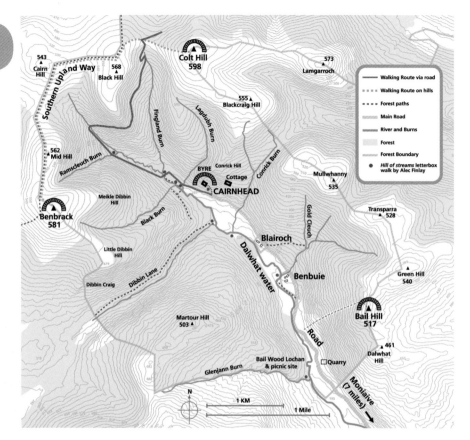

Map legend:
- Walking Route via road
- Walking Route on hills
- Forest paths
- Main Road
- River and Burns
- Forest
- Forest Boundary
- *Hill of streams* letterbox walk by Alec Finlay

top of Colt Hill you can easily descend to the signpost if you want to do both, and then continue on. You need to really enjoy walking to make the journey to any of the arches; be sure to choose a clear day, or the views will be wasted.

The start of both walks is from the car park near the Byre at Benbuie, it is the easiest place to get to, and one of the *Striding Arches* is located here. It is signposted from Moniaive, which has a good lunch stop at the Green Tea House. Be warned that the road from Moniaive to Benbuie is a very long single-track road which becomes progressively more rugged and potholed, and by the end is more of a forest track. There is a small car park at the end, and the arch is a few minutes' walk from here. If you cycle, you might be better off parking at Moniaive and cycling to the Byre.

An old abandoned farm building, the Byre has been excavated back to the original cobbled floor and renovated with a new roof. The door is never locked so the building offers shelter while also being part sculpture, with one of the enormous arches stretching inside through a large window at one end; it is a strange sensation to share the house with such an incongruous structure. Outside at the entrance to the property can be found work by stone carver Pip Hall, who has inscribed slabs with words and names relating to its history.

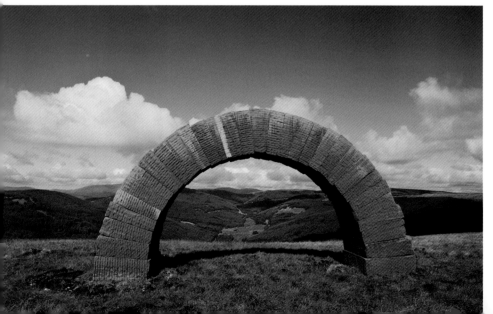

LEFT: The arch on Bail Hill. *Photo: © Mike Bolam*
RIGHT: The arch on Benbrack Hill. *Photo: © Mike Bolam, both courtesy of Striding Arches project*

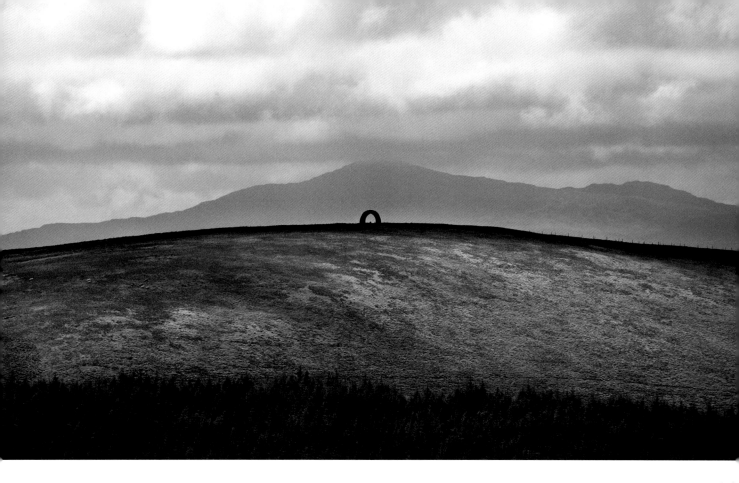

## FINDING YOUR WAY AROUND

There are information boards in the car park about the location of the arches, but make sure you come prepared; I have included some of the information below. It is recommended that you have the Explorer map OS 328 (2½ inches to a mile), although we managed without, but you will definitely need proper boots and provisions.

For the most accessible arch, on Colt Hill, follow the forest road 2½ miles up the glen and turn right near the top, turning off the track at the fingerpost. Continue for ⅓ mile along the edge of the forest plantation to the arch on top of Colt Hill.

The second-most accessible arch is on Benbrack, a 9-mile walk (round trip). Follow the forest road up the glen for 2½ miles and, near the top, turn left off the track at the way marker. Continue for 2 miles along the edge of the forestry plantation to the Southern Upland Way. Follow the Southern Upland Way to the arch on Benbrack Hill.

The final arch on Bail Hill is a shorter distance (about 4 miles) but a much steeper elevation straight up through the forest on an unmarked path. This can apparently be started from a forest track found off the road near the Lochan picnic site and quarry, heading towards the Byre. There is a stile, and an information board at the bottom. I have not included any further details because none are available; it is up to the individual to find their own way at their own risk.

# 41  Little Sparta Trust

Dunsyre, Dolphinton, ML11 8NG
Tel: 07826 495677
www.littlesparta.co.uk

**Facilities:** Toilet
**Open:** Wed, Fri & Sun, 2.30pm–5pm from
27 May–30 Sep.
**Admission:** £10, plus £5 for photography
permit if needed.
**Time needed:** 1½–2 hours

## Getting there

### BY CAR
From Edinburgh take the A702 to
Dolphinton, and turn right to Dunsyre.
About a mile after passing through Dunsyre,
you will find Little Sparta's car park on the
right. There is a signpost in the car park, but
don't go too fast or you could easily miss it.
There is a long track to walk up, which leads
through fields from the car park.

### BY PUBLIC TRANSPORT
There are minibuses running from
Edinburgh to Little Sparta on about seven
Friday afternoons, operating a package deal
for about £25, which includes entry to the
gardens (check website for details). There
is also a bus that runs from Edinburgh to
Dunsyre, followed by either a 3-mile walk
or pre-booked taxi ride.

RIGHT: *Apollo & Daphne*, Little Sparta, year
unknown. Acrylic. *Photo: Alison Stace, courtesy of
the Estate of Ian Hamilton Finlay*

FAR RIGHT: *The Present Order*, Little Sparta, year
unknown. Carved stone. *Photo: Alison Stace,
courtesy of the Estate of Ian Hamilton Finlay*

## OVERVIEW

The gorgeous gardens of Ian Hamilton
Finlay are a continuous treasure trove of
hidden areas, little paths, ponds, bridges
and secret areas sheltered by trees, as
well as some open fields and a small lake.
There are beehives, roses, manicured lawns
and carefully planted paths, brick-lined
walkways and small water features. It is
hard to say if Ian Hamilton Finlay was a
sculptor or not. He was certainly a poet and
an artist, and his greatest work was really
the whole garden with its many artworks,
from concept to design. Throughout the
gardens he created, placed and built into
and around are site-specific poems in
solid form. Words appear on bricks along
a pathway, or on a bridge joining two
sections, such as '*That which joins also
divides*', forcing you to consider the bridge
you are crossing in a much more conceptual

way. There are sundials with words and poems, and a miniature house in which you can glimpse, but not enter, a secret world – a thatched cottage of Alice-in-Wonderland proportions. Every area has been carefully considered to lead you to the next, which is always different from what has gone before. Finlay, who did not see himself as a sculptor, worked with stonemasons and lettercutters to create the garden over a period of 25 years. It was done with poetry and philosophy as its focus, but the overall effect is of a garden as artwork. Since his death, the gardens have been run by the trust, established in 1994.

## FINDING YOUR WAY AROUND

You'll be given a map on arrival at reception, with a list of the various garden areas, but this is more of an overview. The idea is not to follow a preordained path but to wander and explore, finding things unexpectedly and being surprised as each area leads you to something new. Ultimately, you can't get lost as each area eventually leads into the next one way or another, until finally you return to where you started.

## THINGS TO SEE

Things to see are really too numerous to mention, tucked around every corner in every bit of stonework and revealing themselves in every new vista, but it is worth heading to the edge of the garden (overlooking the fields) to see the giant poem, *The Present Order*.

# 42 Galloway Forest Park

Kirroughtree Visitor Centre
Tel: 01671 402420
www.forestry.gov.uk (search for Galloway
Forest Park and Art in the Forest)

**Facilities:** Café & toilets at centre
**Open:** Daily. Visitor centre Mar–Oct,
10.30am–4.30pm; Jul–Sep, 10.30am–
5.30pm. Open bank holiday weekends
10.30am–5.30pm.
**Admission:** Free
**Time needed:** 2 hours (for Talnotry trail)

## Getting there

**BY CAR**
From the north, take the A77 and then
turn off onto the A714 towards Glentrool.
Pass Glentrool and continue on to Newton
Stewart, then take the A75 signposted
towards Dumfries (for 3 miles). Turn left at
Palnure and look for signposts.
From the direction of New Galloway, take
the A712 to Newton Stewart, turn left at
the T-junction onto the A75, then left at
Palnure and follow the signposts.

**BY BUS**
Take the 431 from Newton Stewart to
Gatehouse of Fleet, or the 500 or X75 from
Newton Stewart to Dumfries. Get off at
Palnure and it's a short walk.

RIGHT: *Quorum*, Matt Baker, 1997. Carved stone.
*Photo: Alison Stace*

FAR RIGHT: *The Eye*, Colin Rose, 1999. Red quarry
tiles. *Photo: courtesy of the artist*

## OVERVIEW

Galloway Forest Park is an enormous,
beautiful area covering approx. 300 sq
miles, with many trails and forest drives
to explore. The artwork in the forest was
commissioned in 2000, so some of it is
now overgrown. Some pieces are still
lovely, but artwork was never the main
focus, so there is not a great deal of it.
You need to come as much for the walk
as for the artwork, but if you are local or
on holiday in the area then it is worth an
afternoon visit.

The two main walks with artwork are
the Talnotry Trail – the one I would
recommend, though it only has two
artworks – and the Raiders Road forest
drive – a long, fairly rough drive with
a couple of nice stopping points with
sculptures, though the artwork on this
trail is a bit disappointing. The third trail
with artwork is the Papy Ha Trail, but
all the artwork is in the form of seating,
and is often hard to find. The main road
through the forest is the A712 (Queen's
Way), and all the trails start from named
car parks off this road.

As you would expect, the walks in the
forest can be beautiful, with gorgeous
views, lochs and streams, heather and
many hills – the Talnotry Trail is a fairly
steep climb to start with. However, if you
are right in the thick of the forest, you
may find yourself walking a road hemmed
in by trees on both sides. The walking can
be strenuous in places, so you will need
proper walking boots or shoes.

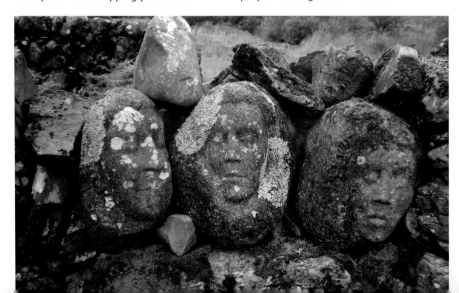

## FINDING YOUR WAY AROUND

There are three visitor centres in the forest: Glentrool, Clatteringshaws and Kirroughtree. Clatteringshaws centre is the nearest for the Raiders Road forest drive, while Talnotry is between Clatteringshaws and Kirroughtree, off the A712. The first step is to go to a visitor centre and pick up the big fold-out leaflet containing the maps. It has a good overview of the area as well as showing the trails in more detail.

The best trail is Talnotry, which has some lovely views and two good pieces of artwork to find. Start at the car park of the Grey Mare's Tail on the A712 (all the car parks are marked). Climb up the hill, and if you like you can make the brief detour to Murray's Monument, a tall grey tapering shape you will see above the trees as you climb up. Follow the wooden path waymarkers with the red stripe around them. The views from the monument are amazing, and afterwards you only need to retrace your steps a short way back to the path and continue along the trail. For part of the way this follows the forest road, but when you come to a small concrete bridge that crosses the stream, the path turns off to the right. Don't do this just yet, but carry on up the forest road for about 10 minutes to the Black Loch, where you'll find a splendid sculpture called *The Eye* by Colin Rose, a tall cone shape which is easy to spot.

Next, retrace your steps back to the trail and then take the turn-off (now to the

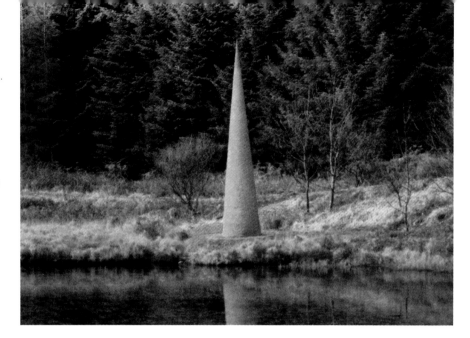

left) at the bridge. Follow the path into the sheep pens, where amongst the old stone walls you'll see *Quorum*, by Matt Baker – eerie hidden carved faces – that take a bit of finding. After this the trail follows the stream for a bit before heading downhill. You can make a short detour off the path to see the waterfall (follow the sound of the water) on your way back down the hill. It takes about two hours to do the whole thing.

The Raiders Road forest drive also has a couple of stopping-off points which are marked from the road if you are passing. One of these is a land-art form called *Labyrinth* (or *The Path*), by Jim Buchanan, which you can walk around. It probably looked great originally, but has become a bit overgrown. Further along the road is the Otter Pool, a beautiful spot beside the River Dee. You will find some picnic benches here, and beside

them a carved stone otter, *The Otter* by Gillian Forbes, looking very pleased with his catch.

## THINGS TO SEE

Both pieces on the Talnotry trail are worth seeing. *The Eye* is a tall cone made of red quarry tiles which works well in its surroundings. If you get up close you'll see a hole right through the centre of it, which acts as a spyhole onto the loch. *Quorum* is a series of carved faces in the wall. Reminiscent of death masks they really suit their windswept location, and are well worth looking for. *The Labyrinth* is formed from a raised path with slate chips creating a circular pattern standing up out of its boggy moat, it is still a draw although it has lost its edge to the encroaching forest. *The Otter* and *The Labyrinth* are both nice to see, but only if you are passing that way.

# 43 Frank Bruce Trail

Feshiebridge, Cairngorms
www.frank-bruce.org

**Information only:**
Forestry Commission Scotland
Glenmore Visitor Centre
Glenmore, near Aviemore
Tel: 01479 861220
**Or**
Forestry Commission Scotland
Inverness, Ross & Skye Forest District
Tower Road, Smithton, Inverness IV2 7NL
www.forestry.gov.uk/scotland
Tel: 01463 791575

**Facilities:** None (picnic benches and car parking)
**Open:** Daily, dusk till dawn
**Admission:** Free (parking £2 for 3 hrs or £3 per day)
**Time needed:** 35 mins

## Getting there

**BY CAR**
From north or south take the A9, then turn onto the B9152 (heading towards the B970) at Kingussie, Aviemore or Inverdruie. From the B970 follow signs to Feshiebridge, which is near Loch Insh. If coming from the north, drive through Feshiebridge and as you exit, you pass the sign indicating where Feshiebridge begins. Cross the small bridge and then the trail is signposted up ahead on the right. From the south, look for signs just before entering Feshiebridge.

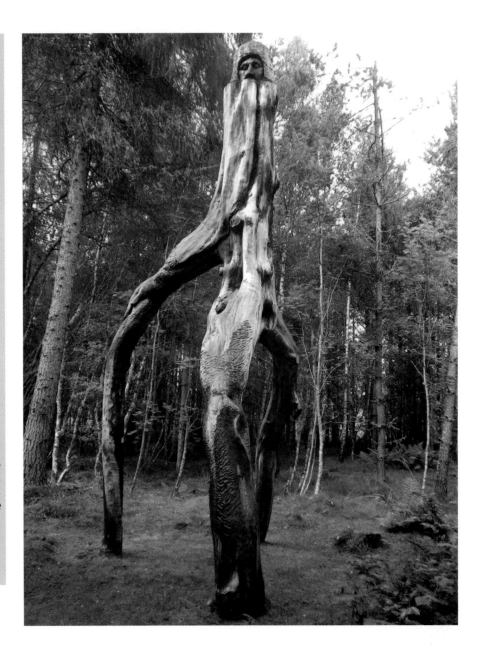

*The Walker*, Frank Bruce, date unknown. Carved wood. *Photo: Alison Stace*

## OVERVIEW

This trail is all the work of one man, Frank Bruce, an untrained artist who carved nearly all the works from wood (a few are in stone) in situ in the small woodland. The work covers a long period from 1965 to his death in 2009. Some of these pieces are quite disturbing in their portrayal of war and famine. Some of the work seems very primitive, while others are more proficient, but essentially the trail shows off one man's work developed over a number of years. Moreover, it is a short walk to see quite a lot of work – 12 works in total, although some of these pieces include several carvings. Being so close to Aviemore, it is easy to pay a visit if you are here on a walking or skiing trip. You can print out information from the website, which lists the sculptures and has a small map, but it is not essential as the flat gravel path is very easy to follow and all the works have a wooden post with the title of the piece, as well as a sign with a small but useful explanation of the idea behind the piece. Leaflets are also available from the Glenmore visitor centre (and forestry commission office if you apply in advance) should you want one.

## FINDING YOUR WAY AROUND

There are two car parks, but the simplest option is to park in the first one and just walk a few minutes to the start of the trail – look for the wooden post to point the way. A very easy path leads you around the trail, so you can't really get lost. The path takes you through a small woodland, and then around in a loop. At the end you can either follow the path back through the first sculptures, or turn onto the rough road (turn right) and walk back to the car parks.

## THINGS TO SEE

One of my favourite piecs was *The Archetype*, the first sculpture you come to, made from an enormous tree with a carefully carved face. *One World* is a tree with four heads carved into it; it works well, although it is a little monstrous to look at and is starting to show its age. *Two Patriots* depicts what looks disturbingly like a man clubbing a woman, giving a strong impression of the chaos and violence of war. The text explains that 'to make a war a patriot on both sides is needed'. *The Walker*, impressive because of its sheer height and scale, has cleverly used the shape of the tree to fashion a man with a stick, and it changes slightly as you walk round it. *Third World*, although unsophisticated, is very powerful. A man holds another figure, apparently a dead child, while three other giant blindfolded heads look on.

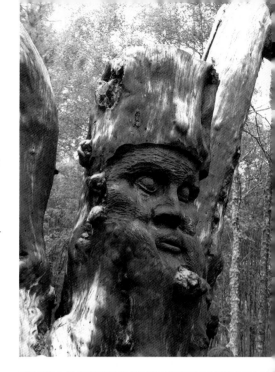

TOP: *The Archetype*, Frank Bruce, date unknown. Carved wood. Photo: *Alison Stace*

RIGHT: *Two Patriots*, Frank Bruce, date unknown. Carved wood. Photo: *Alison Stace*

# 44 Perth Sculpture Trail

## OVERVIEW

This pleasant 45-minute walk along the River Tay goes mainly through a small park, as well as some pretty gardens adjoining the path, and has a varied mix of work to see. Commissioned by The Perthshire Public Art Trust, and well maintained, most of the sculptures date from 1997 and 1998. The trail is a bit of a mixed bag, but there are some 24 works to see, including quite a lot of good pieces, mainly stone and metal, all clearly marked out by information boards at the start and about halfway through.

At the end of the path, cross the second bridge you come to, turn left and walk back along Tay Street, taking a short detour to your right down the High Street (which comes off Tay Street), where another couple of great public artworks are located. One is a bronze figure (*Fair Maid*), a character from Walter Scott, while the other is a fantastic bronze by David Annand — of two figures with a giant hoop, pulling against each other. One, wearing a blindfold, leans forward holding the hoop, while the other stands casually against the other side of the hoop, stopping it from shifting. The piece is entitled *Nae Day Sae Dark* (taken from a line in a William Souter poem), and is well worth the detour. Along the actual sculpture trail some of my favourite pieces were *Foxtrot Ridge* by David Annand, *Benchmark* by John Creed (a whole series of creative benches) and the *River Arch* by Doug Cocker. Also look out for *Millais's Viewpoint* by Tim Shutter.

## FINDING YOUR WAY AROUND

The Shore Inch car park is by the river. Once you have parked, walk to the Ferguson Art Gallery on the corner (with the great bronze torso outside), go under the bridge, and then climb the stairs to your right at the side of the bridge which will take you onto the narrow pedestrian tunnel running alongside the railway. It's quite a long walk over the River Tay on the pedestrian walkway of the bridge, but just keep going and eventually you'll reach the other side, where you'll find the park and an information board for the sculpture walk. The path starts on your left and leads you through Bellwood Riverside Park, Rodney Gardens and the Norie-Miller Park. At the end of Rodney Gardens is a bridge, but walk past it and keep going as there is more work beyond. Towards the end you follow the road back along the river to the next bridge (Bridge Lane). Cross the bridge, come back along Tay Street (making the High Street detour, if you have time) and as you go look out for the quirky cartoon bird forms along the wavy railing of the riverwalk.

OPPOSITE, TOP LEFT: *River Arch* by Doug Cocker, 1998. Granite. *Photo: Alison Stace*

OPPOSITE, BOTTOM LEFT: *Foxtrot Ridge* by David Annand, 1992. Bronze resin. *Photo: Alison Stace*

FAR RIGHT: *Benchmark* by John Creed, 1998. Steel, oak, industrial brick. *Photo: Alison Stace*

---

Bellwood Riverside Park, Perth

**Information only**
Perth Tourist Office
45 High Street, Perth
Tel: 01738 450600

**Facilities:** None (but many cafés nearby)
**Open:** Daily
**Admission:** Free, (parking £1.30 for 3hrs)
**Time needed:** 1½ hours, round trip

## Getting there

### BY CAR
Perth is reached by the M90 from the direction of Edinburgh (south) or from the north along the A9. As you come into Perth, take the A989 and head towards the river. Follow signs to the Ferguson Art Gallery, and park in the Shore Inch car park on the other side of the road.

# 45  Loch Ard Family Sculpture Trail

Loch Ard Forest, Aberfoyle

**Information only:**
Aberfoyle Tourist Information
Trossachs Discovery Centre
Main Street, Aberfoyle, Stirlingshire
FK8 3UQ
Tel: 01877 382352
www.trossachs.co.uk/Sculpture-Trail.php
**Or**
Forestry Commission Scotland
Cowal & Trossachs Forest District
Aberfoyle, Stirling, FK8 3UX
Tel: 01877 382383
www.forestry.gov.uk/qefp

**Facilities:** None
**Open:** Daily, dawn till dusk
**Admission:** Free
**Time needed:** Brown trail approx. 1 hour,
walking; Red trail approx. 2 hours, walking.

## Getting there

From the M9 at Jct 10 take the A84
towards Callander, and then the A873
towards the Port of Menteith and
Aberfoyle. At Aberfoyle, turn off left onto
the B829 (signposted to Loch Ard forest
and Milton). Follow signposts to the forest
until you find the car park (don't stop at
first tiny one but continue to larger one
with info board).

RIGHT: *Osprey*, Rob Mulholland, 2008. Spling Ring
Trail. *Photo: Alison Stace*

OPPOSITE: *Dragonfly*, Rob Mulholland, 2008. Spling
Ring Trail. *Photo: courtesy of the artist*

## OVERVIEW

Loch Ard Sculpture Trail is very
picturesque, and the sculpture pieces
all relate to nature and wildlife, with
signs for children to engage with various
quizzes along the way. There is a lot of
walking, though, between works, and
since you can also cycle the trails this
might be a bit quicker for any impatient
members of the party, especially if you
want to do both trails. You can pick up a
map from the tourist office in Aberfoyle
but be careful which map they give you,
as one has times for walking and the
other for cycling. Both trails start and
end at the car park so you can always
start with the shorter trail to see if you
find one is enough.

The red route (Lochan Loop Sculpture
Trail) has some spectacular scenery and
follows the edge of Loch Ard for a good
chunk of it. This route takes much longer
– allow a couple of hours for walking. All
the sculpture is by the same artist, Rob
Mulholland, and there are four works set
on the route, located alongside the Loch.

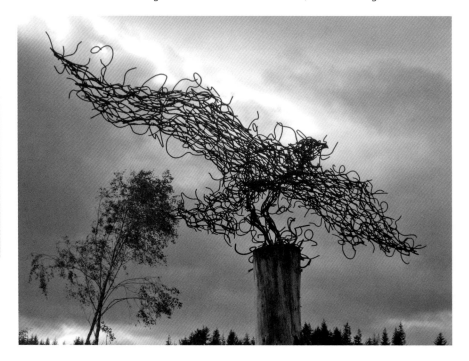

## FINDING YOUR WAY AROUND

Collect a map from the tourist information at Aberfoyle (specifying whether walking or cycling). Start from the main car park with the information board, i.e. not the very small one you come to first. The information board is helpful, but it is much easier if you have the map with you, and you still need to diligently follow the waymarkers. The letters marked on the maps are nothing to do with sculpture, but simply posts with letters on for children to find. However, these markers do help with navigation and often appear on a wooden post at the junction of two paths. Make sure you also pay attention to the wooden waymarkers with the colours of your route on them, as there are many trails here and you could walk a long way in the wrong direction if you miss them. By looking out for both letters and waymarkers you shouldn't find it too hard. At the start of the Spling Ring Trail it is not clear where the path begins, but follow cycle-route directions for the Loch Ard Trail and then you'll realise you are on the brown route, while the red route starts from the opposite side of the car park, nearer the road you came in on.

## THINGS TO SEE

The brown sculpture route (Spling Ring Sculpture Trail) had three sculptures on the route which were all very good and looked great with their various backdrops. The works on this trail were all by Rob Mulholland. *The Osprey* on the post was

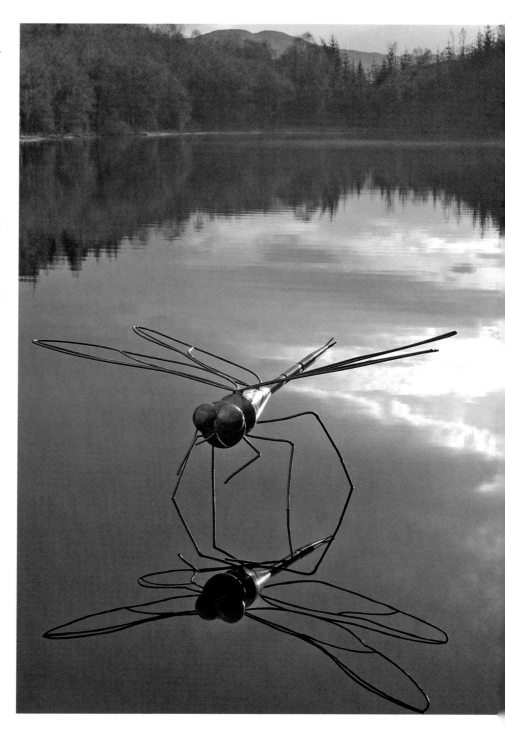

*Now You See Me Now You Don't*, Rob Mulholland, 2008. Lochan Loop Trail. *Photo: courtesy of the artist*

by far the best, as it really looks like a bird in flight, and because it is done in wire you have the feeling that someone has done a huge black sketch against the sky. The large dragonfly at the head of Lochan Spling works well with a stunning backdrop of water and scenic hills behind it, while the giant pike, although somewhat comical, was still impressive. Some pieces were very easy to spot, while others were less so, but all are flagged from the path with big signs offering

a question for children to engage with, which helps to act as a signpost to find the work. Look out for *Sol Stood Still*, a nice oblong work with a huge circle cut out with a Barbara Hepworth feel, which can be found in the car park.

On the Lochan Loop, there are four works on the route, alongside the Loch. *Now You See Me Now You Don't* is a family of foxes which cleverly blend in with their surroundings so that from

some angles they almost disappear entirely as they stealthily run through the woods. The *Eagle Pole* shimmers in the sun and looks very much like a tribal emblem, as it blazes out overlooking the water. There is also a large *Cone* shape – logs bound together have the cone cut out of them so you see both the cone itself and the negative space it occupied. *Red Rebels* is a very funny take on Star Wars – with the red squirrels battling the grey in the tree tops.

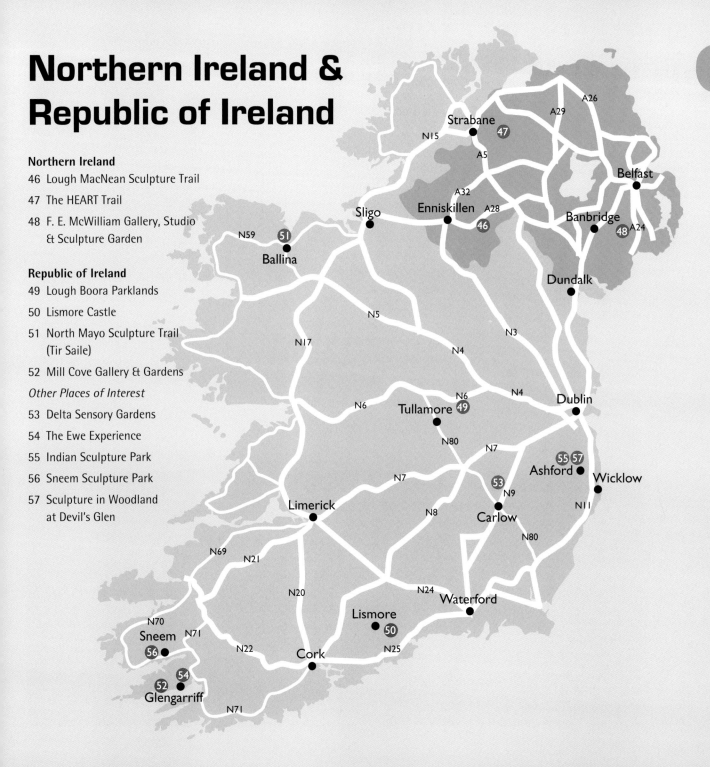

# Northern Ireland & Republic of Ireland

**Northern Ireland**

46  Lough MacNean Sculpture Trail

47  The HEART Trail

48  F. E. McWilliam Gallery, Studio & Sculpture Garden

**Republic of Ireland**

49  Lough Boora Parklands

50  Lismore Castle

51  North Mayo Sculpture Trail (Tir Saile)

52  Mill Cove Gallery & Gardens

*Other Places of Interest*

53  Delta Sensory Gardens

54  The Ewe Experience

55  Indian Sculpture Park

56  Sneem Sculpture Park

57  Sculpture in Woodland at Devil's Glen

# NORTHERN IRELAND
# 46  Lough MacNean Sculpture Trail

Fermanagh Tourist Information Centre
Wellington Road, Enniskillen BT74 7EF
Tel: (028) 6632 3110
Fax: (028) 6632 5511
Email: tic@fermanagh.gov.uk
www.discovernorthernireland.com/Lough-
MacNean-Sculpture-Trail-Enniskillen-P2643

**Facilities:** None
**Open:** Daily (dawn till dusk)
**Admission:** Free
**Time needed:** A whole day for everything
by car; two days walking

## Getting there

### BY CAR
First go to the tourist office in Enniskillen
to collect the leaflet with the trail map.
Several roads lead into Enniskillen: the A4,
the A32 and the N16. Wellington Road
comes off the big junction at the bottom of
town. From here you can drive to the first
point, which is in Belcoo on the A4, though
you don't have to follow the trail in any
particular order. This is too big an area to
walk around in a day. You will need a car,
or else a couple of days and a good level
of fitness.

RIGHT: *Letterbreen Mark*, David Kinane, c. 2000.
Bronze. *Photo: Alison Stace*

OPPOSITE: *Homage to the Lough* (back view), Ned
Jackson-Smyth, c. 2000. Steel. *Photo: Alison Stace*

## OVERVIEW

Dating from 2000, this sculpture trail,
located on the border between Northern
Ireland and the Republic, was apparently
inspired by peacekeepers. It was obviously
a well-thought-out and carefully
commissioned trail, with a good variety
of work. Unfortunately, it has not been
well maintained, so some pieces have
fallen into disrepair, though many are as
impressive today as they must have been
at the start. The trail has 13 sculptures
set over a 40-mile circular route, so you
will need a car if you want to see all or
even most of them in a day. It would be
possible to walk or cycle if you can spare
a couple of days, but the route follows
the road and there are some 7-mile
stretches between pieces.

## FINDING YOUR WAY AROUND

The information on the trail map is
fairly minimal, but without the map and
instructions it is nearly impossible to find
everything. We drove around all day but
still failed to find a few sculptures (those

that constitute No.4 on the map), all by the same artist, which were listed simply as 'Located in the Claddagh Glen between Blacklion and Florencecourt'.

The trail follows two loughs, Upper and Lower Lough MacNean, crossing over between them at Blacklion and Belcoo. One side of the trail follows the N16, while the other side follows the A4.

## THINGS TO SEE

For me, the best pieces were numbers 1, 2, 5, 7 and 8 (although the latter needs some serious repair). The numbers refer to the trail map (which is too large to reproduce here). Due to space restrictions I have not included them all below.

No.1, *Homage to the Lough* by Ned Jackson-Smyth, has three tall metal pieces with stencilled shapes cut out. They looked like sails, but could represent waves as well. In front of them is a wooden canoe, which appears to ride the waves. They stand on the pathway at the lough edge (Cottage Meadow) at Belcoo, in the field opposite a row of shops.

Sculpture no.2, *Letterbreen Mark* by David Kinane, stands at the corner of two roads, where the road towards Moybane and Killycat turns off the A4 at the Letterbreen junction for Springfield/Boho. Do not turn off the main road as the work is literally at the junction, somewhat hidden by bushes, ivy and moss. It was worth excavating, as it is an interesting circular bronze piece which forms a calendar. There is a spyhole,

through which you are supposed to see that the months are written on the inside of the form. I thought this was a great idea, but condensation on the inside of the lens made the spyhole impossible to use. Perhaps in the heat of summer this would disappear.

Sculpture no.3, *Monument* by Niall Walsh, is in a small parking lot within the grounds of Florencecourt House. You need to drive in and up towards the house. The piece itself is a nice work of charred wood, somewhat spoiled by being situated in a car park.

Sculpture no.5, *Imagine* by Louise Walsh, is located right beside the lough at the Lough MacNean Park (by the kids' playground) on the A16. Three large stones stand in line facing you with words inscribed and three holes. On closer inspection, these holes line up, giving you a perfect view of a little island in the Lough, while the words around the hole explain the concept.

Sculptures no. 7, 8 and 9 are all located off the R281, a small road leading to Kittyclogher. The R281 has a tiny signpost off the N16 which is hard to spot, but the turning is opposite a building called The Ballroom of Romance, which has a small rainbow painted on its side. Once on the R281, you will almost immediately see a road to your right signposted to Glenfarne demesne and Lough MacNean (just before the cemetery). Take this small road for some distance into the forest until you reach a car park. Then walk back to the sculptures, or pull off the road into one of the forest logging areas, park and walk along the road to them – it takes about two hours there and back to see all three.

At one point you will reach a junction in the road with a sign saying 'walkers' directing you left, but you need to go right which will bring you to the edge of the lough and sculpture 7 (*Inish Octa & Glen Fearmuighe* by Martina Galvin). This would have been amazing originally, as it is made from stainless steel, Perspex and a mirror coating that would have reflected the water of the lough. Unfortunately, the

mirror coating has broken so the effect is
lost. The three tall oblong structures have
small thin windows in them however, so if
you stand well back facing the Lough, you
can still see the reflected light shining
through the windows.

To continue, do not turn down the
path beside the information board and
sculpture no.7, instead go back to the
forest road you turned off and carry on.
No. 8 (*Reflectress* by Anna MacLeod) is a
similar concept in a different form – this
small stone dome has a hollow middle
with thick green glass inset, and from
certain angles the light shines through
it reflected from the lough, making a
lovely luminous green stained-glass
window effect.

IMAGINE

an island where all could live in peace

Make it real

# 47 The HEART Trail

**Information only**

HEART Sculpture Trail
Strabane District Council, 47 Derry Road
Strabane, Co. Tyrone, Northern Ireland
BT82 8DY
Tel: +44 (0)28 7138 2204
www.strabanedc.com/filestore/documents/
HEART_BROCHURE.pdf
www.strabanedc.com/filestore/documents/
HEART_SCULPTURE_MAP.pdf

## Getting there

**BY CAR**

This trail has no particular order, and is
scattered through many towns in Northern
Ireland and just across the border. These
include Ballybofey/Stranolar, Sion Mills,
Newtonstewart, Lifford, Castlederg,
Plumbridge, Donemana, Moville, Ardara,
Ballyshannon and Ramelton Village. Many
of these are on or just off the A5, as well as
on the A32 and N15.

## OVERVIEW

The HEART Trail (standing for Heritage,
Environment, Art and Rural Tourism) is a
public art trail, comprising 12 sculptures
scattered across 12 different towns and
villages, put together by Strabane District
Council and Donegal County Council.
Although this means you have to drive
between them, the towns involved are
all relatively close together (between 10
and 20 minutes apart), with many located
along the same road or routes through
towns. Most of the sculptures are very
interesting, though a few are simply
inventive benches, so if you do not want
to see them all, it is worth being selective.
A couple of the best ones have been
made by Cod Steaks, a company which
specialises in public art and often creates
very inventive, large-scale artworks.
There is a very good summary of the trail
online, which it is best to print out in
advance. This gives information on the
artists, the inspiration, the materials and
the location.

*The Matrimonial Tree*, Cod Steaks Ltd. Made from
hand-worked sheet metal. Located at Ballybofey.
*Photo: courtesy of Cod Steaks*

## FINDING YOUR WAY AROUND

With the information sheet you can follow directions to the sculptures. Because they are public works, most are easy to find and are in very prominent places, such as on a corner of the main road, on a roundabout or at a big junction. Unfortunately, *Rivers and Castles*, on the A5, is much more visible heading towards Omagh than in the opposite direction due to a turn-off in the road and a large hedge. It is located on the corner where the semicircular bypass comes off the A5, but go slowly! *The Flax Spinner* is located on the corner of Mill Lane as you enter Sion Mills from the direction of Newtonstewart, and is on your right just before the bridge. *The Three Coins* are impossible to miss as they are located on a roundabout on the way into Lifford.

## THINGS TO SEE

The more interesting sculptures are also the non-practical ones which incorporate the histories of the towns in unusual ways. A variety of artists have been commissioned, and thus the styles, materials and approaches vary widely, though a high standard is maintained throughout. *The Matrimonial Tree* by Cod Steaks, for example, uses the ancient local tradition of celebrating a wedding by planting two trees together, which then intertwine as they grow. *The Flax Spinner* is a large bronze work of a young woman at a spinning machine. She seems absorbed in her work. This

is a marker for the history of the town of Sion Mills, which grew up around Herdman's Linen, a spinning mill which is sadly now closed. The information sheet on the website gives the relevant details for each sculpture and offers a great insight into the inspiration behind each piece. The trail as a whole is a bit of a trek, but if you are passing through any of the towns it is well worth stopping to find them.

RIGHT: *The Flax Spinner*, Eamon O'Doherty, 2008. Bronze. Located at Sion Mills. *Photo: Alison Stace*

BELOW: *Three Coins*, Cod Steaks Ltd, 2008. Bronze. *Photo: Alison Stace, by permission of Cod Steaks*

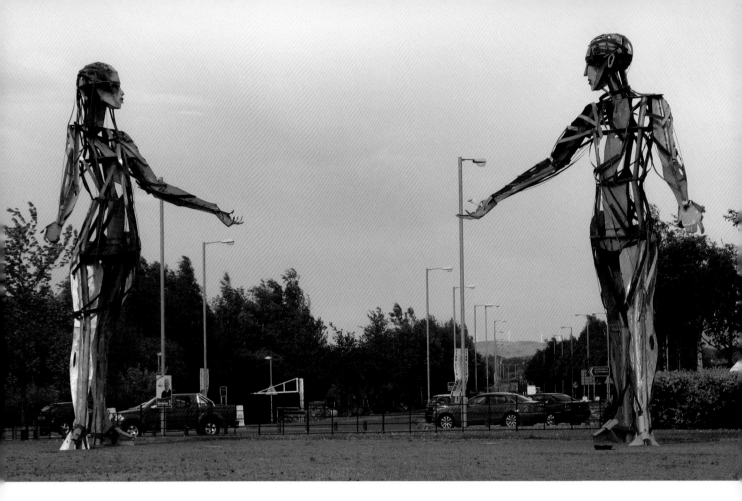

While on your travels, look out for a separate but very impressive sculpture on the large Lifford Road roundabout on the way into Lifford. As you follow signs to Lifford, you will see *Let The Dance Begin*, designed by Maurice Harron, five enormous steel and bronze figures against the skyline – one playing a pipe (fife), one a fiddle and one a drum, with two other figures poised and ready to dance. These tower over the traffic and sit on the symbolic site of an old border crossing – now shut. The sculpture aims to bring people together – both literally through the dissolution of the border division and also through music and dance. There is a layby which you can pull into and it is well worth stopping to see it.

*Let The Dance Begin*, designed by Maurice Harron, 2000. Stainless steel and bronze. *Photo: Alison Stace, commissioned and funded by ACNI; Strabane District Council; Sustrans; Ulster Wildlife Trust*

# 48 F. E. McWilliam Gallery, Studio and Sculpture Garden

200 Newry Road
Banbridge
County Down BT32 3NB
Tel: +44 (0)28 4062 3322
www.femcwilliam.com

**Facilities:** Café, toilets.
**Open:** Mon–Sat 10am–5pm, Sun 1–5pm
(Jun–Aug only), Jul–Aug open until 6pm
**Admission:** Free
**Time needed:** 1 hour

## Getting there

**BY CAR**
From the A1 between Belfast and Newry,
take the A26 at Banbridge. The A26 comes
off the A1 in a semicircle, part of which is
the Newry road. Follow the brown signs.
(Depending on which way you come, you
may need to double back but find yourself
unable to turn across the dual carriageway.
Keep following the signs to bring you back
the other way.)

## OVERVIEW

The gallery and gardens were set up as a
memorial to the sculptor F.E. McWilliam,
a contemporary of Henry Moore who
also worked in the modernist tradition
and was best-known during the 30s, 40s
and 50s. He liked his work to be seen
outdoors, hence the garden. He was
born in Banbridge, but lived for many
years in London, building a studio in his
garden at Holland Park. This has been
recreated to great effect in the garden
at Banbridge: the atmosphere, tools and
workspace are reminiscent of Barbara
Hepworth's studio in St Ives. Next to the
studio is a storeroom with many of his
original maquettes, which may be seen
by special arrangement. The glass and
wood open-plan gallery looks out on the
garden, and at the time of visiting an
interesting sculpture flowed from inside
to outside through the glass wall, as if
the wall wasn't there; the gallery is host
to a variety of changing exhibitions, not
always related to McWilliam.

*Man At Ease*, F.E. McWilliam, 1962. Bronze. *Photo:
Alison Stace by permission of F.E. McWilliam Gallery*

The garden itself is actually quite small, but has been beautifully designed by landscape architect Thomas Kaiser, around some enormous plinths and stone benches (which can also double as plinths), as well as open wooden structures and small hedges which divide the space into a series of 'rooms'. Many pieces of McWilliam's very varied work are featured in the garden, all bronzes, and the curators hope to add more. Other artists' work is featured alongside his in the summer months. The nature of the plinths restricts the type of work which can be shown, but the long-term plan is gradually to fill these with other McWilliam sculptures. The other exhibitions change every summer but don't often feature in the winter due to the risk of weather damage. Opened in 2008, the gallery, studio and garden combined make it a small but fascinating place to visit.

## THINGS TO SEE

I have chosen to mention a few of the permanent McWilliam sculptures. There was no other exhibition outside at the time of our visit, but you can check the website for details of other artists exhibiting in the summer.

*Man At Ease*, 1962, was the work which I could relate most to Henry Moore and that era of modernists. The large, solid forms, although more angular than Moore's work, have a similar abstract quality. *Woman in a Bomb Blast*, 1974, is one in a large collection on this theme,

mostly untitled but known as *Women of Belfast*. These sculptures clearly depict the results of bombs, the women's legs and arms flung out from the force in all sorts of contorted positions, often with material wrapped around them, emphasising the movement. Despite leaving Northern Ireland at 18, McWilliam never lost touch with his roots and kept a close eye on events in the province, with this series reflecting his hatred of intolerance and the chaos caused by men.

The fantastically angular figure called *Matriach* probably fits in the best with the architectural style of the garden, and she seems to dominate the space she occupies, despite being both seated and largely hollow.

TOP LEFT: *Woman in a Bomb Blast*, F.E. McWilliam, 1974. Bronze. *Photo: Paula O'Hara and © Estate of F.E. McWilliam*

LEFT: *Legs Static*, F.E. McWilliam, 1978. Bronze. *Photo: Paula O'Hara and © Estate of F.E. McWilliam*

RIGHT: *Matriarch*, F.E. McWilliam, 1982. Bronze. *Photo: Alison Stace by permission of F.E. McWilliam Gallery*

# REPUBLIC OF IRELAND
## 49 Sculpture in the Parklands

## OVERVIEW

The whole area of the Lough Boora parklands includes fishing lakes, wetlands and wildlife areas, located in the peaty boglands of what was previously an industrial peat-cutting site. The sculpture park is a relatively small part of the huge parklands, but it's still a large place to see, set in a flat, windswept and slightly eerie landscape. The dark peaty earth makes a great backdrop to some fantastic and often enormous pieces of sculpture. The work needs to be large to assert its presence in the landscape, and does so with often with dramatic results. Much of it has been made from the old pieces of machinery, trains and track left behind from the park's industrial past. Beginning in 2002 with eight site-specific pieces, these have been added to annually by the changing artist-in-residence. Recently these have dwindled due to funding cuts, but a grant in 2013 means new sculpture will be commissioned and a new visitor centre built. Other temporary work has also been created: Patrick Dougherty constructed a fantastic and enormous willow weaving here in 2008, which stood for many years. Bear in mind as you look around that the governing idea has been for the artists to respond to the fantastic landscape, and the industrial legacy left by the boglands.

Lough Boora Parklands
Lough Boora, Co. Offaly
Email: info@sculptureinthe parklands.com
www.sculptureintheparklands.com

**Facilities:** Toilets
**Open:** Daily, all year, dawn to dusk.
**Admission:** Free
**Time needed:** 1½ hrs

## Getting there

**BY CAR**
From the east: Take the N52 from Tullamore towards Birr, and at Blueball turn right onto the R357 for Cloghan/Shannonbridge. Look for brown signposts for the parklands.
From the west: From Birr take the N52 towards Tullamore, then take the the N62 towards Athlone, turning right at Cloghan onto the R357. Look for brown signposts to the parklands.

The park has a very good website with information on the work and a small map which can be downloaded before you go, or obtained at the information centre nearby (see below).

## FINDING YOUR WAY AROUND

Once you have turned onto the R357, drive past the entrance to Finnamore Lakes (depending on your direction) and continue until you come to a grey stone house set back off the road – it should have a small board outside in the road. This is the visitor information centre (different from the pavilion within the park). It looks unlikely, as it has no sign on it to indicate what it is, but inside is a small office where the map can be obtained. Be warned that it may shut over lunch. If you miss it or it is shut, there are boards at various points around the park so you are unlikely to get lost, but the map is useful to have. (You can also download it from the website before you set off.) Once you have your map, continue on down the road for a few minutes, passing a large complex of parkland buildings and car parks, until you find a green sign for Sculpture in the Parklands and you come to the cycle-path road. Continue on down the cycle-path road until you pass the first lake on your

LEFT: *Bog Wood Road*, Johan Sietzema, 2005. Found bog oak. *Photo: Alison Stace, by permission of Sculpture in the Parklands*

RIGHT: *Sky-train* and detail, Mike Bulfin, 2002. Reclaimed train and parts. *Photo: Alison Stace, by permission of Sculpture in the Parklands*

right and reach the head of the second lake, with a small parking area to the left and information boards on your right.

The path takes you around the park pretty much in a big loop. If you start at the Sky-train, ignore the small path to your right and instead continue straight on so that you walk in front of the sculpture. The path then leads you right around, so you are unlikely to miss anything, but be sure to turn off along the short detour to your left towards the end (rather than crossing the first metal bridge), which takes you past many good pieces before you then cross back over the canal using the Tippler Bridge. The paths are all pretty good with gravel to compensate for the peaty ground.

## THINGS TO SEE

There are many great pieces of work to see here. Given that the idea was to respond to the landscape and previous life of the area, many of the sculptors have taken this almost literally, using old machinery and metal parts left behind. The rich rusty colours contrast well with the dark peaty earth. In *Bog Track*, one of my favourites, the artist Johan Sietzema has used 'thrown away' bogwood – quite literally large dead oak trunks which stand like eerie black ghosts, salvaged to create something new while offering a kind of memorial to the forests that once stood here. *Sky-train* by Mike Bulfin I thought looked better in the flesh than from its photo, especially as you see it up close to start with and then from a distance on the return journey. *Boora Pyramid* by Eileen MacDonagh was built from enormous glacial stones, unearthed during the peat collecting, and evokes ancient civilisations.

*Raised Circle* by Maurice MacDonagh almost looked as if someone had simply drawn a line around a specific area, arbitrarily enclosing some trees while leaving others outside. Raised up on thin legs, it appears to float above the ground. Jorn Ronnau's *Lough Boora Triangle*, in contrast, is at first glance, from the outside, a not hugely attractive and very heavy-looking hulk of a sculpture. However, its beauty is revealed when you get up close and look inside, where a secret triangular seat greets you, along with the detail created by the fascinating

pattern of the logs stacked together. From the inside looking out, only a thin strip of land and sky is visible. Part of its aim was apparently to act as 'a space for meditation', and to my mind it has perfectly achieved this.

*The Rhythms of Time* by Marian O'Donnell had the feel of an ancient amphitheatre and I thought worked really well, the semicircles within circles and the tall posts all giving a feeling of ceremony and performance. Before crossing back over the canal through the somewhat unnerving Tippler Bridge (you can see the water beneath you), make sure you go to see *Passage*, by Alan Counihan, off to your left. This brilliant piece uses reclaimed metal parts to create a tunnel cut out of the earth along which you walk, with a feeling of ritual and procession, before heading up some stairs towards three tall posts. At the end, turning back you will see another post lined up with the exit. This very simple piece has given reclaimed metal pieces a new function for which they seem almost to have been made.

TOP LEFT: *Boora Triangle*, Jorn Ronnau. Bog oak and iron. *Photo: Kevin O'Dwyer, courtesy of Sculpture in the Parklands*

BOTTOM LEFT: *System No.30*, Julian Wild, 2009. Welded scrap metal. *Photo: Alison Stace, by permission of Sculpture in the Parklands*

RIGHT: *Rhythms of Time*, Marian O'Donnell, date unknown. Turf, steel, stone, bronze and bogwood. *Photo: Alison Stace, by permission of Sculpture in the Parklands*

# 50 Lismore Castle

## OVERVIEW

The gardens at Lismore are gorgeous, very well maintained and a delight to wander through, with the added bonus of sculpture on top. The castle is a private residence and not open to visitors. Strangely, the gardens are split into two levels, and straddling them is an ancient tower house (the Riding House), which acted as part of the castle fortifications. To access the gardens you need to enter the house and see the gardens in two stages. The work is evenly spread between them, with the best work in the lower gardens. Although there is not a vast amount to see here, the work is all of a high standard and the place itself is so lovely that, all in all, it is well worth a visit. The upper gardens, which I would suggest you visit first, also house the very unexpectedly contemporary gallery. Cleverly converted from a derelict west wing of the castle, this hosts changing exhibitions by some well-known artists. The upper gardens – a walled garden built by the first Earl of Cork in 1605 – have a much more formal feel and are laid out in a grid, with paths intersecting it. The lower gardens by contrast have rolling grassy areas and an imposing yew-tree avenue (where Antony Gormley's figure can be found). The work has been well sited within the grounds, with each piece carefully positioned.

Lismore, Co. Waterford, Ireland
www.lismorecastle.com
www.lismorecastlearts.ie
Tel: +353 (0)58 54061
Time needed: 1–1½ hours

**Facilities:** Toilets, beverages available.
**Opening times:** 31 Mar–30 Apr, weekends only. Easter weekend, open Fri–Mon. 1 May–30 Sep, open Tues–Sun (closed Mondays except bank holidays).
**Daily hours:** 11.30am–5.30pm (last entry 4.30pm)
**Admission:** Adults €8, concessions €4, children €4, family tickets €20.

## Getting there

Lismore is on the N72 between the N25 and the N8. Once in Lismore, follow signs to the castle and park in the castle car park before walking up the small road.

## FINDING YOUR WAY AROUND

Once you have parked, walk up the little road to the castle. Get a map of the work and gardens at the entrance, inside the tiny tower house. The map is very easy to follow and there is no set route. All the sculptures are located with a letter on the map, but an easier way to navigate and find them is to use the plants since many of them are numbered on both the map and at their base or somewhere near their stem. The best plan is to go to the upper level first, having paid your entry fee in the tiny house with its lovely cobbled floor (which has a deceptively ancient-looking figure-of-eight pattern on the floor made from pebbles), and climb the very narrow and winding wooden staircase upstairs, walking through the top floor to the upper gardens. The gallery is also on this level, where you can see everything fairly easily. When you come out of the house, turn right and head towards the pink bench, which is *Nachempfindung* by Franz West. The gallery is just to the left of this, up the stairs. Once you have seen the upper gardens (and the gallery), you can go back downstairs and then out into the lower gardens through the back door. Before you go, make sure you buy a ball bearing for the *Ball in Earth* sculpture (see overleaf).

LEFT: *Hunting*, Bridget McCrum, 2001. Bronze. *Photo: Wishy Martin, courtesy of Lismore Castle Arts*

RIGHT: *Over and Under Series IV*, Eilís O'Connell, 1999. Bronze, unique cast for Lismore Castle. *Photo: Alison Stace, by permission of Lismore Castle Arts*

## THINGS TO SEE

On the upper level, the two works which stood out for me were *Hunting* by Bridget McCrum – a large bird of prey, very solid against the sky – and *The Irishman* by Edwin Whitney Smith. This torso sits under a tree looking out across the gardens, and the dappled shadows play across the face of the figure. I also liked *Those Fields*, *Those Hills* by Marie Lund, a tree trunk cut off and cast in concrete – presumably a comment on the land that we have ravaged for our own purposes.

TOP: *Wrapt*, Eilís O'Connell, 1999. Bronze. *Photo: Alison Stace, by permission of Lismore Castle Arts*

LEFT: *Learning To Be I*, Antony Gormley, (detail below), 1992. Iron, air. *Photo: (left) Alison Stace, (below) Andrew Lawson, courtesy of Lismore Castle Arts*

OPPOSITE: *Three Lismore Columns*, David Nash, 2005. Oak. *Photo: Alison Stace, by permission of Lismore Castle Arts*

On the lower level, all the pieces worked really well. Just outside the back door, to the right is what looks like either some sort of water attachment or a stand with a missing sculpture. Thinking some part of it was broken, I checked at the desk, apparently a common occurence. It is in fact *Ball in Earth*, a sound sculpture by Roman Signer. You need to buy a ball bearing from the cash desk (1 euro) and then place it in the opening at the top of the tube. Make sure you keep the little lid open to hear the ball rattle its way down the tube to hit a bell located underground. It makes a great sound, and I liked the idea of a secret bell hidden deep underground. However, there is nothing to tell you what you should do, so unless you ask for a ball bearing you would never know, and could easily miss it entirely.

Standing in the yew-tree avenue is Antony Gormley's figure *Learning To Be I*, hilariously standing in line as if he was one of the trees lining the avenue. It is obviously a site-specific piece and works brilliantly well. The *Three Lismore Columns* by David Nash are also really well sited, set off to their best in a clearing, their relationship to each other changing as you walk around. Eilis O'Connell's *Wrapt* piece looks great, set off well by some beautiful coloured trees and flowering shrubs behind it, while another O'Connell piece at the other end of the gardens called *Over and Under Series IV* is a simple, statuesque tower shape that fits in very well with the form and elegance of the castle it stands beside.

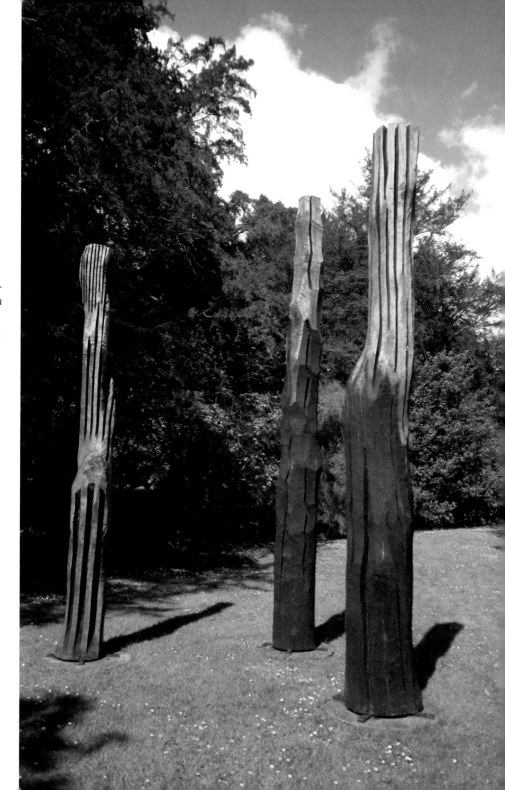

# 51 North Mayo Sculpture Trail (Tir Saile)

## OVERVIEW

Tir Saile stretches all along the coastline, so trying to see everything in a day is almost impossible – you will certainly need two, and a car. It is well worth sending off for the small booklet that accompanies the trail, available from the email below. It contains directions, although these can be somewhat minimal, but also drawings of the works and information on local flora, fauna and history. Some things are very easy to find while others are quite hard, but all are signposted so when you do get to the spot or thereabouts, you know you

are on the right track. General signposts are brown and read Tir Saile, while those for specific works have the letter of the sculpture on them (see below), which is a great help. The hardest to find and easiest to get lost around are sculptures D and E, but D is well worth the trip, so don't be put off. You will need patience and determination for this trail, but it does bring rewards. Bear in mind, though, that most of the sculptures were installed in 1993, and some have been overtaken by grass or battered by the elements.

The idea behind the trail was to use a limited range of organic materials which would last through the next five millennia (consequently, many are made of stone), and to reflect the location, considering things such as ancient settlements, farming and local folklore. A nice summary given in the Tir Saile guidebook was that 'Artists, moved by their experience of the location, took the landscape and inscribed upon it their thoughts and feelings in visible form.' As is sometimes the case with these projects,

Along the North Mayo coastline, Co. Mayo

**Information only**
Ann & Laurence Howard
Tel: 00353 (0)98 45107
Email: 1claggan@eir.com
www.mayo-ireland.ie/Mayo/Towns/Ballina/
TirSaile/TirSaile.htm

## Getting there

**BY CAR**
The sculptures are spread out along the coastline, so it's best to start from Ballina on the N59. The first sculpture is sited next to the R314 (the Killala road); look for the brown signpost labelled Tir Saile.

*Tonnta na mBlianta*, Simon Thomas, 1993. Gneiss, basalt, copper, iron and stainless steel. *Photo: Alison Stace*

the results are mixed, but it is part of the joy of exploring them to decide for yourself how successful each one is. To save you a fruitless search however, if you are starting at Ballina, sculpture A was an 'exhibition site' off the N59, but nothing is shown here now.

Due to space restrictions, I have only listed the sculptures I felt were the most successful, and had best survived the inevitable weathering. The letters correspond to the letters given on the map in the booklet, which is available to order by post, as mentioned previously.

## FINDING YOUR WAY AROUND & THINGS TO SEE

**C** *Tonnta na MBlianta* by Simon Thomas. Once you are through Killala on the R314, follow this road until you cross a small bridge and the road divides, then turn right towards Kilcummin Pier (signposted). Look for brown Tir Saile signs, and at the crossroads turn right again. The pier is tiny, but you will know you have reached it when you see the Tir Saile sign and come to a small row of cottages facing a row of large boats hauled up on land. Divers also use this pier at weekends so you may find parking a bit tight. Facing the sea, if you turn to your right you will see a large harbour wall built into the cliff. You need to get up close to see it clearly, as it doesn't look much from a distance, but it has a subtle range of earthy colours – oranges to yellows and browns. A series of circular holes has been drilled into the rock face,

creating a larger circle, and into each a new material has been wedged, in an order that follows human discovery and development of these materials – starting with gneiss as the oldest, then basalt, copper, iron and stainless steel. Both the concept and design of this piece remain very beautiful, despite time and the elements.

**D** *Tearmann na gaoithe* by Alan Counihan was my favourite piece, but to reach it you will find it much easier to start from sculpture E, which is a little further on along the road. From sculpture E, continue on the path past E keeping the sea on your left, and walk in a straight line hugging the cliff edge, going from stone stile to stone stile. After about 15 minutes you will start to see the stone roof appearing on the horizon of the cliff edge: from this angle it will look quite square. Once you reach sculpture D you will find a very well-preserved little triangular stone house – although it is not quite a house as you can see straight through it from one side to the other, framing the sea, with in the centre a small seat built into the wall. This fantastic shelter has a superb drystone wall roof which reaches right to the floor, Perfectly situated on the headland between Lacken Bay to the left and Killala Bay on the right, the shelter commands great views and looks as if it has been here since time began. Moving on from here, the road you are parked on is a dead end and does not continue all the way around the bay, so you need to retrace your steps to the R314.

*Tearmann na Gaoithe*, Alan Counihan, 1993. Sandstone. *Photo: Alison Stace*

**E** Finding E is quite tricky. From Kilcummin pier, continue on the small road into the village (not heading towards the sea, which is obviously a dead end). Going through the village past the church, the road brings you to a crossroads. Two directions point to Foubert's Path, but ignore these and go straight ahead on the road with the derelict cottage at the corner. The road looks unlikely as it becomes very rough and potholed. You pass a white cottage on your right and then a white house on your left, and also the sign for D, but carry on until you reach the end of the road where there is a hairpin bend and space to park. This road overlooks Lacken Bay with its beautiful sandy beach. As the road turns the corner you will see the signpost for sculpture E. Facing the sea, to the right of the car-parking space you will

see a row of stone slabs heading off down the hill, creating a sort of fence. Squeeze between these and you will see a faint path in the grass. On your left at the cliff edge is sculpture E, *Echo of Nawascape* by Mariyo Yagi, which was probably once a very organic-looking stone spiral. It still remains but the grass has overtaken it, and over time the stones have settled somewhat, meaning some of its original glory is lost.

**F** This sculpture is located on the R314 right in front of Saint Patrick's College, Lacken Cross (between Killala and Ballycastle). Please note that this is private property so you cannot get a close look unless the gates are open. The sculpture featured in the Tir Saile guide no longer exists and in its place stands a new work – a tall, monumental bronze sculpture which has an educational theme tied in with the local fishing trade. It

gives the impression of a small stream stood on end, with large fish swimming through it, while at the bottom of the stream lie books, pencils and calculators.

**G** *Court Henge* by Tony Murphy is a take on Stonehenge but without the megalithic stones. Located on your right as you come in to Ballycastle on the R314 (from Killala direction), it is situated within a walled enclosure containing the Ballycastle holiday cottages – or at least they are located around it. It aims to provide a central gathering and play area, with the stone walls enclosed by earth mounds offering seating as well as enclosing a space.

**H** *Battling Forces* by Fritze Rind. From sculpture G, continue on the main road and turn right beside the old ruin on the R314 in Ballycastle towards Rathlacken

and Downpatrick Head (signposted Tir Saile). Following the signs along a twisty rural road brings you quite soon to the sculpture, which is on a bend by a space for parking. It is on your left by the sea; you will recognise it instantly by its title.

**L** *Acknowledgement* by Marion O'Donnell is located on Claggan Island, in the north-eastern corner of Blacksod Bay. The island is connected to the mainland by a thin strip of sand which you can drive across all year round. The sculpture consists of two walled, manmade earth slopes, creating a narrow passage allowing you to walk between them. The aim was to create an acknowledgement for all the lost souls that have died unclaimed or unnamed, drowned at sea or from suicides.

**O** Continuing on the R313 towards Aghleam and An Fod Dubh (Blacksod) feels a bit like driving to the end of the earth through small and often unnamed villages, and is a fair way, but the Tir Saile signs continue (though often as part of larger signposts) and will lead you to *DeirBhle's Twist* by Michael Bulfin, which I felt was definitely worth the effort. A large stone path leads you towards the sculpture, which is enormous and clearly visible from the road. Reminiscent of Stonehenge, a series of large monoliths create a curving line of stone, leading you into the centre of a spiral. This piece has a very dramatic feel as it is situated quite high up on a hilltop. Michael Bulfin is quoted in the guide: 'The stone is the landscape. It was always here. I have just, in a sense, rearranged it.'

**P & Q** Although not listed in the guide-book, the information board at site O shows three more sculptures. These late additions to the trail were all designed by Travis Price. *Thin Places* consists of two shrines dedicated to those lost at sea. Found at Anagh Head, Doonamoe, Belmullet.

**R** *Vault of Heaven* by Travis Price is a shrine processional dedicated to the children of Erris. It is located at Scotts Port, Belmullet.

OPPOSITE: *Battling Forces*, Fritze Rind, 1993. Lacken sandstone and limestone. *Photo: Alison Stace*

THIS PAGE: *DeirBhle's Twist*, (and detail). Michael Bulfin, 1993. Stone. *Photo: Alison Stace*

# 52 Mill Cove Gallery & Gardens

## OVERVIEW

The lovely grounds of Mill Cove Gardens overlook the sea, so once you have finished your visit, make sure you allow time to take tea outside and admire the view. Mill Cove Gardens are a hidden treasure, located on a slightly far-flung bit of land, and the winding but scenic drive is totally worth it as both the work and the gardens are an unexpected treat. Open since 2007, the gardens have been gradually expanding ever since. All the work is of a high standard, and the gallery often works with the Botanic Gardens in

Kenmare, Co. Kerry
Tel: +353 (0)27 70393
www.millcovegallery.com

**Facilities:** Toilets, tea rooms (in summer)
**Open:** Apr–Jun and Sep, Wed–Sun 11am–6pm; July–Aug, daily 11am-6pm.
**Admission:** €3
**Time needed:** 1–1½hours

## Getting there

### BY CAR
Mill Cove Gallery is on the R572, Beara Peninsula, 25km from Glengarriff on the way to Castletown Bere. Look out for small signposts as you approach, on white boards that could be easy to miss.

LEFT: *Ball Player*, Ana Duncan, exhibited in 2012. Bronze. *Photo: Alison Stace, by permission of Mill Cove Gallery & Gardens*

RIGHT: *Venetian*, Ken Drew, exhibited in 2012. Bronze. *Photo: Alison Stace, by permission of Mill Cove Gallery & Gardens*

Dublin, which runs an open competition annually called Sculpture in Context. Much of the work comes on to them from the show, and sometimes vice versa. Having run several galleries in Dublin, the owners John Goode and John Brennan decided to have a change of scene and open up the gallery and grounds here.

The gardens are set on a sloping hillside which leads gently down towards the sea, with a large grassy area and small paths that lead you around. No map is needed; instead you simply have a list of the works, all of which are numbered. Mill Cove promotes Irish artists, and there is a good variety of media and types of work, from ceramics and stone to steel, cement and bronzes. At the bottom of the garden a long series of steps takes you down to a terrace which overlooks the beach running along the bottom of the garden and back up the other side; work is positioned at intervals, often set nicely against the backdrop of the sea or the lush garden on the other side. Some of the work is part of the gallery's permanent collection but most of it is for sale, so some of what is mentioned here may have gone by the time this book is published.

## FINDING YOUR WAY AROUND

The gardens are not so big that you are in danger of getting lost, and are well laid out so that each area flows into the next, with the path on the whole leading you around very easily. There are only a couple of places where you need to stray from the path: on the first level where you wander around the grassy area and some pieces are hidden around a corner in amongst some trees, and towards the bottom of the garden where you need to backtrack a little to get to the steps leading down to the next section. Otherwise, it is all very straightforward, with the path heading down and overlooking the beach, then eventually bringing you back up to the other side of the gallery.

## THINGS TO SEE

If you have time, it is worth having a look around the little gallery, which has many nice paintings and changing work. In the grounds there were so many good pieces, and while some remain for considerable lengths of time, others move around so may not still be there, though some artists are well-known and will often have different work here. A brief summary of a few of the fantastic pieces of artwork will give you an idea of the kinds of things the gallery displays. Amongst the pieces that stood out was *Venetian* by Ken Drew, a lovely curved form with a window, looking like a little piece of architecture in amongst the flowers. Ana Duncan had several figures in a series which was dotted around – all bronzes holding a ball in different poses and all with very flowing,

curved forms, so that body and ball almost become one. My favourite was *Ball Player*, with the ball held in front of the figure on elongated arms. The very funky form of *Zengdi* is actually a permanent piece by Jim Turner – a tall tower with a spiky ball at the top that is quite different from most of the work here.

Amongst the trees stood three forms on poles: *Three Birds* by Anna Campbell. These very fragile-looking forms are actually made from bronze but were so beautiful and delicate that you could imagine them as real birds. This artist also created *Fragile State*, a house on legs (actually a couple of them). Standing on what appeared to be spindly wooden branches, uneven and thin, the whole

impression was of a beautiful but fragile house for the faeries.

Coming back along the lower path I was struck by an unusual female head and shoulders with extremely long horizontal hair. Entitled *Daughter of Earth & Water*, and made, unusually, from fibre and cement, this piece by Ayelet Lalor seemed perfectly at home amongst the elements.

TOP LEFT: *Blue Man*, Eleanor Swan, exhibited in 2012. Ceramic. *Photo: Alison Stace, by permission of Mill Cove Gallery & Gardens*

ABOVE: *Dandelion*, Naomi Jobson, exhibited in 2012. Stainless steel and ceramic. *Photo: Alison Stace, by permission of Mill Cove Gallery & Gardens*

RIGHT: *Fragile State*, Anna Campbell, exhibited in 2012. Bronze. *Photo: Alison Stace, by permission of Mill Cove Gallery & Gardens*

# OTHER PLACES OF INTEREST
## 53 Delta Sensory Gardens

### OVERVIEW

This is an unusual sculpture garden as it is actually a whole series of tiny garden 'rooms', which have been developed for sensory awareness and enjoyment. It is designed 'with a therapeutic focus and benefit, for people of all abilities'. The gardens are a very well-hidden and unexpected area of beauty and calmness. They are much more extensive than they look at first glance, and while you probably could whip through fairly quickly if you wanted, the aim is to meander and contemplate. Each little garden room area leads onto the next,

each with a different theme and name. The sculpture garden is one amongst them, but actually pieces of sculpture are scattered throughout. The majority of the work is by Bob Frasier, who trained at art college but works at the gardens and creates pieces for suitable spaces in that setting. These range from organic forms to giant stone tools, such as the gardening shears, which seem to have been left casually on a wall. There are also some lovely pieces by Martin Monks, commissioned by Carlow County Council and rescued from an old courthouse.

*Giant shears*, Bob Frasier *Photo: Alison Stace*

*View of the sculpture garden*, sculpture by Bob Frasier. Stone. *Photo: Alison Stace*

Strawhall, Carlow
Tel: +353 (059) 9143527
www.deltasensorygardens.com

**Facilities:** Café, toilets
**Open:** 9am–5pm Mon–Fri, 11am–5.30 pm weekends and public holidays. Closed weekends Jan–Feb ( but open by appointment ).
**Admission:** Adult €5, children free (with adult), senior/concessions €4
**Time needed:** 30 mins–1 hour

### Getting there

At the roundabout of the R417 & N80, take the small road which leads you down past a number of large retail warehouses then follow signposts along the road.

## FINDING YOUR WAY AROUND

A brief warning to say that Google maps has for some reason located the gardens in the wrong spot, nearby at Strawhall, when in fact they lie just off the Athy Road roundabout (see directions). I expect this error to be remedied at some point however, but if you are using sat nav and find yourself in the wrong place, this could be why. Once you are inside the gardens, a series of 'rooms' divided by hedges, weavings and small walls leads you around, broadly speaking, in a big loop - you can't get lost.

BELOW LEFT: *Sculpture*, Martin Monks, in the Stolen Child Garden. Wood. *Photo: Alison Stace*

BELOW RIGHT: *Mother Nature*, Bob Frasier, in the Stolen Child Garden. Earth, rocks and moss. *Photo: Alison Stace*

## THINGS TO SEE

Starting on the left-hand side, you can walk around the gardens following the path through every area in a big circle. As well as work in the sculpture garden, look in particular for Martin Monks's stone man with his book in the willow garden, then wander through to the back of the gardens where it unexpectedly opens out into a gorgeous little lake scene, complete with abandoned rowing boat and waterfall. A particularly modern but attractive area is beyond this, where a series of oval windows are echoed and reflected into the distance. My favourite garden, however, is on the other side as you come back up towards the entrance. This is the Stolen Child Garden, created by Mary Reynolds and shown at the Chelsea Flower Show in 2003, winning a gold medal. This wild and natural-looking garden has little islands and ponds and has, of course, been very carefully thought out. Here you'll find another couple of wooden figures by Martin Monks, and there is also a hidden sculpture of *Mother Nature* by Bob Frasier, initially very hard to find but worth the hunt.

When you are finished in the gardens, make sure you put your head into the music room, behind the reception room when you first enter the gardens. Inside you will find a very serene space filled with coloured lights, playing fountains and music. All in all the Delta Sensory Gardens is a delight to visit, and an unexpectedly relaxing place to find tucked away.

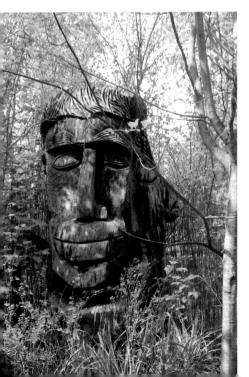

# 54 The Ewe Experience

## OVERVIEW

On arrival, you will find a gate and a bridge, and you need to buzz for the owners to come and let you in, and pay on entry. The Ewe Experience sculpture garden is set in lovely surroundings, with a river running through it crossed by wooden bridges. The garden is a child's delight and, with so many quirky things tucked into every corner, almost overwhelming. Both house and gardens have been created by the owners, the Lyndorffs (and opened to the public in 2006). Indeed most of the sculpture itself has been created by Sheena Lyndorff, and much of it is very comic in its approach. There are other pieces, however, that have a more thoughtful quality, such as the Stairway to Heaven, made from a ladder and many pairs of boots. Much of the work is made from ciment fondu and latex, creating a versatile medium that can be readily sculpted while being relatively weatherproof.

Although Kurt Lyndorff does have maps of the garden, he does not give them out automatically as most people don't use

Glengarriff, West Cork, Ireland
Tel: +353 (0)27 63840
www.theewe.com

**Facilities:** Café (in summer), toilets
**Open:** Daily 10am–6pm during summer. Spring and autumn by appt.
**Admission:** Adult €6.50, children €5, family €20 (2 adults, 2 kids)
**Time needed:** 1–2 hours

## Getting there

### BY CAR
Located on the N71, 3 miles north of Glengarriff between Bantry and Kenmare – it is well signposted with pointing hand sculptures as you approach it. Turn into the small car park.

them, so if you want one you need to ask. However, they are not really necessary as a system of numbered pointing fingers guides you throughout. The numbers do not correspond to any list, but simply lead you from one part to the next. The tiny paths weave in and out and up and down, taking you over every inch of the forest and hillside (though you need to keep track of the numbers). You also need to watch your footing, as there are branches and rocks to trip you up while you are otherwise distracted by hidden pieces of work (a pram would be impossible). All the pieces are very accessible, the idea being that art is for everyone, not just a reverential elite. Thus the gardens are more about having fun and interacting with the pieces. In that vein, there are various board games throughout, using pebbles and sticks or rocks, with instructions on how to play.

We spent an hour here but if you have children, or more time, you could no doubt spend much longer as there is so much to see in every corner. In the summer a small café serves drinks, cakes and ice cream in a lovely setting overlooking the river.

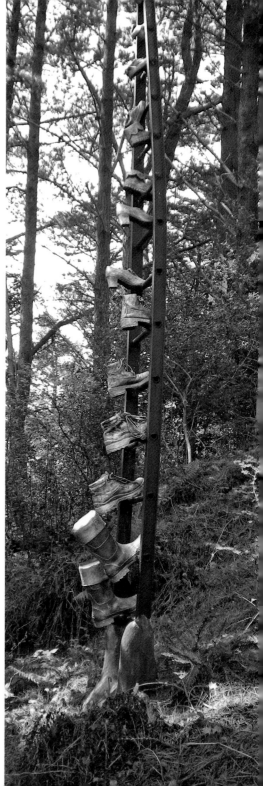

TOP LEFT: *'Tis a Grand Ride Back Tho'*, Sheena Lyndorff. Mixed media. *Photo: courtesy of The Ewe Experience*

BOTTOM LEFT: *Milk maidens*, Sheena Lyndorff. Recycled milk cartons. *Photo: Alison Stace*

RIGHT: *Stairway to Heaven*, Sheena Lyndorff. Mixed media. *Photo: Alison Stace*

BELOW: *Whirled Wide Web*, Sheena Lyndorff. Mixed media. *Photo: Alison Stace*

# 55 Indian Sculpture Park

Victoria's Way, Roundwood
Co.Wicklow
Tel: +353 (0)1 281 8505
www.victoriasway.eu

**Facilities:** None
**Open:** Daily, 28 Apr–9 Sep, daily from
12.30–6pm
**Admission:** €2.50, under-16s free
**Time needed:** Approx. 1½ hours

## Getting there

### BY CAR
**From Dublin** take the N11 towards
Wicklow. Turn right at Kilmacanogue
towards Glendalough, and after about
7 miles turn right towards Sally Gap on
the R759. At the first crossroads turn left
towards Roundwood on the L1036, looking
for the park on the left.

**From the south**, take the N11 and turn off
towards Roundwood onto the R764. Drive
through Roundwood and, as you come
out again, take the left fork in the road
towards Sally Gap, the R1036. Look for
the park about a mile or so further along,
on your right.

RIGHT: *Yoni Mudra*, Victor Langheld. Black granite,
(the entrance to the park). *Photo: Alison Stace*

OPPOSITE, TOP LEFT: *Lord Shiva*, Victor Langheld. Black
granite. *Photo: Alison Stace*

CENTRE: *The Split Man*, Victor Langheld.
*Photo: Alison Stace*

TOP RIGHT: *Veena Ganesh*, Victor Langheld. Black
granite. *Photo: Alison Stace*

## OVERVIEW

With all sculpture parks and trails, the
'time needed' is inevitably a bit of a
generalisation as obviously everyone walks
at a different pace and will spend more
or less time looking at work, taking in
the views, etc. In the case of the Indian
Sculpture Park, this is certainly the case.
Each work has a board with an explanation
of sorts, and it takes a lot of concentration
to read each one, to fully understand it,
and then to digest the information and
reflect on it. This was the aim of the park,
and if you do this for each piece you could
be here well over an hour and possibly
as long as three. The owner and creator,
Victor Langhel, says this is exactly the
idea, and that it is for people 'having their
mid-life crisis to come and reflect on the
next 30 to 40 years of their life. It is not a
fun park – people should take the time to
think about things.' Of course it is up to
the individual at what level they engage
with the work and the thought behind it,
and you can equally just stroll through
and enjoy the surroundings and the
interesting work. The park is open for most
of the spring and summer, but check the
website for exact dates and also for any
other opening weekends if the weather is
particularly good.

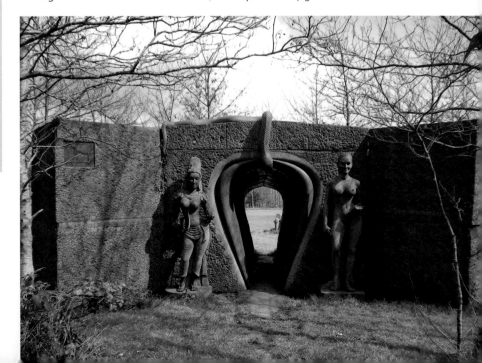

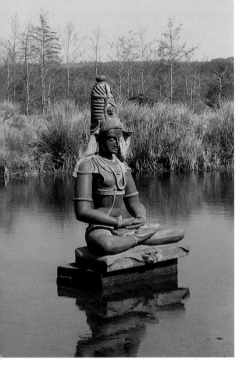
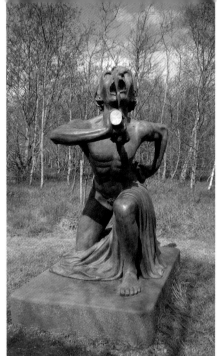
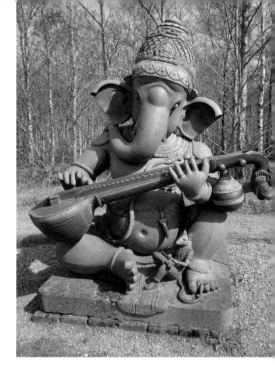

The owner, Victor, has a very interesting history, the most recent part of which is that having been a Buddhist monk for 20 years in India, he decided to come home to Ireland and set up the park, 'I was looking for something meaningless to do with my life,' he says with a glint in his eye. All the works are based on religious iconic figures, but with a large twist of personal interpretation. The first field for example, greets you with a semicircle of large Ganesh figures, each one playing a musical instrument, creating a sort of band. At the foot of each sits a mouse, reflecting or contemplating the great beyond, one or two in interesting outfits. The entrance to the park is through an enormous tunnel, with figures on either side. The tunnel, which is pear-shaped with lots of small protrusions inside, turns out to be a giant vagina – the idea being presumably that

as you walk through it you experience a sort of rebirth or awakening. The entrance has been dedicated by Victor to the cryptologist Alan Turing.

Further into the woods, the work becomes much more personal, extreme and dramatic. *The Ferryman* wades through a lake looking distinctly malnourished and exhausted, the board explaining that the ferryman is a metaphor 'for the individual who tries to be still, to remain the same, decays and dies'. He cannot reach the opposite bank to touch the 'other', which is what is needed to renew and rejuvenate and become 'real'. Elsewhere a giant *Split Man* cuts himself into two – head first – with an unwieldy sword, because as a 'dysfunctional human' he 'cannot or will not dedicate his or her life to one goal' and therefore will never attain

enlightenment; while an unexpectedly serene *Lord Shiva* contemplates life sitting cross-legged in a lake. The work is quite dark in places, and quite complicated if you engage with the text as well, but overall this is probably some of the most unusual work you will see anywhere, so for something a bit different it is definitely worth a visit.

## FINDING YOUR WAY AROUND

The park is set amongst fields, woodland and small lakes, and if the weather is good it is quite beautiful. It is a large area, so parts remain quite wild, but a clearly marked path leads you in and out of the trees to each sculpture and then around the lakes and back to the field. Where it is unclear an arrow points the way, but overall it is a very easy trail to follow.

# 56 Sneem Sculpture Park

## OVERVIEW

These sculptures are located beside St Michael's Church, overlooking the river at Sneem, and take the form of large drystone architectural constructions. Amongst them are pyramids along with other symmetrical shapes and forms resembling Egyptian tombs. They were all designed by one man, James Scanlon, and then constructed by local stoneworkers. In 1987, after Sneem won the National Tidy Towns Award, the Arts Council of Ireland offered money to invest in commissioning sculpture for the town.

The result was these few well-designed pieces, completed in 1990, and still well maintained today.

One sculpture looks out over the water, the circular window creating a small frame on the landscape behind it. Another is a cone shape with Egyptian influences, with lines running down from the top to the floor, straddling the tiny doorway. Entitled *The Way the Fairies Went*, these architectural forms certainly have an otherworldly feel about them, and in the case of the ones

with the tiny windows and doors, you can easily imagine that this is where the fairies go to disappear into their secret world. As the artist explains, the idea was for children to be able to enter while adults could not. Although there are only four works here, they are well thought out and carefully sited overlooking the water, and the whole place is picturesque and rather magical. If you are in the area it is a nice place to stop off. Sneem also has two town squares with a few other pieces of sculpture to see.

Sneem, Co. Kerry
http://sneem.net/sculpturepark/

**Facilities:** None
**Open:** Daily, all year
**Admission:** Free
**Time needed:** 20 mins

## Getting there

Sneem is located on the N70 between Kenmare and Cahersiveen. Driving into Sneem from the direction of Kenmare, look to your left for St Michael's Church at the end of a dead-end road, beside the river before you cross the bridge.

LEFT AND OPPOSITE: *The Way the Fairies Went*, James Scanlon, 1990. Stone. *Photos: Courtesy of the artist*

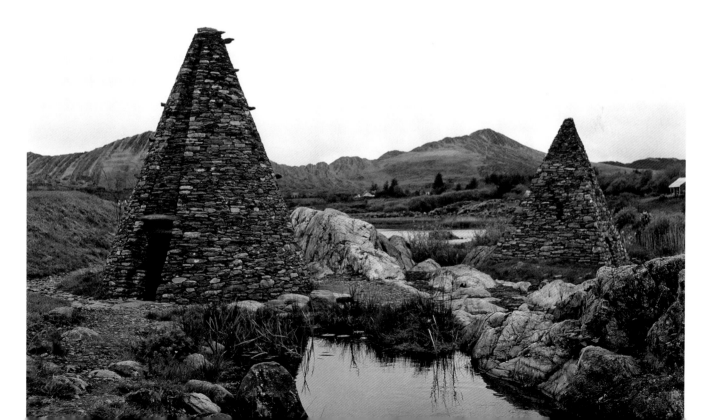

# 57 Sculpture in Woodland at Devil's Glen

Devil's Glen Wood, Co. Wicklow
Tel: +353 1 201 1132
www.coillte.ie/aboutcoillte/community/
community_partnerships/leinster/devils_
glen_co_wicklow/

**Information only**
Coillte, Newtownmountkennedy,
Co. Wicklow
Tel: +353 1 201 1111

**Seamus Heaney walk map:**
www.coillteoutdoors.ie/index.php?id=
54&trail=31&trail_type=1&&no_cache=1
**Waterfall walk map:** scroll right to bottom
of the page, at www.coillteoutdoors.
ie/?id=53&rec_site=25

**Facilities:** None
**Open:** Daily 9am–9pm, road to Waterfall
Walk open 9am–5pm (1.6km)
**Admission:** Free
**Time needed:** 1½–2 hours

## Getting there

**BY CAR**
Take the N11 towards Wicklow, then
at Ashford take the R763 towards
Glendalough. Follow signposts, but watch
for the entrance on your right, which
appears suddenly after a sharp bend.

RIGHT: *0121-1110=10210*, Lee Jae-Hyo, 2002.
Wood. *Photo: Dan Collins, courtesy of Sculpture in
Woodland at Devil's Glen*

FAR RIGHT: *Antaeus*, Michael Warren, 1998. *Photo:
Alison Stace*

## OVERVIEW

Sculpture in Woodland at Devil's Glen
is set amongst beautiful woods, with a
river running through and at one point
even a waterfall. This is divided into
two different walks (the Waterfall Walk
and the Upland Walk or Seamus Heaney
Walk). Seamus Heaney lives locally and
has written a number of poems about the
area; extracts from some of these poems
can be seen on benches in the forest.
The first route you come to when you
turn off the road is the Upland/Seamus
Heaney Walk. In theory this is about 4km
long and will take approximately 1½
hours, while the waterfall walk is about
5km and took us about 2 hours (though
that did involve pushing a pram over
rocks and through mud, which inevitably
slowed us down). If you are a very fit
or speedy walker you could probably do
both of these walks in less time. However,
there is less sculpture on the Upland/
Seamus Heaney Walk, and this is mainly
located at the start, so if you don't want
to do both walks, you can stop and see
the sculpture on the first walk (allow
about 35 minutes) then drive on to the
waterfall walk.

The work at Devil's Glen was started in 1994 to raise an awareness of wood as a medium, the idea being to encourage both artists to use wood as a material and the public to enjoy the woodland. The project was certainly successful, though unfortunately many pieces have since disintegrated or been vandalised. The work that remains, however, is lovely, while some pieces are being repaired and new work is being commissioned. It is certainly worth a visit, but be prepared for a fair bit of walking – you have to work for your sculpture! If you do have the map, the numbers of those sculptures still there are: 1, 2, 17, 3 & 6 (Upland Walk); then 7, 8, 10, 11, 12, 13, 16, with 18 & 19 not shown (Waterfall Walk).

The two walks combined offer a good variety of work, but the Waterfall Walk had many nice pieces along the first half, with much less on the way back. I would recommend trying to visit in good weather as the lower path on the return journey can be quite muddy and hard-going in patches. The views from the waterfall walk were fantastic, but bear in mind that in places the path is extremely high up on a steep hillside. You will need good shoes or boots, waterproofs, and supplies to take with you. The walk does have some steep areas – there is a fairly steep uphill climb to start with – and the pathway is a bit rocky (this is not a problem unless you are pushing a pram) with a very steep part at the end (although this can be avoided if you take a slightly longer route back).

## FINDING YOUR WAY AROUND & THINGS TO SEE

Due to space restrictions, I have only mentioned works below that were largely intact and retained some impact, or stood out. Other sculptures remain but are sometimes diminished.

The map for Devil's Glen sculpture can be obtained from the office in advance by post, which is useful because it comes as a small printed pamphlet with information on the work. There is also information on the sculptures on the website if you scroll to the bottom. The map for the Seamus Heaney/Upland Walk and the Waterfall Walk can be printed out from the internet (see information box opposite).

The Upland Walk starts from the car park just off the main road and is signposted next to the information boards. It is marked in yellow and has yellow way markers along the route. If you only want to see the sculpture rather than doing the walk, you can start by setting off up the path towards no.2 Lee Jae-Hyo's very enigmatic wooden sphere entitled *0121-1110=10210*. This is certainly one of the best pieces here, remarkably well preserved and well worth the short walk (about 10 minutes) to reach it. On the way, no.17, *Silva Sancta*, is worth a look, although you might miss it if you didn't know what to look for – Deirdre M. Donoghue has put a fence around an area containing the sacred trees of Ireland (ash, yew and oak) as well as Douglas fir; the idea is to create a space to be

LEFT: *Panorama*, Janet Mullarney, 2001. Wood. Photo: *Alison Stace*

*Stone Voices*, Suky Best, 2007. Photo: *Alison Stace*

experienced as 'a psychological landscape as well as a geographical area'. Returning to the car park, No.1, *Antaeus* by Michael Warren, stands just to your left on the small forest road leading to the Waterfall Walk (an impressive oak form which stands on the banking).

For the Waterfall Walk, follow the forest road from the first car park until you reach the car park at the end. Park in this car park and set off from the path beside the information boards, which you'll see on your left as you arrive. The views from the Waterfall Walk are fantastic, but keep an eye on the path as you are on a steep hillside. Some of the initial works come up very fast, such as Jacques Bosser's *Chago*, which stands overlooking the car park. Other pieces are damaged or diminished, but look out for Max Eastley's

*Pine Ghosts*, comprising grid-like wings attached to the trees towards the top of the path. Then, as you turn the corner from the climb, you come to the very creepy *Seven Shrines* by Kat O'Brien, of which some remain, complete with what appear to be body parts suspended in them (but are in fact natural forms found in the wood).

From this point, the work becomes more spread out until you reach two different *Panoramas* by Janet Mullarney. Suspended from the trees, these wooden frames literally create a sort of window with perspective to focus your gaze and emphasise the view. As you walk, watch out for *Stone Voices* by Suky Best, scattered along the walk, consisting of 20 limestone plaques, attached to boulders, with phrases carved into them.

These are all snippets from stories the artist collected from local residents and children. After the path divides, you can continue, if you wish, to the waterfall. Returning back, retrace your steps and take the lower path beside the river. It is a long walk back before you reach *Wound* by Cathy Carman, two carved forms with a huge hole through them, as if run through by an enormous spear. At the end of the walk you have a choice – you will come to a sign directing you to a small path to your right signposted 'car park'. This involves a very steep uphill climb zigzagging through the trees and is not for the faint-hearted or small children, but it does lead you to *Chrysalis* by Michael Quane. Or you can continue straight on the main path and head back the longer but easier way round.

# Wales

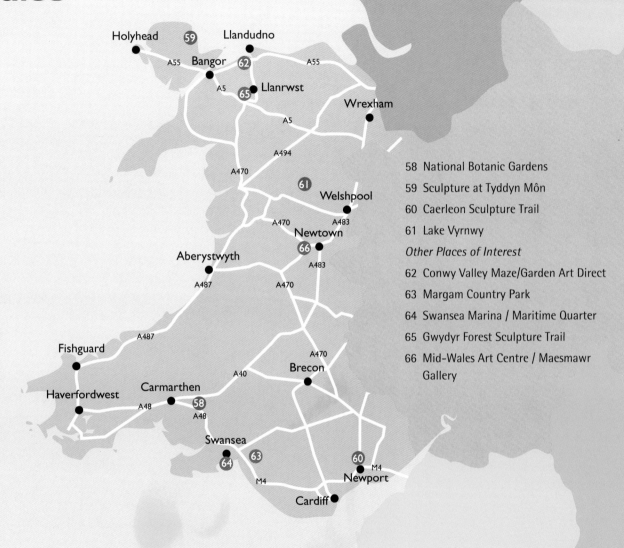

Holyhead  59  Llandudno
A55  Bangor  62
A5  65  Llanrwst
Wrexham
A55

A5

A494

A470

61
Welshpool
A470  A483
Newtown
66
A483

Aberystwyth

A487  A470

A487

Fishguard

A470
Brecon

A40

Haverfordwest  Carmarthen
A48  58
A48

Swansea
63
64  60  M4
M4  Newport

Cardiff

58  National Botanic Gardens
59  Sculpture at Tyddyn Môn
60  Caerleon Sculpture Trail
61  Lake Vyrnwy

*Other Places of Interest*
62  Conwy Valley Maze/Garden Art Direct
63  Margam Country Park
64  Swansea Marina / Maritime Quarter
65  Gwydyr Forest Sculpture Trail
66  Mid-Wales Art Centre / Maesmawr
    Gallery

# 58 National Botanic Gardens

Llanarthne, Carmarthenshire
SA32 8HG
Tel: 01558 668768/01558 667130
www.gardenofwales.org.uk

**Facilities:** Two cafés, toilets, shop
**Open:** Daily (shut Christmas day), April–
Sept 10am–6pm, Oct–March 10am–
4.30pm
**Admission:** Adults £8.50, kids £4.50, under
5s free, seniors £7.
**Time needed:** 2 hours

## Getting there

### BY CAR
At end of the M4 (Jct 49), follow
its continuation, the A48, towards
Carmarthen until you see brown signs
for the Botanic Gardens, which take you
on the B4310 towards Nantgaredig. The
gardens are signposted off this road.

### BY PUBLIC TRANSPORT
The 166 bus route links Carmarthen train
station with Cross Hands and Pontyberem
and stops in the gardens car park.
Sightseeing trips also run from Cardiff
to the gardens (02920 227227, www.
seewales.com)

RIGHT: *(Punk) Dog Fish*, Deborah Lewis, 2010. Steel,
garden fork, mole trap, nails and limestone. *Photo:
Alison Stace*

OPPOSITE: *Welsh Black*, Sally Matthews, 2009. Metal,
skins and furs. *Photo: Alison Stace*

## OVERVIEW

Part government-funded, these beautiful
gardens are well designed and maintained.
There are also many other things going
on here, with various areas to visit such
as the double-walled garden, the Welsh
Water Discovery Centre (for bird and pond
watching), the tropical house and the
amazing glasshouse. The current gardens
were created over a period of 10 years,
opening in 2000, and stand on the site
of an old estate. Middleton Hall burned
down in 1931 but the ice house and
servants' quarters still remain. William
Paxton turned the original 17th-century
Middleton estate into a Georgian water
park stocked with lakes, streams and
ponds which fed into each other through
dams and sluices. The seven lakes gradually
choked up, but are slowly being reclaimed
and repopulated with wildlife, while the
gorgeous gardens show little evidence of
their former neglect. The stunning new
glasshouse designed by Norman Foster,
virtually a sculpture itself, fits so well into
the landscape it could almost be a natural
form. It is host to a range of temperate
climates, with small sculptures nestling
amongst the plants.

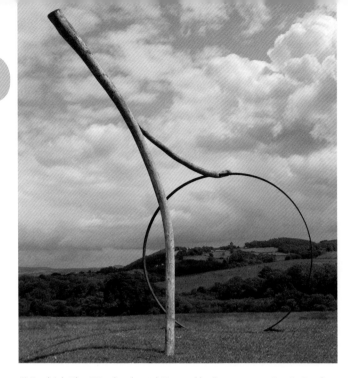

*Pi*, Rawleigh Clay. Wood and metal. Donated by Contemporary Arts Society for Wales. *Photo: Alison Stace, courtesy of National Botanic Garden of Wales*

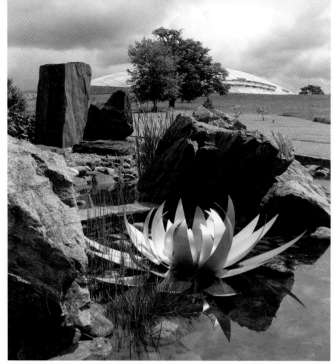

*Water Lily*, Sarah Tombs. Stainless steel. *Photo: Alison Stace*

CYMRU, the Welsh sculpture organisation, has partnered with the gardens to create sculptures that are engaging and relevant. The sculpture is found throughout the grounds, as well as in the small sculpture garden itself. The sculpture garden is a bit of a disappointment compared to the beautifully landscaped grounds, though it was due for renovation at the time we visited so may well have improved. The aim of the sculptures is to help inspire, engage and educate people about the vital work going on at the gardens to create an enormous plant DNA database. In the Wallace Garden, they are creating a DNA garden, through which runs a path in the form of a double helix, representing the DNA code. CYMRU artists are working with the scientists and gardeners to create works that are resonant with the project.

## FINDING YOUR WAY AROUND

You can print off a map of the sculptures from the website, but they usually have them at the entrance (although note that both *Pi* and *Welsh Black* were not on the map at the time of visiting, but they are here permanently). Be sure to get an overall plan of the gardens, too, as there are many different areas. Sculptures are moved around quite frequently, so don't be surprised if the works are not where you expect them to be. However, there is no particular order to the works – so as long as you have a map of the gardens, just wander around and see what you can find.

## THINGS TO SEE

As well as the sculpture trail, there are some good permanent pieces which are not included on the trail map. My two favourites are both fairly near the glasshouse: *Pi* by Rawleigh Clay is a simple representation of the Greek letter situated high up by the glasshouse, framing the landscape beyond; the other piece, further down the hill towards the lake and wild garden, is a life-size bull made of metal

and stuffed with wool and skins by an artist who specializes in animals. Called *Welsh Black,* by artist Sally Matthews, it dominates the patch it stands on. Other permanent works include a great stone, cascading water fountain by William Pye, called *Scaladaqua Tonda* which sits on either side of the path twisting in opposite ways, and an interesting piece called *Kisses Across the Irish Sea* by Sonja Dawn Flewitt, consisting of three framed sets of cast faces, showing the chins and lips of many different people. This work is hung in an alcove near the shop and restaurant, and is easy to miss. Also worth looking at is the interesting mosaic *Creative Growth,* organised by artist Pod Clare, a community collaboration in the form of a DNA helix. This can be found sheltering in a large alcove in the stables courtyard.

At the time of visiting, many sculptures were in the process of being replaced. However, other good works include Sarah Tombs's giant but strangely lightweight *Water Lily,* which sits in a small pond in the very attractive rill, a small meandering stream created in the path leading up from the entrance. At the top of the rill was a curvaceous metal twist called *Liminality* by Benjamin Storch, whose undulating form curved around on itself and looked completely at home against the landscape. Also in the sculpture garden, sitting in a flowerbed, was Georgina Park's *Inertia,* an unnerving piece made from two wheels held together by some incredibly realistic resin hands and wrists. The most recent addition is *The Boar on the Hill* (2012), made by artist Michelle Cain with help from British Basketmakers' Association volunteers.

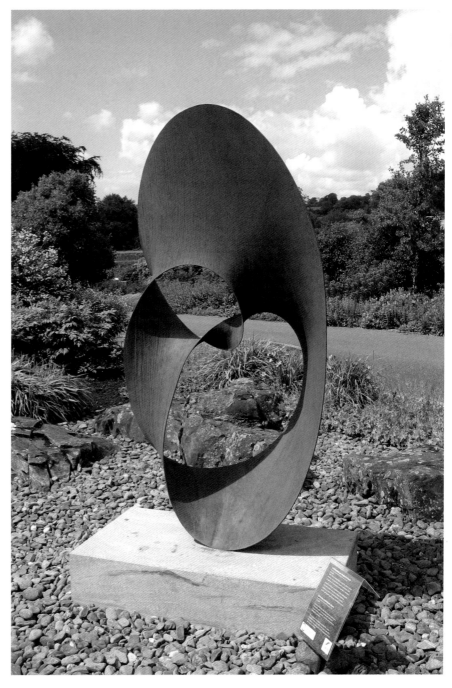

*Liminality,* Benjamin Storch, 2010. Cor-Ten™ steel. *Photo: Alison Stace*

# 59 Sculpture at Tyddyn Môn

Brynrefail, Dulas, Amlwch
LL70 9PQ
Tel: 01248 410580
www.tyddynmon.co.uk

**Facilities:** Toilets and café. Also go-karts, mountain boards, children's tractors and crazy golf.
**Open:** 9am–4pm Mon–Fri, and some weekends in summer (check website)
**Admission:** Adults £5, under 12s free.
**Parking:** Public parking at the top by the entrance, disabled parking further down by the offices.

## Getting there

### BY CAR

From north and south: Take the A5 or A55 towards Bangor and the Menai Bridge. From the A55 come off at Jct 8 onto the A5025 towards Amlwch. Once past Moelfre, Tyddyn Môn is signposted from this road at Brynrefail. On arrival there is parking near this main entrance, but you can also drive down towards the offices and park in the main courtyard, though this can get busy.

## OVERVIEW

Tyddyn Môn is a registered charity set up in 1988 for people with learning disabilities, providing day care and learning facilities. This well-equipped centre offers the opportunity for learning and also for earning a small wage – the café, for example, is run by residents with help from staff. It now has a great many other activities on offer, such as go-karting and crazy golf.

Tyddyn Môn is also a quiet treasure trove of very good sculpture, installed between 2000 and 2005 courtesy of an Arts Council grant. The work is by well-known artists who worked with residents of the centre at the ideas stage. There are many other things available here, including adventure playgrounds, farm animals and organic vegetables, as well as a lovely path that takes you down to the beach. The eight sculptures in beautiful surroundings are definitely worth a visit. Even if the location is a little far-flung, these substantial pieces of work are well maintained on the whole and are all within easy walking distance.

*Three Giant Seeds*, Howard Boycott, 2003. Brick.
*Photo: Eryl Crump, courtesy of Tyddyn Môn*

## FINDING YOUR WAY AROUND

Maps are available on the leaflets provided by the centre, which you can obtain from the café or print from the website before your visit, but there are also sheets available with more detailed summaries of the pieces and the ideas behind them. The map is a bit hard to follow when you do not know all the buildings, but it is a small area overall, with many staff on hand to point you in the right direction. There are four metal gates with seasonal themes leading you into different areas; designed by Ann Catrin Evans with some of the trainees at the centre, these are marked on the map and can help you navigate.

## THINGS TO SEE

Of the eight sculptures, *The Pony* by Sally Matthews was one of my favourites. It stands near the original farm shop, looking as if it is trying to peer over the fence. Matthews has used the heavy metal material perfectly to create a muscular animal that has both the presence and the power of an actual pony. Passing through one of the gates leads you to *The Shell* by Dominic Clare, based on a whelk found on the beach. The large stones set around the shell form create a circle used for telling stories.

TOP: Mosaic seating created by visiting artists in collaboration with staff and clients at Tyddyn Môn. *Photo: Alison Stace*

RIGHT: *The Pony*, Sally Matthews, 2003. Reclaimed metal. *Photo: Alison Stace*

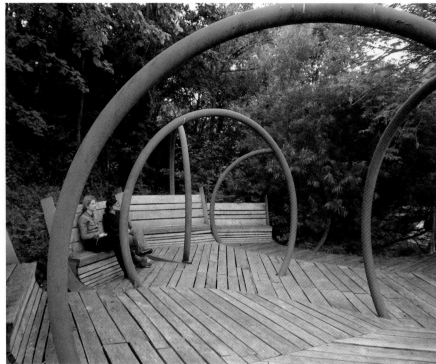

ABOVE: *High Water Mark* (detail), Nigel Talbot, 2005. Oak. *Photo: Alison Stace*

TOP RIGHT: *Amphitheatre* (2005) inspired by Sean Curly's workshops. *Photo: Alison Stace*

Continuing on brings you to *The Pier*, an architectural structure which, situated high up, gives a great overview of the *Amphitheatre* by Sean Curly, a really dynamic space with curved bands for theatre and storytelling. Unfortunately for the Pier much of the black woven natural wooden boarding which made it an interesting structure became unstable, resulting in a safer – but less exciting – replacement. Next to this architectural structure is the *High Water Mark*, a very tall piece of wood with engraved copper plates set into the wood. The engravings include words describing the various trainees that attend the centre along with ceramic stamps they have made. The impression is of an ancient marker with pieces of history embedded into it.

Back at the last gate, following the trail along the edge of the field brings you to one of the best works, *The Shelter* by Ann Catrin Evans. With a great angled roof and a large circular hole cut out of the side, you can get some gorgeous undulating views of the shelter's structure through the hole, with the field as a backdrop. If you look closely at the roof you will see some words written by local poet Lewis Morris in the 18th century in a letter to his brother; the centre's leaflet explains that the aim is to be able to 'sit, sheltered by his words, within the landscape he describes, whilst we enjoy the beauty of the land they both so loved'.

*The Shelter*, Ann Catrin Evans, 2003 (various views and detail of roof). *Photos: Eryl Crump, courtesy of Tyddyn Môn*

# 60 Caerleon Sculpture Trail

Caerleon, Newport
www.caerleon-arts.org

Tourist office: High Street, Caerleon.
Tel: 01633 422 656

Ffwrwm Arts Centre: High Street,
Caerleon, NP18 1AG.
http://web.me.com/alessandrovolpides/
The_Ffwrwm/Welcome.html
Tel:01633 430 777

**Facilities:** Public car park off the high street
(fee payable). Cafés, toilets and several
good pubs in the town.
**Open:** Daily, all year (Ffwrwm sculpture
garden open 9am–5pm daily)
**Admission:** Free
**Time needed:** 1–1½ hours

## Getting there

### BY CAR
The town of Caerleon is found off the M4
at junction 24, near Newport. Follow signs
to the public car park off the high street.

RIGHT: *Lovespoon*, Ed Harrison, 2010. Wood. *Photo:
Alison Stace*

OPPOSITE, TOP LEFT: *Arthur Guinevere Lancelot* (detail),
Dave Johnson, 2003. Wood. *Photo: Alison Stace,
courtesy of Caerleon sculpture trail*

TOP RIGHT: *Roman Soldier Head*, Philip Bews, 2003.
Wood. *Photo: Alison Stace, courtesy of Caerleon
sculpture trail*

## OVERVIEW

If you are near the pretty town of
Caerleon and have an hour or so to spare,
make sure you stop to see this trail. It
runs through the town, which was built
on top of an old Roman site. Some of
the old walls of the town still stand, and
Roman ruins and a museum testify to the
town's history. Quirky and characterful
little cottages line the winding streets,
along with the odd ancient pub: the
17th-century Bell Inn at the end of Isca
Road has a nice garden and is a very good
stopping-off point for lunch or a drink,
while the Hanbury Arms has great views
along the river. Both have sculptures in
their gardens.

This trail has been built up around the
annual sculpture symposium that has
been running in the town since 2003,
when sculptors come from both the UK
and abroad to carve or construct pieces
which are then placed throughout the
town. The festival and symposium are
partly funded by Newport City Council
and partly by the town itself, which holds

fundraising events throughout the year. The size of the town makes the trail very accessible, and the setting makes for an attractive and enjoyable wander. Some of the older sculptures have been replaced as they have aged, but there are still some 30 sculptures or so scattered through the town which can be found using the town map you print from the festival website (www.caerleon-arts.org) or from the tourist information centre. We spent an hour and a half and saw most things, though not all.

While on your walk through the town, be sure to go into the Ffwrwm Arts & Crafts Centre, located in an 18th-century walled garden off the main street. Inside the walls are many wooden sculptures both old and new, as well as some that are still in progress, including, at the time of our visit, Ed Harrison's enormous *Lovespoon*, propped up, featuring a dragon which appears to fly along with a huge wooden chain between its teeth while dragging behind it what look like three cannonballs.

## FINDING YOUR WAY AROUND

If you forget to print off a map, there is a small tourist information centre on the high street, which has maps of the town and can point you in the right direction. There is currently a new map being drawn up by the arts festival in conjunction with the council showing all the current sculptures. Wandering around you will see many sculptures, although some are quite tucked away. To get you started it is worth photocopying the ones mentioned below. Since the town is relatively small, you are unlikely to get lost once armed

with the map. Even if you fail to find all the sculptures, you will certainly find enough that you won't be disappointed. Bear in mind that some of the pieces are located within private grounds, but these are always within easy view of the pavement, even if through a fence or over a low wall.

## THINGS TO SEE

Since the sculptures have been made by a wide variety of sculptors, the subjects and quality do vary a great deal, but there are enough good ones to make this a worthwhile visit. Try to find the enormous head, which looks like that of a Roman soldier, set in the field by Hanbury Garage near the river. On the theme of heads, a splendid trio stand in the garden of the Hanbury Arms pub, overlooking the river, representing Arthur, Guinevere and Lancelot. From here you can see the red Welsh dragon made by Yildiz Guner from Turkey. And yet another head, *Celtic Warrior* by David Lloyd, stands on the corner at the end of Isca Road by the Bell Inn; carved from the stump of the tree, its enormous roots billow out behind it in a tangled mass of hair. It is well worth the walk to see it, although the setting is not the best, standing between a lamppost and a noticeboard, with a postbox right next to it.

In a private garden in front of the house opposite the Roman Museum is another fantastic Yildiz Guner sculpture of a woman's face and hands, holding the form of a ship and looking very

mournful: it would seem she is trying to save it. On the diagonally opposite corner, just inside the churchyard is *Oaken Couple* by Milan Vacha from the Czech Republic: a tall couple embracing sadly, almost buried in their long cloaks. And just across the Broadway from the ship is a striking representation of *King Arthur* by Sarka Vachova, also from the Czech Republic. It sits in the grounds of the Endowed School but is clearly visible through the fence from the road.

RIGHT: *Woman with Ship*, Yildiz Guner, 2007. Wood. *Photo: Alison Stace, courtesy of Caerleon sculpture trail*

BELOW: *Welsh Dragon*, Yildiz Guner, 2007. Painted wood. *Photo: Alison Stace, courtesy of Caerleon sculpture trail*

# 61 Lake Vyrnwy

RSPB nature reserve
Bryn Awel, Llanwddyn
Oswestry, Shropshire, SY10 0LZ
Tel: 01691 870 278
www.rspb.org.uk/lake vyrnwy
www.lake-vyrnwy.com/index.html#

**Facilities:** Public toilets near RSPB shop and tearooms very nearby.
**Open:** Daily, dusk till dawn
**Admission:** Free
**Time needed:** 1 hour

## Getting there

### BY CAR
**From the north:** From the A5 (between Betws-y-Coed and Llangollen) take the A494 towards Dolgellau. Turn off this road onto the B4401, and then the B4391 towards Pen-y-bont-fawr. Take the B4396, then the B4393 to Lake Vyrnwy and Llanwddyn. Follow the brown tourist signs to the lake and look for the RSPB shop in Llanwddyn.

**From the south:** From Welshpool take the A490 to Llanfyllin, then the B4393 to Lake Vyrnwy and Llanwddyn, following directions as above to the RSPB shop.

## OVERVIEW

The RSPB shop, though not responsible for the sculpture trail, has maps of the lake area and can point you in the right direction for the start of the trail (see under 'Finding your way around' for further directions). There are also toilets nearby. All the sculptures here are made of wood, the result of annual sculpture symposiums begun in 1999 by Tom Gilhespy. For many years artists came from all over the world who were not necessarily used to carving or working with wood beforehand. Although the symposiums have been discontinued, the works remain as a sculpture park, with each artist having one piece. The sculptures are no longer maintained, but the area as a whole is looked after and paths are easy to walk around. Unfortunately, as pieces disintegrate they are removed rather than replaced, but there are still many great pieces intact (the information board lists about 50 sculptures originally). The sculpture park

*Giant A-shape chairs*, artist unknown. Wood.
Photo: Alison Stace

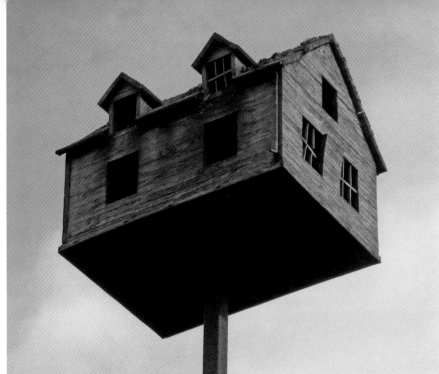

area is situated alongside the river bank, with views of the dam as a backdrop. If you have time, try to drive on afterwards to the top of the lake where you'll find a couple more nice pieces.

## FINDING YOUR WAY AROUND

From the RSPB shop, walk downhill past the teashop and the stepped green area on your left until you reach a small car park. Next to it are a few sculptures and the official entrance to the park, a large wooden gateway called *Wild Boar Gate*. Do not go through the gateway, but take a left turn onto a path leading beside the water, past a few sculptures, down to the footbridge. Cross the footbridge, then turn left onto the path that leads you into the main sculpture park area. Do not

take the disabled short cut (unless you need to) but continue on the path, which curves around, bringing you past various sculptures at the start of the trail. There are quite a few things to see as the path winds back and forth in a big circle past all the sculptures, before bringing you back to the footbridge where you started. As you return, once past the arch in the stream you can take a left path uphill to a flat area containing the last few pieces – the area you missed at the start – before exiting through the wooden gateway.

## THINGS TO SEE

There is a general feeling of unity here as all the pieces are made from wood, with some works seeming to have come from one old solid tree trunk. All the

best work is in the main park across the river, although Kirsi Kaulanen's *Female Machine*, in the woods as you walk down to the river, is an interesting piece, looking like an enormous spider or scorpion (the tail is somewhat hidden in the trees). Some of the work has weathered significantly and some pieces have been removed (unfortunately these are not being replaced). There is still a good selection of work to look at, however, but reading the names of pieces and artists can be a challenge, as often these are very worn: there is a main board near the gateway which lists them all if you are particularly interested.

As you walk along the path, having crossed the river, you will find Rosemary Terry's *Cupboard*, which is quite literal:

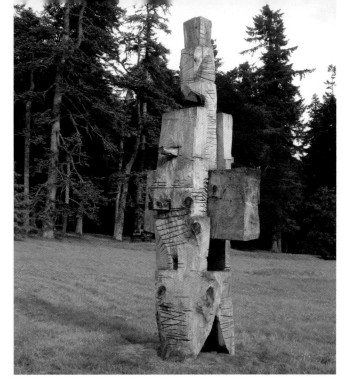

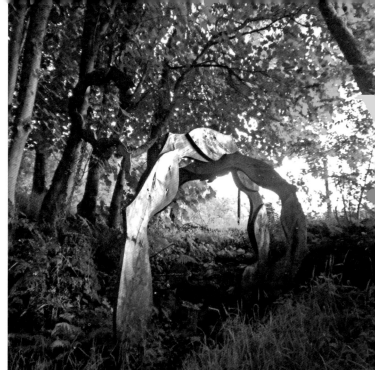

two open halves of a giant piece of wood with enormous kettle and supplies. *A Place for Tea* by Kristaps Gulbis, with the dam as a backdrop, is a lovely tiny house, high up on a pole in the clouds – ideal for a fantasy tea party. Nearby, *The Thinker* by Urmas Rauba is a simple cylindrical form with great presence, while *The Cage* by Aime Kuulbusch is more complicated, a very good work slightly spoiled by the apparent damage it has suffered.

After visiting the park, if you have time, drive round the lake (heading up the right hand side passing Lake Vyrnwy Hotel). In the water beside the car park and picnic benches half-way round are some wooden *Dolphins* (not the most impressive, but the location is perfect for them), but further on at the top of the lake is another car

park with some interesting pieces. A life-size carthorse and cart, made from metal and wood, penned in a makeshift paddock, has great character, if it is a little worn. Opposite, a bit higher up on the banking are some fantastic 'A'-shaped wooden seats, which have a great architectural feel about them, and lean back slightly. They have been placed in a square, with a beautiful view of the hills behind them. It's worth stopping here to have your picnic and take in the scenic quiet.

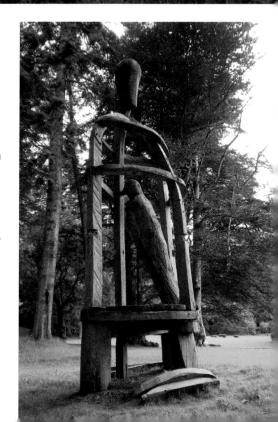

OPPOSITE: *A Place for Tea* (and detail), Kristaps Cuibis (Latvia), 2003. Wood. *Photo: Alison Stace*

ABOVE LEFT: Temple (unknown artist). *Photo: Alison Stace*

ABOVE RIGHT: Female Machine, Kirsl Kaulanen (Finland), 2004. *Photo: Alison Stace*

RIGHT: *The Cage*, Aime Kuulbusch (Estonia), 2002. Wood. *Photo: Alison Stace*

# 62  Conwy Valley Maze/Garden Art Direct

WALES

Ty Hwnt i'r Afon
Dolgarrog, Conwy
LL32 8JX
Tel: 01492 660900
www.gardenartdirect.co.uk

**Facilities:** Toilets, tea/coffee facilities
**Open:** Weekends 10am–6pm, midweek
from Easter to end Oct, but ring before
making a special journey, as it is sometimes
shut due to weather, etc.
**Admission:** Adults £10, family £20 (2
adults, 2 kids), child £5.
**Time needed:** 2–3 hours

## Getting there

### BY CAR
**From the north:** From the A55 heading from
Chester to Bangor, turn left onto the A470 at
Llandudno Junction, then take the B5106 in
the direction of Ty'n-y-Groes and Dolgarrog.
Once through Dolgarrog, after the houses
thin out, look for a gateway by an enormous
white urn on the wall by the road (the two
white urns mark the edges of the garden).

**From the south:** From the A5 which runs
between Bethesda and Llangollen, take the
B5106 towards Llanrwst and Dolgarrog.
Once through Llanrwst, but before you
come into Dolgarrog itself, look for the
huge white urns on the wall by the road.
The entrance is by the second urn.

## OVERVIEW

Begun in 2001, the Conwy Maze and
woodland walk have grown and expanded
over the last 10 years. The maze is now
the largest in Britain, the maze and
woodlands stretching over a 10-acre site.
The maze doesn't seem very complicated
at first, but you actually need a couple
of hours to find your way up and down
the little paths lined with hedges, which
all begin to look very similar (and even
a little claustrophobic) once you get
lost. Make sure you take waterproofs if
it is likely to rain, as you can get very
wet walking past all the damp hedges.
Artworks are scattered throughout, and
occasionally the maze will open out into
a wider space that might be a rose garden
or a Japanese garden. These areas are a
bit of a relief and set off the artworks

very well. Often you can see something
interesting peeking out over the hedges
but it can take a while to get to it, given
the many decoy paths. The sculpture is a
mixture of old and new, and is aimed at
those looking for garden pieces to buy.

## FINDING YOUR WAY AROUND

This is tricky, given the maze, but it seems
that all paths eventually lead back to a
certain point that takes you through to the
next section. The only way to remember
the parts you have seen is by the open
areas in between, and the artworks
scattered throughout, which often appear
in an alcove or as a feature nestling in a
dead end. These sometimes look as if they
have not been very carefully installed,

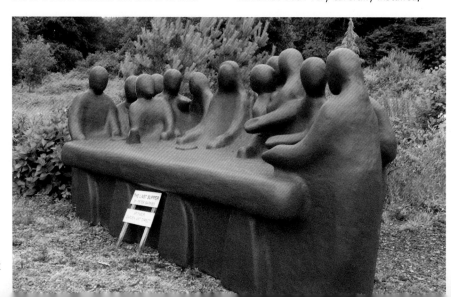

*The Last Supper*, Peter Barnes. Bronze resin. *Photo:*
*Alison Stace*

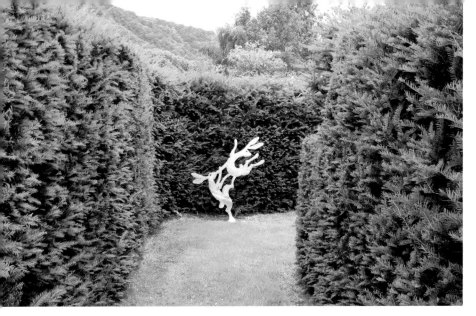

View of the maze with *Fighting Hares* by Giovanni Jacovelli, 2011. Perspex. *Photo: Alison Stace*

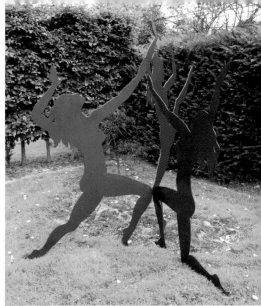

RIGHT: *Charlie's Angels*, Giovanni Jacovelli, 2011. Perspex. *Photo: Alison Stace*

BELOW: Lion, unknown artist. Bronze. *Photo: Alison Stace*

though this is partly because things get moved around or sold off as garden pieces. As you come out from the end of one particular hedge-lined walkway, you will suddenly turn a corner and find yourself looking at a Japanese Zen garden with raked gravel and bonsais; be very careful of the path here as the grey slate hides a huge boulder which, especially in the rain, is very easy to trip over while you are distracted – as I discovered!

## THINGS TO SEE

Sculptures are a mixture of stone and bronze works, some of which are antiques, often bought from abroad. They range from traditional English bronzes of lions or children to Buddhas and Chinese dragons, but there are also many contemporary pieces made by the owner, Giovanni

Jacovelli. These are often constructed from flat pieces of metal arranged into 3D works and painted with bright colours – on my visit, for example, some dancers near the centre of the maze, and some fighting hares at the end of a long hedge-lined path. Other great finds were some enormous Egyptian-style bronzes, unexpectedly lying in the grass in an open area, and a little Alice-in-Wonderland scene inside curved hedges, with tiny chairs and table waiting for a tea party while outside a bronze Alice lies in the grass peering in.

The woodland walk is spectacular, but only for the hardier types as paths are very narrow and weave through the bushes beside fast-running water that rushes over slippery boulders. The sculpture here is a bit more sporadic, but can be glimpsed through the trees as you go.

# 63 Margam Country Park

## OVERVIEW

Margam Country Park is a thousand acres of parkland, amongst which sits the mansion house, known as Margam Castle, built in 1830 by Christopher Rice Mansel Talbot (not open to the public, although you can walk around the majestic staircase in the hall). The lovely Orangery dates from the 18th century and is used for weddings. Make sure you take a look at the ruins of the monastery just near it, which are as old as 1147. The grounds are huge and contain mountain-bike trails and also a 'Go Ape!' area, while the sculptures are contained within several small areas. The sculpture here is not that extensive, given the size of the grounds, but there are several good pieces and the setting is so lovely that you will thoroughly enjoy your ramble to find the eight or nine works. With little bridges and ponds, the well-kept bushes and grounds are a delight to walk through. If you are short of time, you can probably see all the sculptures in an hour, but this place is at its best if you take the time to enjoy the grounds at a leisurely pace.

Margam, Port Talbot
SA13 2TJ
Tel: 01639 881635
www.margamcountrypark.co.uk

**Facilities:** Café and toilets
**Open:** 1 Apr–3 Sep, daily 10am–5pm; 4th Sep–31st March, daily 10am–4.30pm (note that from 5th Nov opening hours for Mon & Tue are 1–4.30pm). Check website for exact dates as they change slightly each year.
**Admission:** Free, but parking is £3.70.
**Time needed:** 1 hour

## Getting there

### BY CAR
From the M4, come off at Jct 38 and follow signposts.

## FINDING YOUR WAY AROUND

The sculptures are not marked on any of the maps provided, but it is quite nice to wander the grounds and see what you can find; they are all within easy access. Make sure you get a basic map of the grounds at the entrance, as it will help you in your search. The main areas to focus on are: the rose garden, through the gate in the fence at the back of the house, where you can enter the hall and the grounds below; continuing down to the area around the Orangery, in particular the left-hand side as you descend through the gardens; and the Farm Trail, which has a couple of pieces kids will enjoy.

## THINGS TO SEE

There are a few things which stood out. Through the rose garden which leads you down towards the Orangery you will find *The Shout*, a harrowing sculpture of a woman holding what looks like a dead child, while to your left through the trees you will find a bulbous, amorphous organic form which sits very well in its surroundings. Further down near the Orangery are three tall carved wooden sculptures, which all look much more recent and have very interesting details and symbolism. Unfortunately, there are no titles on them so you will have to work it out for yourself, but they look a bit like totem poles. Near the Orangery, but much further to your right, is a fabulous sculpture of a woman,

entitled *The Wishing Stone*, which almost looks as if it has been stretched, or as if the wind has somehow elongated it, as all appears not quite in proportion. Meanwhile, below the Orangery is a strange metal sculpture that looks as if it has been dug up from the seabed.

OPPOSITE, TOP: *Pan*, artist unknown, unknown date. Wood. *Photo: Dave Duggan, courtesy of Margam Country Park*

LEFT: *Dragon*, unknown artist, unknown date. Wood. *Photo: Alison Stace*

ABOVE LEFT: *Shout*, Glynn Williams, unknown date. Stone. *Photo: Alison Stace*

ABOVE RIGHT: *The Wishing Stone*, Paul Williams, unknown date. Stone. *Photo: Dave Duggan, courtesy of Margam Country Park*

# 64 Swansea Marina/Maritime Quarter

## OVERVIEW

If you are passing through Swansea and have time, this is a fairly short but very interesting sculpture walk. The sculptures were mainly installed in 1987 by Swansea City Council, supported by many sponsors. There are two car parks by the marina, so park at one of these and head to the seafront and along the Marine Walk in the maritime quarter. Around the marina are newly built flats situated between the end of the marina and the seafront. In front of these flats, spread out along the seafront, are about eight sculptures all on a maritime theme, including some interesting wall reliefs built into the side of one of the flats. They are all centred around The Tower of the Ecliptic, a strange-looking observatory on the seafront with sculptures on its roof. It's a very pleasant half-hour stroll by the beach with great views of the sunset if you time it right.

## THINGS TO SEE

At the top end of Marine Walk is an enormous pair of what appear to be stainless-steel sails by Rob Olins, which are entitled *Acoustic Sculpture* (suggesting there is more to them than we found) which shine impressively in the sun. As you walk further along you will also find a large mermaid on a rock by Gordon Young. Indeed, she is almost part of the rock, the sculpture cleverly following the contours of the rock shape. Further on, a tall and somewhat crazy-looking contraption seems to be a representational lighthouse: the *Tower of the Ecliptic* is home to some impressive-looking sculptures, but they are very high up and quite hard to see.

Swansea Marina, Swansea

**Facilities:** None
**Open:** Daily
**Admission:** Free
**Time needed:** 30 mins

## Getting there

### BY CAR
Come off the M4 at Jct 42A and take the A483 into Swansea. Alternatively, you can come in on the A484 from Llanelli. Head for the centre or the National Waterfront Museum. If you come into the middle of town, head towards the sea, past the big Sainsbury's, the civic centre and the museum, until you see brown signs for the marina.

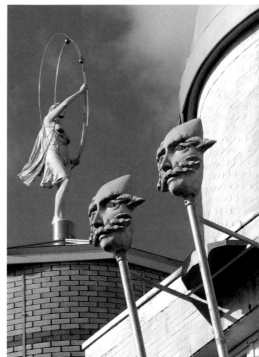

On the roof, in a piece called *Ecliptica*, a woman holds what appear to be planets in orbit, while on the sides of the building some enormous, very theatrical masks – reminiscent of Venetian masks – have something blown across their faces that could be cloth or even seaweed. Further down, near the intriguing wall reliefs on the corner of one block of flats, are three sculptures which stand quite close together and resemble a series of buoys.

FAR LEFT: *The Mermaid*, Gordon Young, 1989. Stone. *Photo: Alison Stace*

ABOVE: *Acoustic Sculpture*, Rob Olins, 2009. Stainless steel. *Photo: Alison Stace*

TOP RIGHT: *Lighthouse Tower*, Robert Conybear, 1987. Stone and metals. *Photo: Alison Stace*

RIGHT: *Ecliptica* sculpture, with masked face sculptures, on *The Tower of the Ecliptical* – designed by Lovell Urban Renewal (architects), Robin Campbell (architect), and Robert Conybear and Uta Molling (sculptors), 1993. *Photo: Alison Stace*

# 65 Gwydyr Forest Sculpture Trail

Gwydyr Forest, Llanrwst
Managed by Golygfa Gwydyr (group responsible for upkeep)

**Facilities:** None
**Open:** Daily, dusk till dawn
**Admission:** Free
**Time needed:** Approx. 1 hour

## Getting there

### BY CAR

**From the north:** From the A55 heading from Chester to Bangor, turn left onto the A470 at Llandudno Junction, and then take the B5106 in the direction of Ty'n-y-Groes and Dolgarrog. This road runs parallel to the A470 towards Llanrwst. Just before you reach Llanrwst, there is a turning to your right signposted to the castle and forestry offices. Take this turning, bearing left past the castle walls and on up to the forestry offices.

**From the south:** From the A5 which runs between Bethesda and Llangollen, take the B5106 towards Llanrwst and Dolgarrog. Once through Llanrwst and over the river, as the road begins to climb look out for the left-hand turning signposted to the castle, then proceed as above.

OPPOSITE, LEFT: *Town Hall*, Megan Broadmeadow, 2009. Board with aluminium backing and photographic print. *Photo: Alison Stace*

RIGHT: *Ysbardyn (Spur)* (and detail), Megan Broadmeadow, 2009. *Photo: courtesy of the artist*

## OVERVIEW

This short trail is situated in the forest high above Llanrwst. It was set up in 2009, and although it only has a few sculptures they are good pieces which integrate well with the landscape. Two artists, Mari Gwent and Megan Broadmeadow, worked in the area, taking the forest and its history as their inspiration to create pieces which would sit well within it. One of the main sources of inspiration is a figure called Dafydd ap Siencyn, a Robin Hood–type character who once lived in the forest with his group of followers and fought for their independence. Gwydyr Forest was therefore once a more integral part of the town and its people, and the idea of the trail is to encourage people to appreciate the forest once more.

## FINDING YOUR WAY AROUND & THINGS TO SEE

Park at the Forestry Commission office and walk up the road until you come to some paths and boards showing you the various routes for mountain biking, called Marin trails. Next to these you will see a gateway with a black footprint, and a sign saying 'Lady Mary's Walk'. This is the path you want, so be sure to follow the wooden posts with the black footprints on throughout the trail – i.e. not the bike routes.

A very steep uphill climb begins to level after about 10 minutes, at which point you will see an enormous black and white photo suspended between the trees. This giant mounted photo of Llanrwst town hall, which was demolished in the 1960s, was constructed in 2009 by Megan Broadmeadow. A somewhat incongruous idea, quite literally bringing the history of the town back to the forest, it somehow fits its surroundings very well.

Keep to the walkers' footpath and continue until you see on your left three enormous columns of oak standing in an open area with the view and horizon beyond them. Created by Mari Gwent, these huge wooden columns stand silhouetted against the sky and on closer inspection have Welsh sayings carved into them, twisting around the trunks. These columns are an homage both to the forest and to Dafydd ap Siencyn. Amongst other things, snippets of a poem about him called 'Derw dol yw dy dyrau' ('the tall oaks are your fortresses'), written by Tudor Penllyn in the 15th century, have been carved into the columns.

Once past the columns, follow the trail until it brings you back up onto the main bike trail/rough road and then turn right, back uphill along this main route for

5 to 10 minutes until you find a small path on your left marked 'For walkers', with a wooden post and a yellow arrow with the number 3. Take this small path through the trees for a short time until you come to *Ysbardyn (Spur)*, another piece by Megan Broadmeadow. This was also inspired by Siencyn, this time from his actual riding spur, which is still in

St Grwst Church as stated on the board (although it may now be under lock and key). This is a giant recreation of the spur made from a whole tree, lying amongst the other trees where he is thought to have ridden. The detail in the pattern has been carefully done, and it takes some walking around before you can make sense of the whole shape.

Coming back along this path and then turning left again onto the main route, you can pick up the walkers' path again and follow the black footprint posts back to the town-hall sculpture and down the hill.

# 66  Mid-Wales Art Centre/Maesmawr Gallery

Maesmawr Art Centre
Caersws
Powys
SY17 5SB
Tel: 01686 688369
www.midwalesarts.org.uk

**Open:** 11am–4pm Thur–Sun during exhibitions or by arrangement
**Facilities:** Toilets, café, B&B also available
**Parking:** Behind the house

## Getting there

**BY CAR**
From north or south take the A483 towards Newtown, then the A489 and A470 towards Caersws. The gallery is behind the large house which stands alone close to the junction of the A470 (Dolgellau to Llangurig) and A489 (Newtown) roads, just 100m from the level crossing.

**BY TRAIN**
Caersws train station and 15 min walk.

RIGHT: *Wire dogs* by Belinda Rush-Jansen, Stefan Knapp's work in background. *Photo: Alison Stace*

OPPOSITE, TOP LEFT: Metal piece by Ambrose Burne. *Photo: Alison Stace*

TOP RIGHT: *Close Encounter* by Jean Lawley-Maitland, 1999. *Photo: Alison Stace*

FAR RIGHT: Two pieces by Stefan Knapp. Enamel paints on metal. *Photo: Alison Stace*

## OVERVIEW

This interesting new gallery is an unexpected find in the centre of Wales. It is based on the work of Stefan Knapp, a well-known artist who created very large, brightly coloured murals and paintings. A Polish artist who survived a Siberian labour camp during the war, he eventually made his way to London. Here he developed a technique using enamels on sheets of metal whereby the enamels could be fired on, making them very hard and suitable for industrial and large-scale projects. His work is recognisable from its use of vibrant colours and flowing lines, often leading your eye around the angular forms. Sadly he died in 1996, and much of his unsold work remains here.

Still a fairly recent arrival in the area, his widow Cathy Knapp has bought land (18 acres) and buildings to create a gallery and sculpture gardens, and has been working on the project for about three years so far. The project is still very much a fledgling one, but the enormous and impressive barn gallery is already

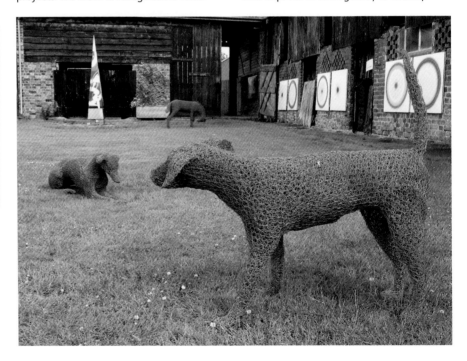

up and running with a courtyard garden and small surrounding areas containing sculptures by a variety of artists, although Stefan Knapp's work is the main focus. The plan is to expand out into the fields as things evolve, and to reclaim more of the outbuildings as space for workshops and artists. The gallery also has changing exhibitions by other artists (at the time of visiting it was a glass artist called Clare Pritchard), and in the courtyard there were wire animals by Belinda Rush-Jansen, steel and iron works by Ambrose Burne, some ceramic heads hidden in various alcoves and some large-scale iron pieces to come from Dave Wade. Cathy hopes to exhibit more international artists as well as local Welsh ones, both indoors and outdoors.

The centre has classes and workshops on offer which are gradually increasing, and various events happening, such as the 'Protest Art' project, which encouraged the general public and local community to come and paint placards in protest at all the pylons being placed in the landscape – these were to be displayed at the side of the main road, followed by a short exhibition in the gallery. The beautiful house has many art objects on display, and also offers B&B, while the café offers refreshments while you admire the artworks around you. If you are passing through this part of Wales the gallery is on a main traffic artery and is well worth a quick visit. It makes for an interesting stopping off point.

# Index